The Study of Italian Drawings

The contribution of Philip Pouncey

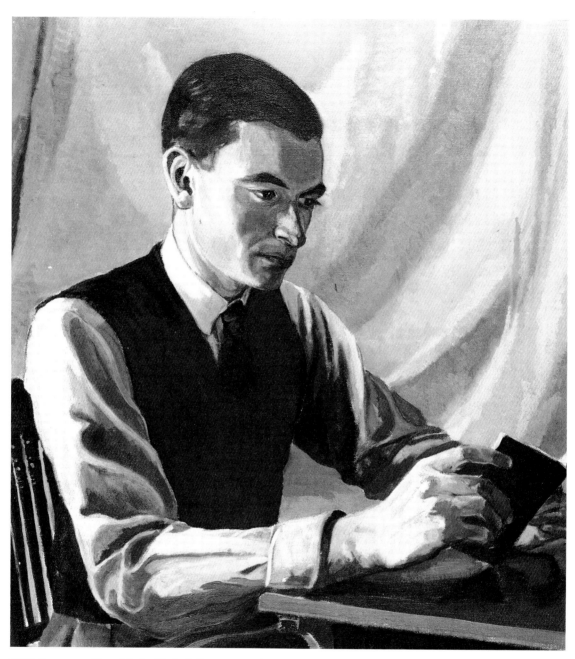

Philip Pouncey as a Young Man by Marjorie Barrett, 1932 (cat. no. 1)

The Study of
Italian Drawings

The contribution of
Philip Pouncey

Nicholas Turner

with an Introduction by
J. A. Gere

Published for the Trustees of the British Museum
by British Museum Press

© 1994 The Trustees of the British Museum
Published by British Museum Press
A division of British Museum Publications Ltd
46 Bloomsbury Street, London WC1B 3QQ

British Library Cataloguing in Publication Data
A catalogue record for this book is available
from the British Library

ISBN 0 7141 2602 0

Designed by James Shurmer

Printed in Great Britain by BAS Printers Limited,
Over Wallop, Hampshire

Contents

The Trustees of the British Museum
are grateful to Sotheby's
and to Luca Baroni of Colnaghi's, London,
for their generous contributions
towards this book

Foreword

Although Philip Pouncey (1910–90) was one of the greatest British art historians, his name remains unfamiliar to a general public. The reason for this paradox is that he published relatively little, and all his catalogues and articles were addressed to fellow specialists in the field of Old Master drawings. To them he was always exceptionally generous with help and information, and so his influence on other students was enormous. His career took him to the National Gallery, the British Museum, and finally to Sotheby's, but it was the two decades that he spent here at the British Museum, from 1945 to 1966, and the three catalogues of Italian drawings in this collection which he published in collaboration with A. E. Popham and J. A. Gere, that established the foundations of his reputation and achievement. This exhibition therefore concentrates on those years.

Two previous exhibitions, held in the Fitzwilliam Museum and the Louvre, have revealed the remarkable number of important drawings whose authors Pouncey first identified. These impressive discoveries transformed our understanding of many artists, some of whose work on paper he revealed for the first time. This achievement was based not only on an extraordinary eye and visual memory, but also on a highly disciplined working method, and it is the intention of this exhibition to explain this for the first time. Pouncey's formidable photographic library, and his sheer hard work in maintaining meticulously indexed records, enabled him to make connections that eluded others.

We hope that this demonstration of a great 'connoisseur' at work will help to confirm the validity as well as the importance of this method of art-historical research among those who have questioned it in recent years. It is only one of a number of tools at the historian's disposal, but it is capable of yielding results that can be quite as objective as those produced by the more commonly practised methods of archival and documentary research. For any museum, such as the British Museum, that has in its possession large quantities of material that require classification and identification, it is of fundamental and irreplaceable importance.

On behalf of the Trustees of the British Museum, I wish to express thanks to those whose generous willingness to lend has added greatly to the exhibition: two private collectors who wish to remain anonymous; the Syndics and Director of the Fitzwilliam Museum, Cambridge; the Trustees and Director of the National Gallery of Scotland, Edinburgh; the Trustees and Director of the Victoria and Albert Museum, London; the Visitors and Director of the Ashmolean Museum, Oxford, and the Governing Body of Christ Church, Oxford.

Thanks are also due to Mr David Scrase, Keeper of Paintings and Drawings, Fitzwilliam Museum, Cambridge; Mr Aidan Weston-Lewis, Assistant Keeper of Italian and Spanish Art, National Gallery of Scotland, Edinburgh; D.ssa Fiorella Superbi, Curator of Collections and Archives, Villa I Tatti, Florence; Professor Michael Hirst, Courtauld Institute of Art, London; Mr Giles Waterfield, Director, Dulwich Picture Gallery, London; Miss Claire Jackson, Records/Archives Assistant, National Gallery, London; Miss Susan Lambert, Curator, and Miss Janet Skidmore, Assistant Curator, Collection of Prints, Drawings and

Paintings, Victoria and Albert Museum, London; Mr Julien Stock and Miss Elizabeth Llewellyn, Sotheby's, London; Mr Timothy Wilson, Keeper of Western Art, and Mrs Rosemary Baird, Assistant Keeper, Ashmolean Museum, Oxford; Miss Lucy Whitaker, Assistant Curator of Pictures, and Mrs Susan Ramus, Research Assistant, Christ Church Picture Gallery, Oxford; M. Stéphane Loire, Conservateur au Département des Peintures, Musée du Louvre, Paris.

Our special thanks must go to Philip Pouncey's widow, Myril, who has offered every possible assistance throughout the preparation for this exhibition. What it may not reveal is how closely Philip and Myril worked together, and how dependent he was on her constant help and her own expertise in the subject. There were very few collections that he visited unaccompanied by her, and the information about his working methods comes from someone who knows them intimately. We are also very grateful to Mr J. A. Gere, a former Keeper of this Department, who collaborated with Pouncey on two British Museum catalogues that now have a classic status, and who was one of his closest friends, for so kindly contributing an essay to this catalogue. It complements the long obituary that he has already published in the *Proceedings of the British Academy*.

The compiler of this catalogue, Mr Nicholas Turner, Deputy Keeper, also wishes to thank Mr Gere for reading the text of the catalogue, correcting a number of errors and making innumerable improvements to the prose. Help of a more practical kind has been provided by Mr Crispin Robinson, Special Assistant, Mr Frederick Ilchman, Miss Vara Lauder, Miss Rhoda Eitel Porter and Miss Claire Van Cleave. Miss Teresa Francis of British Museum Press and Mr James Shurmer undertook the onerous task of preparing the text for the printers, while much of the work in the later stages of the organisation of the loans for the exhibition was provided by Miss Janice Reading.

Antony Griffiths
Keeper, Department of Prints and Drawings, British Museum

I Introduction *by J. A. Gere*

When I joined the Department of Prints and Drawings in 1946, all the Assistant Keepers had to work at desks in one very large room – an arrangement that enhanced the illusion of reliving one's first bewildered days at boarding-school. My neighbour at the next desk, a middle-aged man (as he then seemed to me: he was in fact 35), though far from bewildered was also a newcomer, having until very recently been an Assistant Keeper in the National Gallery. At the outbreak of war in 1939, Philip Pouncey's official duties had taken him to Aberystwyth, where part of the Gallery's collection had been moved for safety. The British Museum drawings were also there, as well as those from the Royal Library at Windsor. They were in the charge of A. E. Popham (1889–1970), then Deputy Keeper of the Department, who took advantage of his enforced exile and freedom from day-to-day administrative chores to begin work on the catalogues of the Italian drawings in both collections.

Pouncey had for some years been engaged in revising the catalogue of the early Italian paintings in the National Gallery, and already in 1936 had pointed out to Popham that a drawing in the British Museum attributed by Berenson to Cosimo Rosselli was in fact by Signorelli (cat. no. 13). He was thus singularly well qualified to help Popham with the fourteenth- and fifteenth-century drawings. The scope of their continuous discussion of problems that arose in the course of cataloguing was widened and enriched by the participation of two distinguished Hungarian art historians also then in Aberystwyth: Johannes Wilde (cat. no. 17), beginning to catalogue the Michelangelo drawings in the British Museum and the Royal Library, and Frederick Antal, whose many interests included the Italian sixteenth century, particularly well represented at Windsor. Pouncey soon saw that drawings, surviving as they have in far greater numbers than paintings, and being relatively little studied, gave more opportunity for the exercise of his outstanding talent for connoisseurship. After spending the last three years of the war at Bletchley, in the branch of the Foreign Office concerned with the interception of enemy communications (devoting his off-duty time to the compilation of a detailed index to the six volumes of Filippo Baldinucci's *Notizie de' Professori di Disegno da Cimabue in quà*, Florence, 1681–1728), in 1945, when Popham succeeded to the Keepership of the Department, Pouncey transferred from the National Gallery to the British Museum, where he continued, now on an official basis, to collaborate on the first volume of the Italian catalogue. The extent of his collaboration is acknowledged by Popham in the Preface, where he is credited with 'some two-thirds of the entries and the revision of much of the remaining third'.

By its very nature, museum work must be object-based; the novice can be trained only 'on the job', and one task that can usefully be given him is that of keeping the register of acquisitions, involving as it does the close scrutiny and description of every object. In 1946 I was required to register the largest surviving fragment of the great collection of drawings formed in the early nineteenth century by Sir Thomas Lawrence, consisting of about 2,000 drawings mostly by the secondary Italian masters of the sixteenth and seventeenth centuries. These had been bought at the final dispersal of the Lawrence drawings

in 1860 by the eccentric bibliophile Sir Thomas Phillipps, whose choice seems to have been an entirely random one. In 1935 Popham had produced a privately printed catalogue of the Phillipps-Fenwick collection, but he was the first to admit that it now needed radical revision. He and Pouncey spent hours closeted together, methodically going through the drawings, many of them still in the auctioneer's wrappers in which Phillipps had bought them in 1860 (cat. nos 45, 48, 50–53 and 85 are drawings from the Phillipps-Fenwick collection identified by Pouncey). The more mechanical work of registration still necessitated the examination – however uninformed – and description of every drawing, and I did my best to profit from the notes inscribed by my learned elders and from Pouncey's eloquent exposition of the reasoning behind some of the attributions. At about the same time I was allotted the more exacting, but more interesting, task of helping him revise the manuscript of the first volume of the Italian catalogue and see it through the press.

Pouncey's knowledge of Italian painting was both extensive and profound, ranging from Giotto at the end of the thirteenth century to Carlo Maratta at the beginning of the eighteenth. In the later eighteenth century he was less interested. I once made the experiment of taking a volume of the Thieme-Becker dictionary of artists and testing his knowledge of the more obscure Italians. He proved to know them all and, like a kindly shepherd who cherishes the weaklings of his flock, had a good word for every one. His enthusiasm for the study of Italian drawings and his power of communicating that enthusiasm made him a superb teacher. I look back on my long years of collaboration with him – between us we compiled two further volumes of the Italian catalogue, *Raphael and his Circle* (1962) and *Artists Working in Rome c.1550–c.1640* (1983) – as the most valuable part of my entire education. He patiently corrected my ignorance, and showed me how drawings should be looked at and their quality assessed. He was also a fastidious writer of English. Whatever I may have learnt of clarity, concision and exactness of expression, the habit of accuracy, attention to fine shades of meaning and to the distinction between fact and hypothesis, the ability 'to express assent and dissent in graduated terms', and such syntactical minutiae as the correct placing of 'only' and the proper use of the relative pronouns 'which' and 'that', I owe to him: not to his precept – for no one was ever less didactic – but to his example.

He was an indefatigable traveller, and there was hardly a collection of drawings in Europe or the United States that he had not investigated. The comments and attributions inscribed in his neat hand on the mounts have brought enlightenment to generations of perplexed students, with whom he was always most generous in sharing his knowledge and his discoveries. His notes, carefully indexed and kept with the relevant photographs in a business-like metal filing-cabinet, were always at the disposal of fellow students. A question about any Italian artist, however obscure, would elicit a dossier of neatly tabulated information and photographs of works often unknown to the enquirer. The information would appear with computer-like speed, thanks to his ultra-efficient system of indexing and filing. Always acutely conscious of the waste of time caused by lack of method and organisation, he was so conspicuously methodical and well organised as to be the object of gentle teasing, which he bore with serene good humour. In spare moments he might be found indexing his pocket diary, an operation whose usefulness he was always ready eloquently to defend; and on his desk stood a row of notebooks in which he entered particulars of every letter he received, with a summary of his answer (cat. no. 93). He devised a simple means of verifying references without the necessity of laboriously retracing the ground, checking

the reference then and there and putting a small tick against it, and a double tick where ambiguity or doubt might later arise (cat. no. 20). Another example of his ingenious labour-saving efficiency was the system of the 'dossier', a folder for each drawing to be catalogued, with space on the front cover for recording details of medium, dimensions, provenance, inscriptions, etc., inside which could be kept any relevant documents, letters and photographs – a device so simple and so practical that it now seems impossible to imagine that it was not always in use (cat. no. 37).

Popham, who had an excellent memory on which he was sometimes tempted unduly to rely, in a moment of impatience once taxed Pouncey with being a pedant. But pedantry implies a greater degree of accuracy than the particular case requires; in a work of permanent reference like a catalogue, it is impossible to be too accurate. After he took his degree at Cambridge Pouncey worked as a volunteer in the Fitzwilliam Museum, where he was given the task of transcribing all the inscriptions on the backs of the pictures. The Keeper of Paintings congratulated him on his performance with the words: 'You did not make a single mistake – it should be mentioned in your obituary' (cat. no. 8). Pouncey was indeed one of those for whom, as A. E. Housman put it, 'accuracy is not a virtue but a duty'.

He dressed formally, or, to use a favourite word of his, 'correctly', in a soberly cut dark suit, his neck encircled by a high, stiffly starched collar. Out of doors he wore a bowler hat. He was always happy to expound the practical advantages of these by then somewhat old-fashioned articles of clothing: the gap between collar and neck promoted a healthy circulation of air round the torso, while the rigid brim of the hat acted as a gutter in wet weather. His dark hair and flashing brown eyes, mobile features and rapid and unusually articulate fluency of speech – his 'infinite capacity for instant verbalisation', as it was once described – combined to give him an almost *méridional* air; but in a strictly genealogical sense his description of himself as a 'simple Dorset yeoman', however paradoxical it may have seemed, was correct.

Pouncey's legendary feats of connoisseurship – the recognition of the drawing by Bastianino (cat. no. 122) is only one of countless examples of his extraordinary intuition – was achieved by life-long and single-minded absorption in the subject of Italian art in general and the study of Italian drawings in particular. 'Behind his arresting brilliance', as was said of another, 'lay patience that shrank from no drudgery, memory that let nothing slip, and absolute honesty in the pursuit of truth.' It was hard for him to grasp the fact that his interest in Italian drawings was not universally shared. He was not one of those art historians who in fact rather dislike works of art, and he made a small but choice and idiosyncratic collection of paintings and drawings. Each drawing, beautifully mounted and framed, was protected from the damaging effect of light by a small curtain suspended from the frame. His house was once broken into, and in answer to an anxious enquiry as to whether any of his treasures had been stolen or damaged, he replied, in a tone of voice that showed that he was genuinely incredulous and even slightly offended, that the burglars had not so much as lifted the curtains to see what was underneath. It seemed to him incomprehensible that even the criminal classes should be so lacking in intellectual curiosity.

II The Career of Philip Pouncey

1 Early Life and the National Gallery, 1924–1945

(cat. nos 1–14)

Pouncey's interest in the history of art began while he was at school at Marlborough College, from 1924 to 1928 (see cat. nos 2–4), and developed at Queens' College, Cambridge (1928–31), where he read English (an entry in his diary for 17 June 1931 records, 'I have got a 2.ii. Not too bad I suppose'). As soon as he took his degree he started work as a volunteer at the Fitzwilliam Museum, Cambridge (see cat. no. 8). His professional career began when he was appointed Assistant Keeper at the National Gallery on 1 January 1934. At the outbreak of war in 1939 he was involved in the transfer to the National Library of Wales in Aberystwyth of some of the collection. He already knew A. E. Popham, then Deputy Keeper of Prints and Drawings at the British Museum, who was also in Aberystwyth and who stimulated his interest in Italian drawings. In 1936 Pouncey pointed out that one of the British Museum's drawings was by Signorelli rather than Cosimo Rosselli, to whom it had been given by Bernard Berenson (see cat. no. 13), and this was the first of many drawings in the collection that he was to reattribute.

1 Marjorie Barrett, *Portrait of Philip Pouncey as a Young Man*

Oil on canvas (grisaille), 1932

Private collection

Illustrated opposite title-page

On 27 August 1932 Pouncey wrote in his diary: '10. Sit for portrait to Mrs Barrett. Sat till 1. She appears to be getting on well with it.' A portrait drawing and a dry-point etching of Pouncey by the same artist are also recorded in the diaries for this and the following year.

From the time he was at Marlborough until shortly before his death, Pouncey kept a pocket diary, briefly recording what he had done each day and the names of any people he had seen. The entries are factual and do not dwell on gossip, but they enabled him to look back in detail on the events of his life. For other diary entries, see cat. nos 5, 12, 104 and 113.

2 Philip Pouncey, *Copy after a Reproduction of Piero della Francesca's 'Portrait of Federigo da Montefeltro, Duke of Urbino'*

Oil on panel, 1928

Private collection

Pouncey painted this copy shortly before he left Marlborough in the summer of 1928. Its grasp of Piero's style indicates Pouncey's precocious understanding of Italian Renaissance art.

3 J. A. Crowe and G. B. Cavalcaselle, *A History of Painting in North Italy*, London 1912

Private collection

This is Pouncey's copy of an abridged version of Crowe and Cavalcaselle's classic history of North Italian painting, the contents of which he had thoroughly absorbed while still at Marlborough. This was the earliest systematic account of the subject down to the end of the High Renaissance. 'By combining acute stylistic analysis with sedulous investigation of all available documentary evidence [Crowe and Cavalcaselle] set themselves to establish the *oeuvre* of each master, to trace his development, place him in his stylistic context, and define his artistic personality' (Gere, 1991, p. 531). Pouncey was to adopt this same method.

4 Philip Pouncey, *The Rectory at Pebmarsh, Essex*

Etching

British Museum (1982. U.286)

Pouncey's father, the Revd George Pouncey (d.1929), was rector of Pebmarsh from 1925 to 1929, during which period this dry-point etching would have been made.

5 Pouncey's diary for 1930

Private collection

The entry for 10 January records a visit to Burlington House: 'see SCC showing GBS round Galleries. Finished Room 7.' At this time Pouncey was still an undergraduate, reading English at Queens' College, Cambridge. He had obviously been struck by the sight of Sir Sidney Cockerell (1867–1962), then Director of the Fitzwilliam Museum,

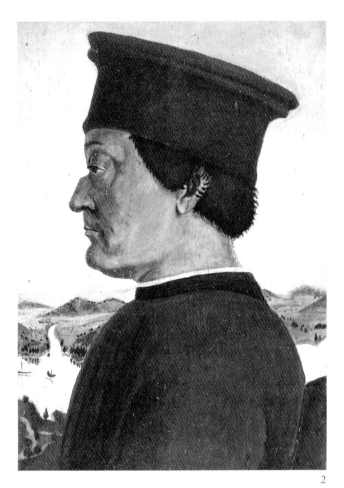

2

Cambridge, accompanying the famous Irish playwright
George Bernard Shaw (1856–1950) around the Royal Acad-
emy's great Italian exhibition (for which see cat. no. 6).
Pouncey himself had been introduced to Cockerell some two
months earlier, on 24 October 1929.

For Pouncey's pocket diaries, see cat. no. 1.

6 Catalogue of the exhibition *Italian Art, 1200–1900*, held at the Royal Academy, London, from 1 January to 20 March 1930, and the souvenir catalogue of the drawings

British Museum

This exhibition, which included substantial loans from Italy,
was one of the most significant cultural events of the time.
Primarily of paintings, it also included drawings and
examples of the applied arts. In the year following the exhibi-
tion, there appeared an illustrated souvenir catalogue of the
drawings, compiled by A. E. Popham, then Assistant Keeper
of the Department of Prints and Drawings of the British
Museum (for whom see especially cat. no. 15).

As Pouncey's diary for 1930 records, he made numerous

visits to the exhibition, and the experience must undoubtedly
have influenced his decision, taken at about this time, to
embark on a career devoted to the study of Italian painting.
On 3 January, on what must have been his first visit, he
wrote, 'London to Burlington House. Perfectly Marvellous.'
Sometimes he spent an entire day examining the contents
of one room (see cat. no. 5).

7 Photograph of Sir Charles Holmes, Director of the National Gallery 1916–28

From a negative in the Archive of the National Gallery,
London

In association with the Royal Academy's exhibition of Italian
art (see cat. nos 5–6), a programme of public lectures was
arranged. On 24 January Pouncey attended one on 'Raphael
and Michael Angelo', given by Sir Charles Holmes (1868–
1936), and recorded in his diary that he 'went up to Sir
Charles Holmes & spoke to him [about pursuing a career
devoted to Italian painting]. He advised me to see Collins
Baker at the N.G. He was extraordinarily pleasant. He
advises me to *draw* & the rest would follow.'

Holmes himself was a landscape painter of professional
standard, and his advice to Pouncey to devote himself to
drawing in order to fit himself for a career in art history is
not surprising. Many eighteenth-century English artists were
of course active collectors and connoisseurs, for example Sir
Peter Lely (1618–80), Jonathan Richardson senior (1665–
1745), Sir Joshua Reynolds (1723–92), Sir Thomas Lawrence
(1769–1830), and many others.

8 Two notebooks compiled by Pouncey of 'Marks and Labels on the Backs of Pictures in the Fitzwilliam Museum'

Fitzwilliam Museum, Cambridge

On 20 July 1931 Pouncey began work as a voluntary attaché
at the Fitzwilliam Museum. Cockerell gave him a number
of tasks, including the above survey which Pouncey began
on 11 August 1931, some two weeks before Cockerell's sum-
mer holiday. With some contentment Pouncey noted in his
diary for 21 September that 'S.C.C. returns [i.e. from holiday]
& expresses surprise that I took down every picture in the
museum', adding in an entry for 24 September that 'S.C.C.
. . . seemed pleased with my index' (see also Introduction,
p. 11).

9 Visitors' book to the Department of Prints and Drawings, 1932

British Museum

While working at the Fitzwilliam, Pouncey began to frequent the Print Room at the British Museum. A note in his diary for 22 September 1932 records that he had caught a glimpse there of Bernard Berenson, the great expert on Italian Renaissance art (see cat. no. 11) and had spoken to A. E. Popham, then the Assistant Keeper in charge of the Italian drawings, whose colleague he was later to become (see cat. nos 6 and 15).

Of the signatures in the visitors' book for that day, those of Nicky Mariano (Berenson's secretary) and Berenson are the fourth and seventh respectively; Pouncey's is the nineteenth.

10 Three notebooks probably dating from Pouncey's first visit to Italy (October 1932 to April 1933)

Private collection

Pouncey's first trip to Italy was of fundamental importance for the development of his career, and his notebooks and diaries show the thoroughness with which he applied himself to studying the Italian art of the Renaissance. Among the drawings in the notebooks are a sketch after *Christ Blessing* by Jacopo de' Barbari (d. *c*.1516), in the Museo di Castelvecchio, Verona; a copy (*illustrated*) after the head of St Nicholas in the *Nativity with Sts Eustace, James, Mark and Nicholas* by Lazzaro Bastiani (*c*.1430–*c*.1512), in the Accademia, Venice (Pouncey noted that the 'General structure of [the] faces [was] derived from B. Vivarini, etc.'); and a plan of the frescoes in the Upper Church at Assisi.

Copying is an excellent way of fixing an image in the memory. Pouncey was here following a tradition practised by earlier art historians such as Cavalcaselle (for whom see cat. no. 3).

11 Photograph of Bernard Berenson, taken in the 1930s

Villa I Tatti, Florence

During Pouncey's visit to Italy in 1932–3, he called on Berenson at his home, the Villa I Tatti, just outside Florence, armed with a letter of introduction from W. G. Constable (1887–1976), then Director of the newly founded Courtauld Institute of Art. He records in his diary that he telephoned the great man on 8 November 1932 and was granted an audience at 3.30 p.m. the following day.

After this introduction Pouncey and Berenson were to meet on several occasions and to correspond with each other on various topics. Less than four years later Pouncey's attribu-

tion of a drawing at the British Museum became the subject of a mild disagreement between them (see cat. nos 13–14). However, they concurred in their admiration for the work of the painter Lorenzo Lotto (see cat. no. 57), about whose drawings Pouncey later wrote a short book (cat. no. 56); Berenson's monograph on the artist had appeared in 1895 and was to be reissued in a number of editions, including one in 1956.

The high regard in which Berenson held Pouncey's opinion emerges from a letter to Pouncey (dated 13 December 1954) from Mlle Roseline Bacou, formerly of the Cabinet des Dessins of the Louvre, in which Pouncey's recent attribution to Lotto of a drawing of the *Entombment* (Louvre, inv. no. 5637; Cambridge, 1985, no. 31) is one of the subjects discussed. Mlle Bacou had found support for the attribution from Berenson, whose blessing was accompanied by a more general tribute. She wrote to Pouncey: 'Votre attribution à Lotto est magnifique. Je n'ai rencontré à Florence que des personnes convaincues; quant à Berenson il m'a dit que vous étiez le meilleur connaisseur qu'il ait jamais rencontré. Qu'en dites vous?'

12 Pouncey's diary for 1934

Private collection

Pouncey joined the staff of the National Gallery on 1 January 1934, the same day on which Kenneth Clark (1903–83) became Director. Something of the routine of a young curator at the Gallery emerges from the entries in Pouncey's diary for 14–17 February. On 14 February, for example, he '. . . Put the Lucas [van Leyden] photos into files', afterwards going to the exhibition *British Art, c.1000–1860* at the Royal Academy. On 15 February he was at the Dulwich Picture Gallery, to 'Discuss preservation of pictures with old Sir Evan [Sir Evan Spicer, DL, JP, Chairman of the Picture Gallery Committee of Dulwich College] & Miss Robinson [a guide/lecturer at the Dulwich Gallery]'; later the same day, 'Clark gives me job of correcting a German guide to Gallery.' On 16 February, 'With Davies [Martin Davies (1908–75), then Assistant Keeper at the National Gallery and Director 1968–73] to British Exhib. for umpteenth time. Sorting out English & Italian photos. Helping Davies re-card index the books wh. have been moved during reorganization of Library.' On Saturday 17 February Pouncey resumed his study of Richard Offner's great *Critical and Historical Corpus of Florentine Painting* (1931–79).

Lazzaro Bastiani.
Accademia.
100. Presepio.

General structure of faces derived from B. Vivarini.
Foreheads however a bit deeper. The Paduan firmness of
drawing has been sfumatosed
Ears are not good & are not quite like B's.
Hands are regular, with large gaps between fingers which are short.

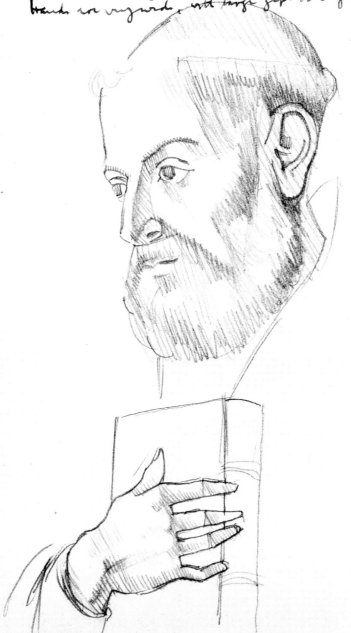

10

13 Luca Signorelli (c.1441–1523), *St Ercolano*

Metal-point with some light brown wash, heightened with white, on light brown prepared paper; 176 × 70mm

British Museum (1902–8–22–5)

Provenance: Resta-Somers (L 2981: Resta number *i. 29*, as Giovanni Bellini); P. & D. Colnaghi

Literature: Berenson, 1903, no. 2386 (as Cosimo Rosselli); Popham, 1936–7, p. 18, pl. 14 (as Cosimo Rosselli); Berenson, 1938, no. 2386; Popham and Pouncey, 1950, no. 234 (as Signorelli); Berenson, 1961, no. 2509 E–6–1 (formerly 2386) (as Signorelli)

In a letter to Popham of 1936 (now lost), Pouncey suggested that this drawing was by Signorelli, thereby making what was probably his first attribution of a drawing in the British Museum. Popham and Pouncey were already acquainted, as a note in Pouncey's diary for 1932 records (see cat. no. 9), but it was to be another nine years before Pouncey joined the staff of the British Museum. The sheet had been attributed to Giovanni Bellini in the Resta-Somers catalogue, but when acquired by the Museum it was placed under the name of Cosimo Rosselli (1439–1507), following a suggestion by Berenson in the first edition of his *Florentine Drawings* (1903). Pouncey, who had been at the National Gallery for only about eighteen months, noticed that the figure corresponds, with minor variations, to that of St Ercolano on the right of Signorelli's altarpiece in the chapel of S. Onofrio in the Duomo at Perugia, a painting at one time dated 1484; he concluded that it was an original study, mostly for the drapery of this figure. For Popham's reply to Pouncey's letter, see cat. no. 14.

For other Italian drawings in the British Museum that Pouncey reattributed before he joined the staff in 1945, see cat. nos 40, 47 and 55.

14 Two letters to Pouncey from A. E. Popham

Private collection

The tone of the first of Popham's letters (dated 28 August 1936) on the subject of cat. no. 13 was characteristically encouraging and is worth quoting in full:

Dear Pouncey,

Very many thanks for your letter and the definite attribution of the little drawing of a standing saint to Signorelli. It is most satisfactory that this drawing, which has puzzled everybody for years, should be placed. It is the small scale and the technique which has put everyone off, but even without the exact correspondence with the Perugia altarpiece, now it is pointed out it is quite obvious!

Wouldn't you write a corrective note for O.M.D. [the journal *Old Master Drawings*] on it? I am certain Parker [Karl Parker, the journal's editor and recently appointed Keeper of Western

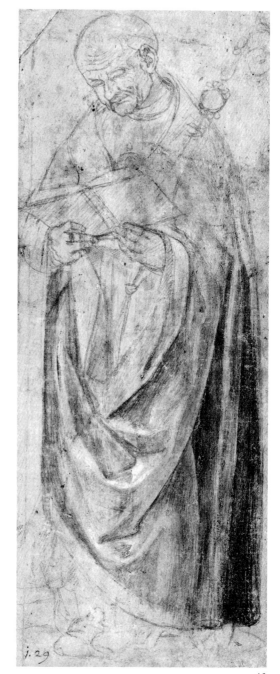

13

Art at the Ashmolean Museum, Oxford] would be very pleased to have it and so should I.

Yours sincerely,
A. E. Popham

Pouncey did not follow up Popham's suggestion that he should announce his discovery in *OMD*, and it was not until the appearance in 1950 of the catalogue of the fourteenth- and fifteenth-century Italian drawings in the Museum (see cat. no. 18), which he and Popham wrote together, that it was published for the first time. In his letter, Popham rightly alluded to the unusual technique of the drawing, for it is true that Signorelli is best known for his robust drawings in black chalk, not for studies in metal-point on prepared paper. Nevertheless, Pouncey did not allow this unusual characteristic to obstruct his thinking, seeing the subtle relationship between the figure in both painting and drawing as the more powerful evidence.

Berenson visited the Department on 28 September 1936 and it is possible that Popham showed him the drawing on that occasion. A paragraph from Popham's second letter (dated 7 October 1936) records Berenson's reaction to Pouncey's attribution:

I showed the drawing to Berenson who I thought rather characteristically refused to admit that it was anything but a copy and persisted that the forms were thoroughly Rossellesque. Cosimo Rosselli must have copied it on his way from Florence to Rome. But Perugia is hardly on the way and Rosselli went in 1482, I think two years before the Perugia altarpiece was painted. However Berenson is inscribing a note (with acknowledgements) in his new Florentine Drawings on the 'connection' between the drawing and the picture.

In the 1938 edition of his *Florentine Drawings* Berenson indeed credited Pouncey for his observation, without accepting Signorelli's authorship: 'As Mr. Phil. Pouncey has pointed out, this drawing was done in connection with the Ercolano in Signorelli's Perugia altar-piece of 1484. It still looks to me like the work of some one very close to C. R. Is it a copy by the young Piero di Cosimo? The head would suggest it.' In his posthumously published Italian edition of 1961, however, Berenson accepted Pouncey's attribution unreservedly, with the comment that the drawing is the 'primo schizzo databile del Signorelli'.

2 The British Museum, 1945–1966
(cat. nos 15–87)

In 1945, when Pouncey transferred from the National Gallery to the Department of Prints and Drawings at the British Museum as an Assistant Keeper, Popham was Keeper (see cat. no. 15). The only other Assistant Keeper was Edward Croft-Murray (1907–80), a specialist in English drawings, who had worked at the Museum since 1933. J. A. Gere joined the Department as an Assistant Keeper in 1946 (see cat. no. 16), and he, too, was put to work on the Italian drawings. Shortly after Pouncey's appointment, Popham wrote to Kenneth Clark, Director of the National Gallery, to explain, 'Though I am delighted to have him [i.e. Pouncey], I hope you will not think that I have tried to filch him away, without consulting you' (letter of 9 October 1944). In his reply Clark paid generous tribute to Pouncey's talents: 'It is a great blow to the Gallery and to me, as he is much the best member of our staff, and the only one of them with whose point of view I am in sympathy' (letter of 10 October 1944; National Gallery Archive).

For the purposes of this exhibition, Pouncey's work at the British Museum has been subdivided into five sections: (i) his work, in collaboration first with Popham and then with Gere, on the catalogues of the permanent collection of Italian drawings; (ii) his attribution of drawings in the collection not covered by these catalogues; (iii) his other art-historical writings; (iv) acquisitions of drawings in which he played a part; and (v) his work on the engraved reproductions of Italian drawings and the Gernsheim photographs.

2(i) Catalogues of the permanent collection (cat. nos 15–33)

From the early years of this century, the writing of standard catalogues of specific sections of the collection had been one of the principal tasks of the curatorial staff. During Popham's Keepership (1945–54) this effort was concentrated on the Italian School, the Dutch and Flemish having been dealt with by him (his volume on the Netherlandish fifteenth and sixteenth centuries was published in 1932) and by his predecessor as Keeper, A. M. Hind (1880–1957). The removal to Aberystwyth of the Museum's collection of drawings in 1939 enabled Popham to begin work on the catalogue of Italian sixteenth-century drawings (see cat. nos 34–6), and he and Pouncey, also there with some of the National Gallery pictures, began discussing problems of attribution; but their brief, informal collaboration was interrupted in 1942 when Pouncey joined the Intelligence Unit of the Foreign Office

at Bletchley, where he remained until the termination of hostilities in 1945. Popham was also assisted by two distinguished foreign scholars, Johannes Wilde, formerly of the Kunsthistorisches Museum, Vienna (see cat. no. 17), and Frederick Antal (see Introduction p. 9).

With Pouncey's transfer to the British Museum in 1945 and J. A. Gere's appointment in the following year, three members of the curatorial staff of the Department were at work on the Italian drawings, until Popham's own retirement eight years later. A plan to publish 'a complete, illustrated catalogue of the Italian Drawings in the Department' is touched on in Popham's preface to the catalogue of the fourteenth- and fifteenth-century drawings (Popham and Pouncey, 1950, p. v). Pouncey was joint author of three of the five titles from this series (see cat. no. 18). These three catalogues are the most substantial result of his work and are among the most significant contribution to scholarship of this Department since the war.

Cat. nos 21–4 are from the catalogue of the fourteenth- and fifteenth-century drawings written with Popham and published in 1950; cat. nos 25–7, from the catalogue of the drawings of Raphael and his circle, written with Gere and

published in 1962; and cat. nos 28–33, from the catalogue of the drawings by artists active in Rome from c.1550 to c.1640, also written with Gere and published in 1983.

15 David Bell (exh. 1939–40), *Portrait of A. E. Popham*

Pencil; 368 × 253mm

British Museum (1954-4-27-8)

Until his retirement as Keeper of Prints and Drawings in 1954, Popham was Pouncey's official superior. He was not exclusively an Italian specialist: he had written volume v of the catalogue of Dutch and Flemish drawings in the Museum (1932), published many articles and was even the author of what is still the standard catalogue of the prints of John Sell Cotman. The two men collaborated on the catalogue of the Department's fourteenth- and fifteenth-century Italian drawings (1950), for which see cat. no. 18. They were on the friendliest terms, as is evident from Popham's numerous letters to Pouncey and his wife Myril, mostly written during

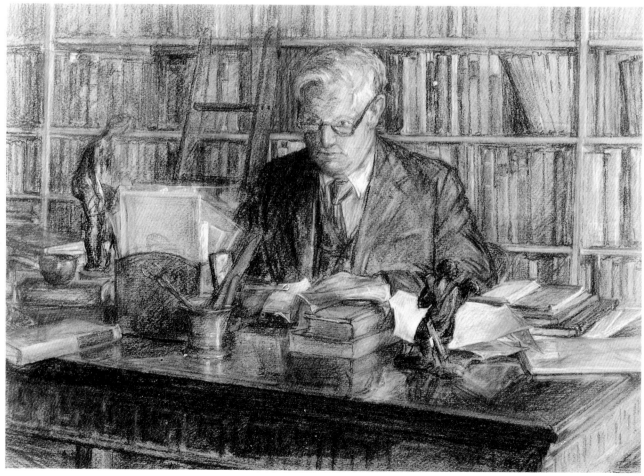

16

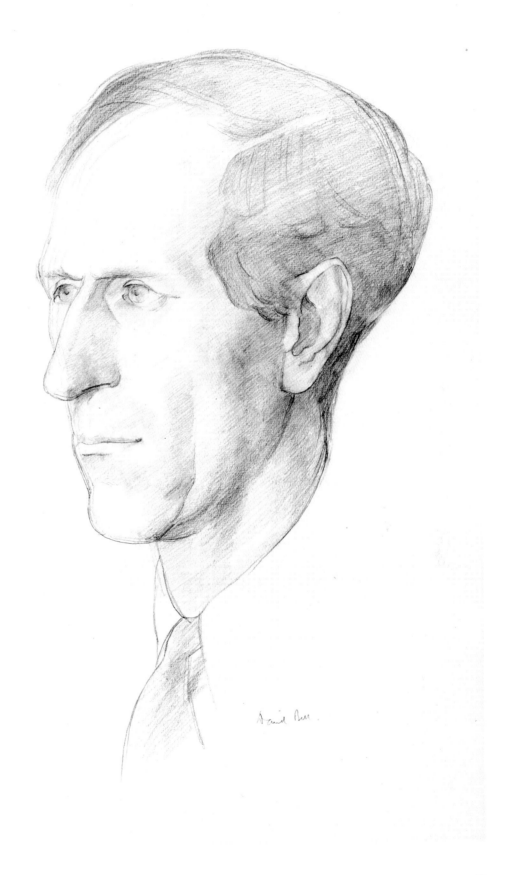

15

the later years of the war period, when Popham was still in Aberystwyth looking after the Museum's collection of prints and drawings, which had been moved there for safety (see Introduction, p. 9), and Pouncey had transferred to the Foreign Office at Bletchley Park. Popham's dry sense of humour was combined with a melancholy expression, once wittily compared to that of an undertaker who has lost the corpse.

For many years it has been the practice for the Keeper, on his retirement, to present a portrait of himself to the Department. This one was given by Popham in 1954. Until 1991 these portraits were hung in the Keeper's study; they have now been removed and are stored in cases with the rest of the collection.

16 Caroline Hervey-Bathurst (living), *Portrait of J. A. Gere*

Pastel; 300 × 427mm

British Museum (1981–10–3–1)

J. A. Gere (b.1921), Keeper of the Department of Prints and Drawings from 1973 to 1981, joined the Museum in 1946 and was put to work on the Italian drawings. He was a long-time collaborator of Pouncey's, writing two catalogues with him, one on drawings by Raphael and his Circle (1962) and the other on drawings by artists working in Rome *c*.1550 to *c*.1640 (1983), the most recent in the series of catalogues of Italian drawings in the permanent collections (for both works, see cat. no. 18).

Gere is shown here in his study at home, not in his office at the Museum. For the series of portraits of past Keepers of the Department, see cat. no. 15.

17 Portrait of Johannes Wilde

From a photograph in the collection of Professor Michael Hirst

One of the leading historians of Italian Renaissance art this century, Johannes Wilde (1891–1970) joined the staff of the Kunsthistorisches Museum, Vienna, in 1923. His work there was cut short in 1938, eight months after the Anschluss, and at the beginning of the following year he came to England. At the outbreak of war with Germany, Kenneth Clark, then Director of the National Gallery, asked him to accompany the Gallery's paintings to Aberystwyth with Pouncey. It was there that Wilde's valuable friendship with Popham began, and in June 1940 the Trustees of the British Museum invited him to compile the catalogue of the Museum's collection of drawings by Michelangelo.

Unfortunately, in the same month Wilde was caught contravening black-out regulations and, absurdly, was suspected of attempting to communicate with the enemy: for this he

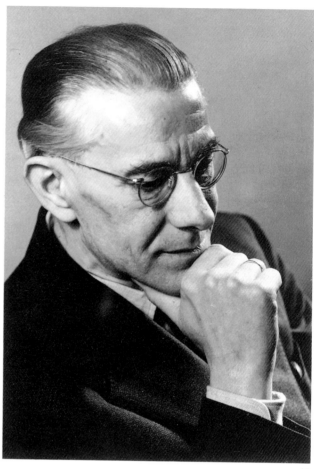

17

was interned and subsequently deported to Canada. Among the addresses noted at the back of Pouncey's 1940 diary was: 'Wilde, No 52064, Aliens Internment Camp, 56 Stepton Rd, Huyton, nr L'pool / Camp 'L', Internment Operations, Ottawa, Canada.' Wilde's period of detainment was short, however, and in 1941 he returned to live in Buckinghamshire as the guest of his former pupil Count Antoine Seilern, who had done much to secure his release.

The photograph was probably taken in about 1955–60.

18 Three British Museum catalogues of Italian drawings

British Museum

The catalogues on which Pouncey collaborated were those of the fourteenth- and fifteenth-century drawings, written with A. E. Popham and published in 1950; the drawings of Raphael and his Circle, written with J. A. Gere and published in 1962; and the drawings by artists active in Rome from *c*.1550 to *c*.1640, also written with Gere and published in 1983, long after Pouncey had left the Museum. Fuller refer-

ences appear in the Bibliography under 'Popham and Pouncey, 1950', 'Pouncey and Gere, 1962' and 'Gere and Pouncey, 1983', respectively.

Also exhibited is the Department's interleaved copy of 'Popham and Pouncey, 1950'. It was normal practice to have one copy of each catalogue specially bound in this way for quick reference to any additional observations, bibliography and the like that might have been noted since publication.

19 J. A. Gere's official monthly diary, 1946–59

British Museum

The few lines' summary of each month's work recorded in Gere's official monthly diary were initialled to the right of the page by the Keeper: until February 1954, by A. E. Popham; thereafter, by Edward Croft-Murray. (A more detailed daily diary was also kept, from which the monthly diary was compiled.)

During this time Gere wrote entries on the drawings to be included in the Raphael catalogue (i.e. those by Perino del Vaga, Peruzzi and others) and prepared the Gernsheim photographs (see cat. nos 86–7) for mounting. Pouncey's official monthly diary for the same period does not survive, but it would have recorded much the same information about work in progress.

20 Carbon copy of typescript entry for a drawing by Girolamo Muziano (1532–92) in 'Gere and Pouncey, 1983', together with an earlier typescript draft entry

British Museum

The drawing, which shows the left-hand part of a *Raising of Lazarus*, is no. 220 in the 1983 catalogue. Although the top copy for each entry must have stayed with the printer, the marked-up carbon copy remains in the Department. The catalogue was written over a period of about fifteen years, after Pouncey had left the Museum in 1965 to become a director at Sotheby's. Rosalind Wood, whose assistance is acknowledged on the title-page, was responsible for assembling the material for the biographical prefaces – a feature of particular importance in a catalogue covering a still relatively unstudied period.

Pouncey visited the Department, sometimes as often as two to three days a month, to work with Gere, who was Keeper for much of this period. On the occasion of these visits, the door to the Keeper's study was kept firmly shut as work progressed. The writing was interspersed with periods of intense discussion, during which even the finest points of prose received careful scrutiny. Pouncey was a staunch advocate of a system of ticking numbered references

to show that they had been double-checked, and some of these small pencil ticks may be seen on the typescript. These and other manuscript corrections are, however, in the hand of Gere, who was responsible for the actual writing, editing and indexing.

Pouncey wrote an earlier version of the entry soon after the war. Typed by Pouncey himself, it has manuscript corrections by both Popham and Gere.

21 Attributed to Giovanni Bellini (*fl. c.*1459–1516), *Three Heads*

Black chalk; 130 × 200mm
British Museum (1900–7–17–31)
Provenance: J. Wadmore; P. & D. Colnaghi
Literature: Popham and Pouncey, 1950, no. 14; Robertson, 1981, p. 133

This drawing was previously given to Francesco Bonsignori (*c.*1460–1519). Its attribution to Bellini was proposed for the first time by Popham and Pouncey, who found the same subtle refinement of the heads as in the artist's paintings. With evident satisfaction, Pouncey recorded in the interleaved copy of the catalogue (see under cat. no. 18) that Scharf had accepted their suggestion 'without reservation' in his review (1952, p. 210). Robertson, in his monograph on Bellini written some years later, described the attribution as attractive but uncertain, though he went on to compare the drawing with the artist's painting *An Incident in the Life of P. Cornelius Scipio* in the National Gallery of Art, Washington.

J. A. Gere (orally) has observed the strong influence of Mantegna and has suggested that the drawing may have been inspired by a particular sort of Roman tomb relief in which a bust of the deceased appears alongside those of members of his family.

22 Attributed to Giovanni Bellini (*fl. c.*1459–1516), *Head of a Man Looking Up*

Black chalk, the outlines pricked for transfer; 389 × 261mm
British Museum (1895–9–15–591)
Provenance: (?) Sir T. Lawrence; Sir J. C. Robinson; J. Malcolm
Literature: Robinson, 1876, no. 154; Popham and Pouncey, 1950, no. 16; Scharf, 1952, p. 210; Ragghianti, 1954, p. 597

The drawing is a fragment of a cartoon, and of remarkably high quality. While in the Malcolm collection, it was given to Melozzo da Forlì (1438–94), but it is unclear whether this attribution was traditional or due to Robinson. Presumably Melozzo's authorship was suggested by the foreshortening of the head, which resembles those in his detached fresco in the Vatican. Although the attribution was widely accepted

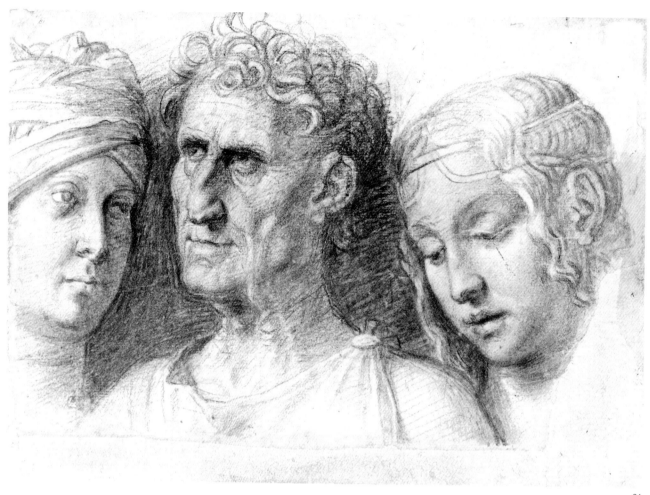

21

in the first half of this century, Popham and Pouncey gave the drawing to Bellini, observing that it displayed 'none of the qualities that we associate with drawings of the central Italian School and which we would expect to find in Melozzo'. They also pointed out similarities with heads in a number of Bellini's paintings, including that of St Christopher in the St Vincent Ferrer altarpiece in SS. Giovanni e Paolo in Venice (Robertson, 1981, fig. xxvia).

In his review of Popham and Pouncey's catalogue, Scharf accepted the proposal with enthusiasm, referring to it as one of 'the most outstanding and perfectly convincing' of the new and hitherto unpublished attributions. Other opinions varied, however, and Ragghianti (1954, p. 597), like one or two subsequent critics, was in favour of returning the drawing to Melozzo. This uncertainty is a reflection of the 'ebb and flow' of attributions from one generation to another and a reminder of how many problems still remain unsolved.

23 Francesco Marmitta (d. 1505), *The Entombment* and two circular compositions of *The Virgin and Child*

Pen and brown ink and pale brown wash; 130 × 74mm, the two roundels 52 and 53mm in diameter respectively

British Museum (1860–6–16–68 to 70)

Provenance: Sir T. Lawrence (L 2445); S. Woodburn

Literature: Popham and Pouncey, 1950, nos 171–3; Cambridge, 1985, no. 34

An old inscription on the *verso* of the *Entombment* indicates that the three drawings, which seem always to have been kept together, were once thought to be by Raphael. In the 1860 Woodburn sale they were given to 'MONSIGNORI (F.)', i.e. the Veronese artist Francesco Bonsignori (for whom see cat. no. 39). While still at the National Gallery, Pouncey observed that the *Entombment* is a study for one of the miniatures in the Durazzo Book of Hours in the Palazzo Rosso, Genoa, which can be attributed with certainty to the Parmese painter, miniaturist and gem-engraver Francesco Marmitta. His observation made it possible for Marmitta to

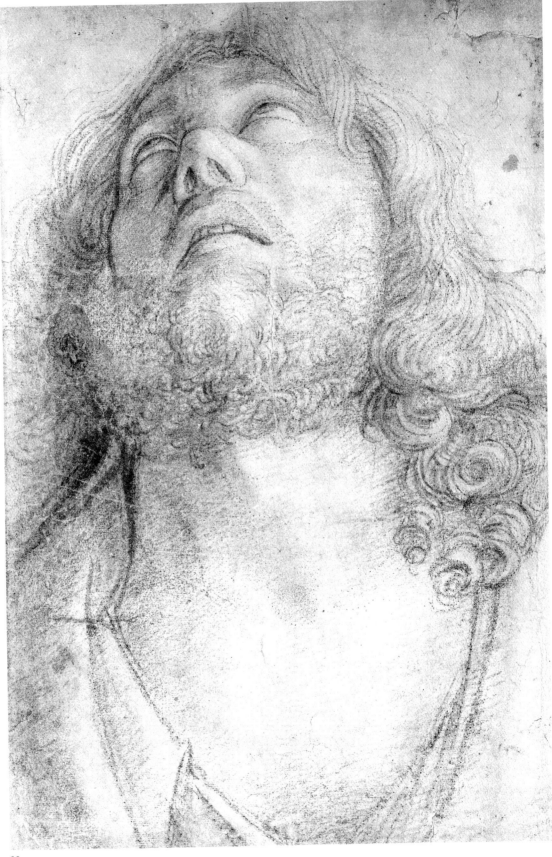

be properly understood as a draughtsman for the first time. The two roundels may also have been designs for illuminations.

Pouncey reported his discovery with some excitement in a memo to Kenneth Clark dated 31 October 1939:

The second drawing which I found in the Bonsignori box is nothing other than the original sketch for one of the best illuminated pages in the book of Hours by Marmitta at Genoa; it represents the Pietà and is really an exquisite thing. There are several minor differences between the drawing and the miniature, for instance in the movement of a hand or the turn of a head. Popham agrees with me that it cannot possibly be a copy. (National Gallery Archive)

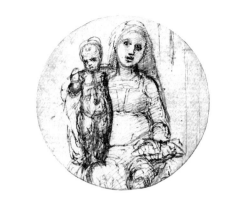

24 Francesco Marmitta (d.1505), *Triumphal Procession*

Red chalk, pen and brown ink and brown wash with white heightening; the left-hand part of the composition is squared; 209 × 315mm

British Museum (5211–76)

Provenance: Fawkener Bequest, 1769

Literature: Popham and Pouncey, 1950, no. 174

This drawing was listed as anonymous early Italian until Pouncey pointed out the resemblance in treatment 'as well as in the types and the suggestion of dusty air' to the bas-relief of the *Flight into Egypt* at the base of the Madonna's throne in the altarpiece of the *Virgin between Sts Benedict and Quentin*, originally in the church of S. Quintino at Parma and now in the Louvre. The altarpiece is now generally accepted as by Marmitta. Moreover, the style of the drawing is consistent with that of the drawings in cat. no. 23.

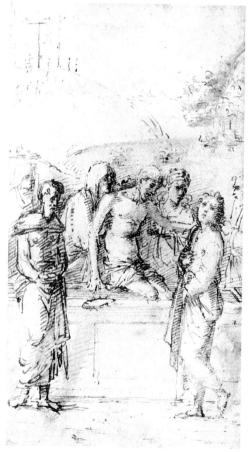

25 Polidoro Caldara, called Polidoro da Caravaggio (1490/1500–(?)1543), *Virgin and Child*

Black chalk; 168 × 152mm

British Museum (1958–12–13–5)

Provenance: Unidentified collector's mark F.C.; J. Skippe; by descent to the Martin family, including Mrs Rayner-Wood; E. Holland-Martin; presented jointly by the National Art Collections Fund and the Holland-Martin family

Literature: Pouncey and Gere, 1962, no. 215; Ravelli, 1978, no. 61; Cambridge, 1985, no. 47

The old attribution to Andrea del Sarto, inscribed in ink in the lower left corner, is untenable. The attribution to Polidoro was proposed by Pouncey shortly before the sale of the Skippe collection at Christie's in November 1958, and was accepted by Popham, who compiled the catalogue of the sale.

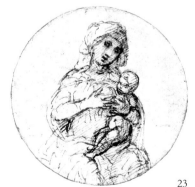

23

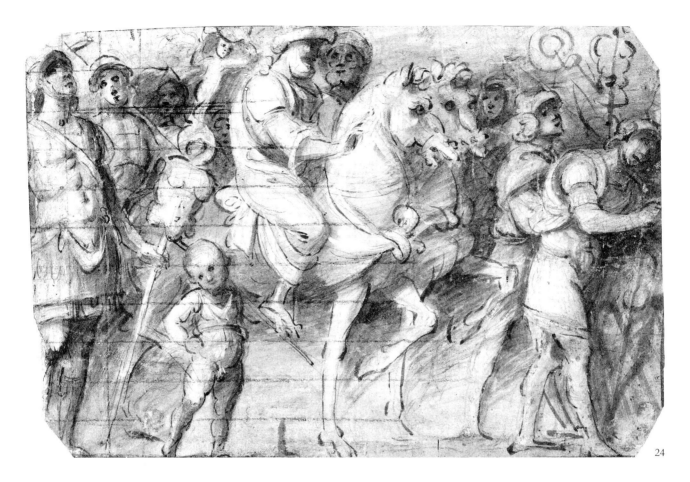

24

26 Michelangelo (1475–1564), *Christ at the Column*

Black chalk, with some stumping, over stylus underdrawing;
heightened with white; 275 × 143mm

British Museum (1895–9–15–813)

Provenance: (?)Cicciaporci; (?)W. Y. Ottley; Sir T. Lawrence
(L 2445); King William II of Holland; G. Leembruggen;
J. Malcolm

Literature: Wilde, 1953, pp. 28f. (as Sebastiano); Pouncey and
Gere, 1962, no. 276 (as Michelangelo); Freedberg, 1963,
pp. 254ff. (as Sebastiano); de Tolnay, 1975, vol. 1, no. 74
(as Michelangelo); New York, 1979, no. 8 (as Michelangelo)

This drawing is a study for the *Flagellation* in the Borgherini
Chapel in S. Pietro in Montorio, Rome, painted by
Sebastiano del Piombo between 1520 and 1524 on the basis
of a drawing supplied by Michelangelo in 1516. It is one
of a number of drawings connected with the composition,
all traditionally ascribed to Michelangelo, which some recent
critics have given to Sebastiano (the subject is extensively
discussed by Gere in his entry for the drawing in the 1979
New York exhibition catalogue).

In spite of its traditional attribution to Michelangelo and its
connection with Sebastiano's painting, Wilde (see cat. no. 17)
omitted this drawing from his authoritative catalogue of the
Museum's Michelangelo drawings, since he was of the opinion
that it was by Sebastiano. Pouncey and Gere urged its
marked stylistic differences from Sebastiano's undoubtedly
authentic drawings (of which two examples are cat. nos 75
and 97). When Wilde was confronted with this point of view,
there followed a lengthy consideration of the problem, at
the end of which he was forced to concede that the drawing
was indeed by Michelangelo.

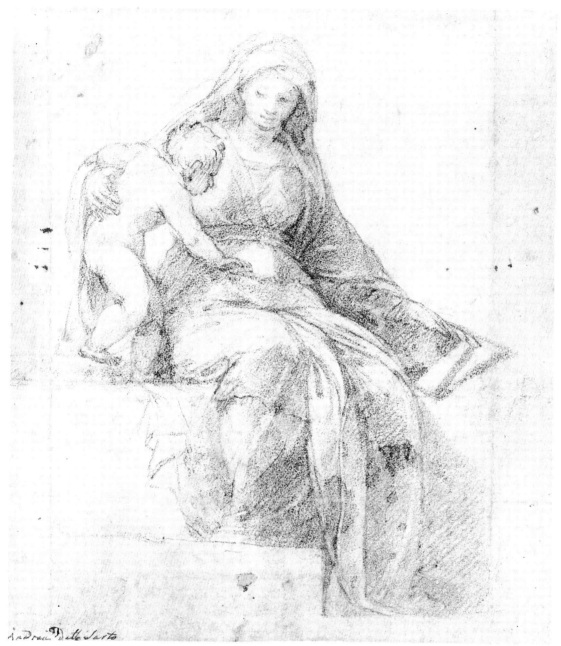

25

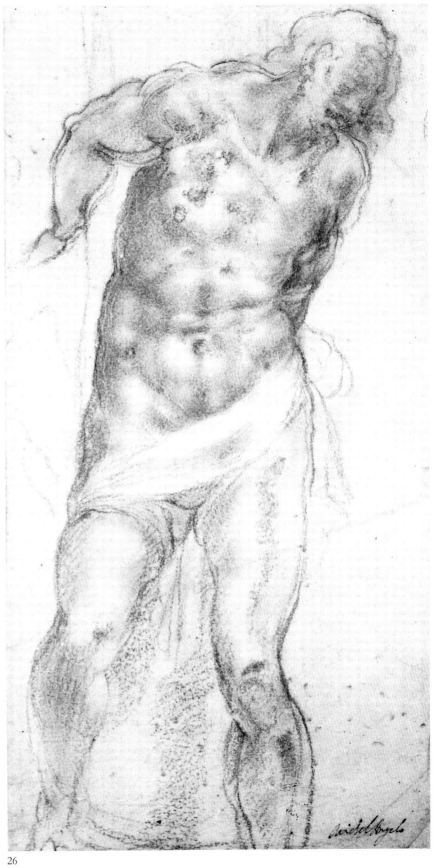

26

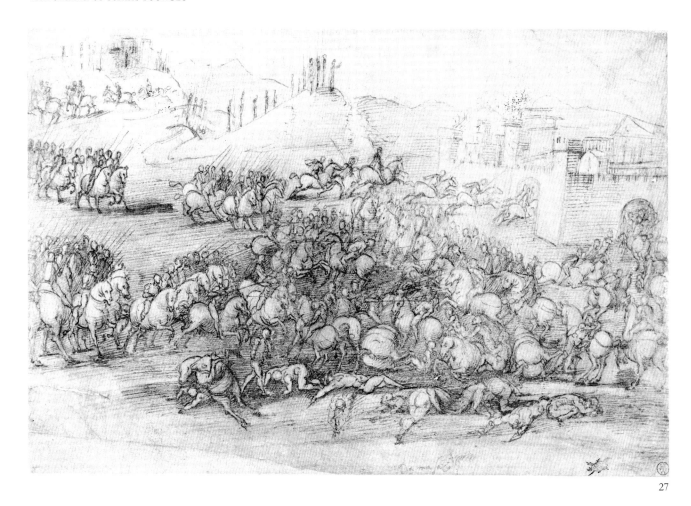

27

27 Girolamo Genga (1467–1551), *Cavalry Battle outside a Town*

Pen and brown ink and red chalk; 224 × 334mm

British Museum (1897-4-10-2)

Provenance: J. Richardson sen. (L 2183); Earl of Warwick (L 2600); P. & D. Colnaghi

Literature: Pouncey and Gere, 1962, no. 271

There is an old attribution to Masaccio in ink at the bottom of the sheet, to the right of centre. When acquired by the Museum, the drawing was placed as 'Veronese School, XV century (Domenico Morone?)'. Pouncey's attribution to Genga is based on comparison with two drawings, one in the Fondazione Horne, Florence, and one in the Louvre. All three are possibly connected with the decoration of the Villa Imperiale at Pesaro.

28 Battista Franco (1510–61), *Seated Nude Youth*

Black chalk; 366 × 274mm

British Museum (Pp. 2–123)

Provenance: Sir P. Lely (L 2092); W. Gibson; Sir J. Reynolds (L 2364); R. Payne Knight Bequest, 1824

Literature: Venturi, 1927, pp. 194f.; Gere and Pouncey, 1983, no. 123

The figure's close correspondence, in reverse, with the *Jonah* on the ceiling of the Sistine Chapel misled some nineteenth-century critics into attributing the drawing to Michelangelo; for Venturi's suggestion that it might be by Raphael there is not even a shadow of an excuse. Popham's attribution in 1940 to Franco, a Venetian artist who was long active in Rome, was confirmed by Pouncey's subsequent observation that this is a study from a youthful model for the figure of Jupiter in the painting of *Venus, Mercury and Jupiter* in the Museo de Arte at Ponce, Puerto Rico – a painting which he was also the first to recognise as a characteristic work of Franco.

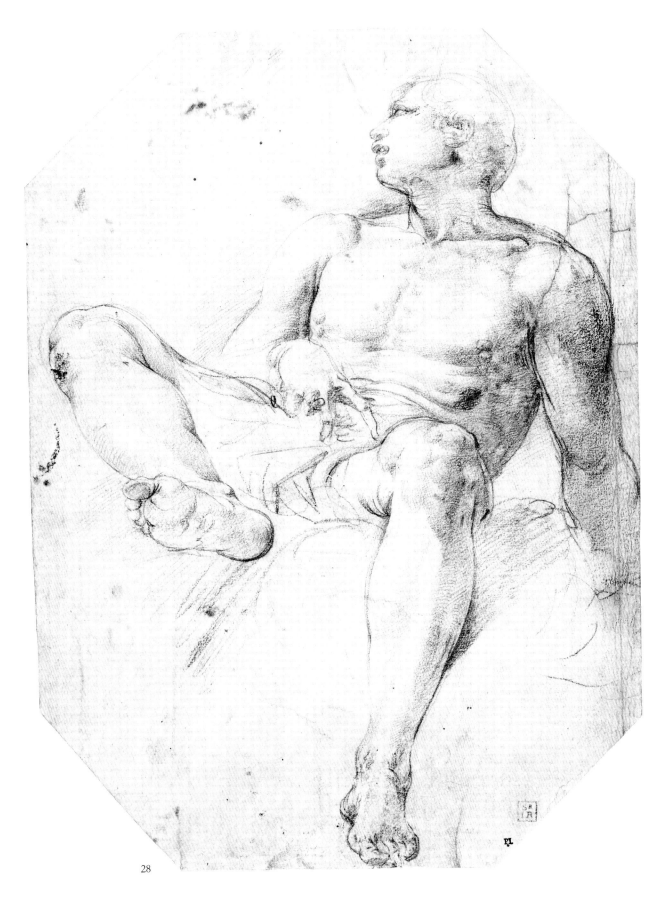

28

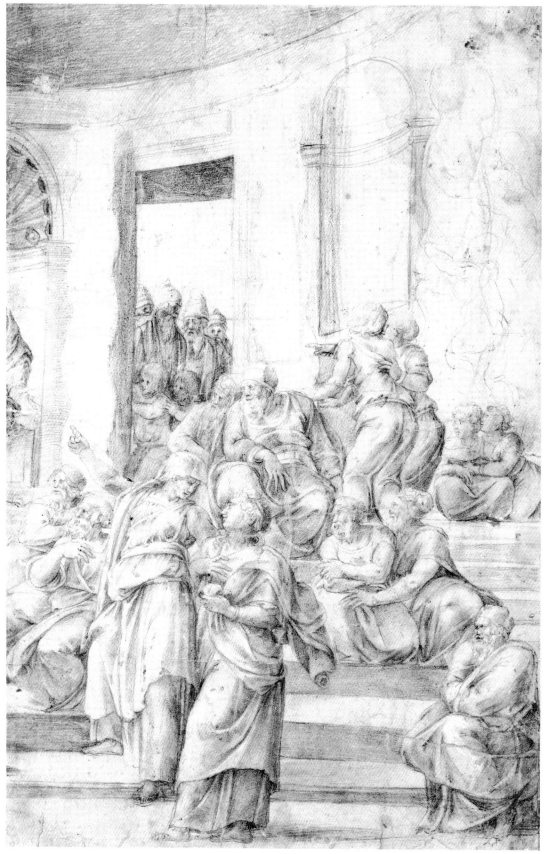

29 Pirro Ligorio (1513/14–83), *Right-hand Half of a Judgement or Disputation Scene (Christ among the Doctors?)*

Black chalk with some touches of white bodycolour; 439 × 238mm

British Museum (1950-5-26-1)

Provenance: Matthiesen, from whom purchased

Literature: Gere, 1971, p. 246; Gere and Pouncey, 1983, no. 196

The drawing was unattributed when acquired, and Pouncey was the first to recognise it as by Ligorio. The subject may be Christ among the Doctors, a suggestion prompted by comparison with another drawing by Ligorio in the British Museum (1950-2-11-7) and lent further weight by the twisted, 'Solomonic' columns of the architectural background, which are of a type traditionally associated with the Temple. If this were indeed the subject, the conspicuous pair of female figures in the left foreground might perhaps be explained as a Sibyl and the Virgin.

The style and handling suggest an early date in Ligorio's career, when he was in Rome and still influenced by Polidoro da Caravaggio.

30 Giulio Mazzoni ((?)1525/30–after 1589), *Time Unveiling Truth*

Black chalk and stumping; 197 × 145mm

British Museum (5210-75)

Provenance: Fawkener Bequest, 1769

Literature: Gere and Pouncey, 1983, no. 218

An old inscription in ink in the lower left corner, *da Micalangelo. B. R.*, was modified by a subsequent hand in a blacker ink with the prefix: *[d]i Sebastiano del Piombo 4/ [im]itatore di* (the last word written over the first word of the earlier inscription). The drawing was attributed to Sebastiano in the Fawkener inventory of 1845 and remained under that name until 1955, when Pouncey noticed its connection with the fresco by Mazzoni in the Galleria (or 'corridoio degli stucchi') of the Palazzo Spada in Rome, a decoration probably carried out in the first half of the 1550s.

Mazzoni, a *stuccatore*, painter and sculptor, came from Piacenza. He was taught stucco-work by Daniele da Volterra (for whom see cat. no. 66), and the Michelangelesque technique of this drawing does indeed suggest Daniele's influence.

30

31 Girolamo Siciolante da Sermoneta (1521–c.1580), *Back View of a Man in a Cloak, Walking away from the Spectator*

Black chalk heightened with white, on blue paper; 342 × 259mm

British Museum (1946-12-21-1)

Provenance: M. de Beer

Literature: Gere and Pouncey, 1983, no. 262; Hunter, 1938, p. 19

On entering the collection, the drawing was attributed to Daniele da Volterra (for whom see cat. no. 66). The attribution to Siciolante, put forward by Pouncey in 1954, was subsequently confirmed by his observation that this is a study for the Apostle in the centre foreground of the *Assumption of the Virgin* in the semi-dome of the Fugger Chapel (third on the right) in S. Maria dell'Anima, Rome, painted not earlier than April 1549. The position of the figure's head is different in the painting, but the drapery corresponds in every detail. The drawing was evidently made in the studio, from a model.

Siciolante, a pupil of Perino del Vaga (1501–47), was active in Rome in the third quarter of the sixteenth century.

32

32 Pellegrino Tibaldi (1527/8–96), *Head and Right Hand of a Young Man*

Brush and dark brown wash over black chalk; some contours lightly indented; the sheet is made up of four pieces of paper joined together; 203 × 218mm

British Museum (1962–7–14–3)

Provenance: Earl of Plymouth, by whom presented

Literature: Gere, 1962–3, pp. 40ff.; Gere and Pouncey, 1983, no. 270

As Pouncey was the first to suggest, this is a fragment of a cartoon or full-size *modello* for the *Adoration of the Shepherds*, signed and dated 1549 (or 1548), in the Borghese Gallery, Rome. The drawing corresponds with the head and hand of the youthful shepherd on the extreme right of the painted composition, though there are some differences in the position of the fingers. Another fragment of this same cartoon is also in the British Museum (1962–7–14–2), and a third in the Uffizi.

Tibaldi, who was one of the greatest exponents of the Late Mannerist style, was active mainly in Bologna. (For another drawing by the artist see cat. no. 74.)

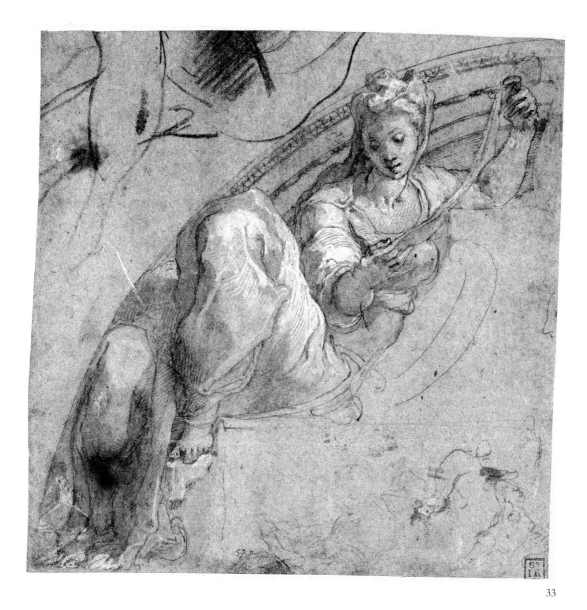

33

33 Taddeo Zuccaro (1529–66), *Sibyl in the Left-hand Side of a Lunette*

Pen and brown wash, heightened with white, on blue paper; 233 × 233 mm

British Museum (Pp. 2–127)

Provenance: Resta-Somers (L 2981 : *59. n.*); Sir J. Reynolds (L 2364); R. Payne Knight Bequest, 1824

Literature: Gere and Pouncey, 1983, no. 328

This drawing appears in the Resta MS. inventory as by Pellegrino da Modena, an attribution which it still bore when it entered the Museum in 1824 with the Payne Knight collection. After the Second World War, other names began to be proposed. Ragghianti thought of Pellegrino Tibaldi (for whom see cat. no. 32), and Briganti of Giovanni Demio (*fl.* 1538–60). Popham was inclined, more reasonably, to think of Federico Barocci in his Early Mannerist phase at the beginning of the 1560s, when he was in contact with the Zuccaros and working in the Casino of Pius IV. The matter was settled when Pouncey observed that the figure corresponds with that in the left-hand side of the lunette over the altar in the Mattei Chapel in S. Maria della Consolazione in Rome, the decoration of which was carried out by Taddeo Zuccaro between 1553 and 1556. The position of the figure was modified in the painting, so that the left knee is no longer so prominently raised.

Taddeo Zuccaro, who was an accomplished draughtsman, was the exponent *par excellence* of Late Mannerist painting in Rome. His early Polidoresque style was succeeded by a short period in which he worked in an extravagant and fantastic vein comparable with that of Francesco Salviati and Pellegrino Tibaldi.

2(ii) Identifications in areas of the collection not covered by the catalogues
(cat. nos 34–55)

Although Pouncey's favourite period was the fifteenth and sixteenth centuries, his knowledge of the whole of Italian art up until 1750 was extensive. The entire collection of Italian drawings in the British Museum was of interest to him, not just the smaller areas covered by the catalogues. He had an accurate memory not only of all the Italian drawings, but also of the Italian prints, whose documentary value he recognised (see cat. no. 99).

This section begins with some of his and Popham's notes on the mostly sixteenth-century drawings that still remain to be fully catalogued (see cat. nos 34–7). The pencil annotation on the mount exhibited at cat. no. 38 is typical of the sort of identification that Pouncey was making all the time, and cat. nos 40–55 are examples of his reattributions of drawings of periods and schools outside the area of the three permanent catalogues.

34 Manuscript volume compiled by Popham, entitled 'Italian Drawings XVI Century BM'

British Museum

The list was completed on 4 June 1943 when the drawings were still at Aberystwyth, though alterations in pencil appear after that date. It was compiled as part of the project to catalogue the entire collection of sixteenth-century Italian drawings, and shows the location of the drawings and whether or not they had been 'listed' and photographed.

The first page shows that cat. no. 47 had already been placed as the work of Niccolò dell'Abbate.

35 Two manuscript entries in Popham's draft catalogue of the sixteenth-century Italian drawings, together with one of the white cardboard folders which he himself made to contain them

British Museum

As previously mentioned (see Introduction, p. 9 and cat. no. 15), Popham spent much of his time at Aberystwyth during the war preparing the above draft catalogue. The entries were written in pen in his neat italic hand on sheets of plain paper ('fiches') some 190 × 120mm, and each was accompanied by a small photograph of the drawing in question taken by Mrs Popham (though many of these were later substituted by Gernsheim photos, for which see cat. no. 86).

The two drawings described here are by Giovanni Balducci (1895–9–15–572) and Giulio Campi (1941–11–8–14); at the bottom of the first entry Pouncey has added a reference in pencil to the *Rivista d'Arte*, which had appeared in 1940.

36 Two of Pouncey's typescript entries for the draft catalogue of sixteenth-century Italian drawings

British Museum

When Pouncey joined the Museum in 1945, among his first tasks was to continue the draft catalogue begun by Popham (see cat. no. 35). It reflected the outlook of a younger generation that his entries were typed, not written by hand, though they were still of the same format as Popham's.

One of the drawings, by Peruzzi, is included in the exhibition (cat. no. 138). The other is by Francesco Menzocchi, an artist in whom Pouncey was interested (see cat. no. 103).

37 Two dossier cards filled in by Pouncey

British Museum

Dossier cards were devised as a convenient means of keeping information about individual drawings. They were introduced in about 1950, at Pouncey's instigation, to replace Popham's *fiches* (see cat. no. 35). A dossier card is a printed folder on the front of which the standard information can be recorded; inside can be kept any relevant material such as documents and photographs. The idea originated at the National Gallery, where each picture has its own file. A Gernsheim photograph of each drawing (see cat. nos 86–7) was to have been dry-mounted in the blank space on the right of the front of the card, but this proved to be unnecessary.

One of the two dossiers shown here is for the Muziano drawing referred to in cat. no. 20; the other is for the Confortini shown as cat. no. 52.

38 Pencil notes written by Philip Pouncey and J. A. Gere on the *verso* of *Mary Magdalen Anointing the Feet of Christ* by Francesco Allegrini (1624–63) after Giulio Romano (1499–1546)

British Museum (Ff. 4–37)

This drawing by the Roman artist Allegrini, which has remained in the unmounted series, was traditionally identified as a copy after Raphael by the Florentine Andrea Boscoli (c.1560–1607). In November 1965 Pouncey recognised that the composition derived from one by Giulio Romano, and suggested that the copyist could have been Allegrini (for whom see also cat. no. 125). Pouncey's pencil note, signed with his initials, appears in the middle of the mount. Such attributions by Pouncey, which accurately identify a given composition and the hand or hands responsible, are found on the mounts of drawings in print rooms throughout Europe and North America (see also cat. nos 42 and 49).

In the following year Pouncey added a second note recording that he had been unable to trace the drawing in the

38

Departmental register. This was followed six years later by a comment by Gere, pointing out that the number does indeed correspond with the appropriate entry for the drawing in the register – an exceptional example of fallibility on Pouncey's part.

39 Francesco Bonsignori (*c*.1460–1519), *Kneeling Woman (Isabella d'Este)*

Black chalk; 285 × 187mm

British Museum (1895-9-15-541)

Provenance: J. Richardson sen. (L 2364); J. Bouverie; C. Hervey; Miss E. Bouverie; Lord Barham; Earls of Gainsborough; Sir J. C. Robinson; J. Malcolm

Literature: Robinson, 1876, no. 104 (as Andrea del Sarto); Pouncey, 1951, p. 99 (as Bonsignori); London, 1981–2, no. 140 (as Bonsignori)

Given to Raphael in both the Richardson and Bouverie collections, this drawing was later attributed to Andrea del Sarto (1488–1530) by Robinson, who observed that it was '... a careful portrait of some Tuscan lady of the time, in mourning costume, and was probably intended to be introduced into a picture'. Pouncey was the first to point out the connection with a figure kneeling in prayer in the left foreground of the altarpiece of the *Veneration of Beata Osanna Andreasi*, painted by Bonsignori in the last year of his life for S. Vincenzo, Mantua, and now in the Museo del Palazzo Ducale of that city (London, 1981–2, no. 139). Osanna Andreasi (1449–1505), a member of a noble Mantuan family, was in life and death the centre of a local devotional cult, of which both Francesco and Isabella d'Este were ardent supporters. The kneeling figure on the left is almost certainly Isabella d'Este, wearing widow's dress following the death of her husband on 29 March 1519.

Bonsignori came from Verona, where he was active in the early part of his career. He visited Mantua in 1487 and became greatly influenced by the work of Mantegna (*c*.1431–1506).

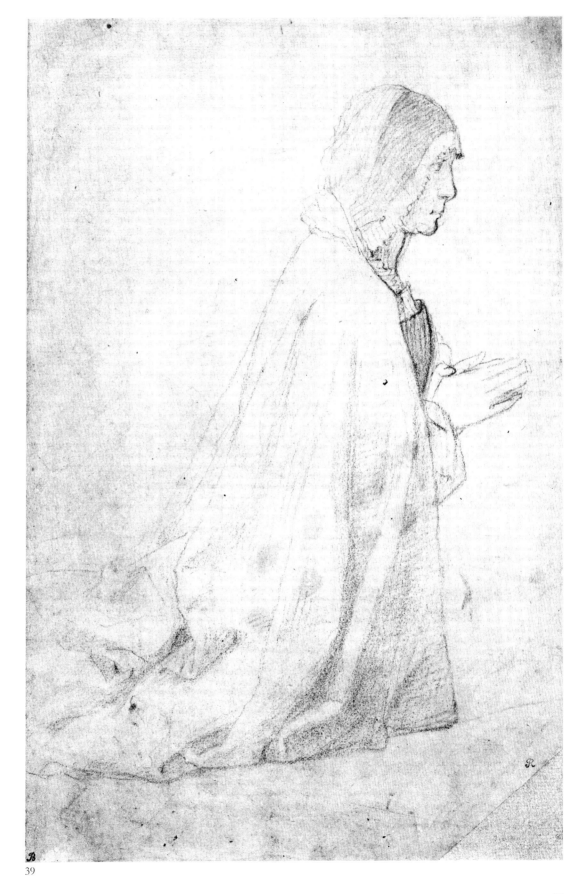

39

40

40 Benvenuto Tisi, called Garofalo (*c*.1481–1559), *Virgin and Child Enthroned with Saints*

Point of the brush in brown wash, heightened with white, on cream-coloured prepared paper; 237 × 231mm

British Museum (1895-9-15-790)

Provenance: Sir T. Lawrence (L 2445); Sir J. C. Robinson; J. Malcolm

Literature: Robinson, 1876, no. 343 (as N. Italian (Ferrarese School?)); Pouncey, 1955, p. 199 (as Garofalo)

This drawing was placed as anonymous North Italian, (?)Ferrarese School, until March 1941, when it was re-attributed to Garofalo following Pouncey's observation that it is a study for the altarpiece, signed and dated 1524, for-merly in S. Silvestro and now in the Cathedral at Ferrara. The altarpiece differs from the drawing in several respects, most notably in being much taller in proportion and in having landscape views to left and right.

Garofalo, who was a pupil of Boccaccio Boccaccino (1467–1524/9) at Cremona, worked briefly in Rome and Bologna before settling in Ferrara, where he was to become one of the leading painters of his generation. His paintings are strongly influenced by Raphael.

This and cat. nos 13, 47 and 55 are among the British Museum drawings that Pouncey reattributed before he joined the staff in 1945.

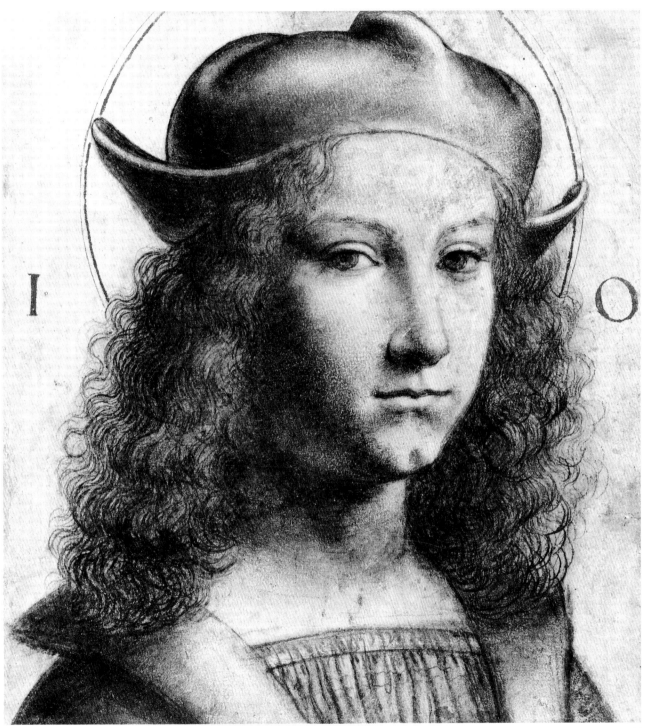

41

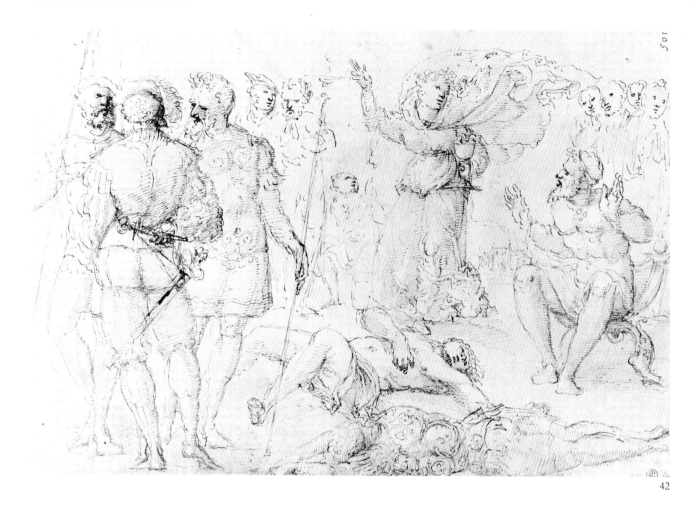

42

41 Attributed to Benvenuto Tisi, called Garofalo (*c*.1481–1559), *Head of a Young Man*

Black chalk; 281 × 263mm

British Museum (1895–9–15–770)

Provenance: Earl of Arundel; Sir P. Lely (L 2092); Dr H. Wellesley; J. Malcolm

Literature: Robinson, 1876, no. 323 (as Milanese School of Leonardo); Cust, 1906, pp. 113 and 367 (as Sodoma); Pouncey, 1955, p. 200, n. 26 (as Garofalo); London, 1974, no. 24 (as Garofalo)

When in the collection of the Earl of Arundel, this drawing, then attributed to Leonardo da Vinci (1452–1519), was etched in reverse by Wenceslaus Hollar (1607–77), without the halo or the letters (Parthey, 1853, no. 1585). It was ascribed to Leonardo in the Wellesley sale, and to the Milanese School of Leonardo in the Malcolm catalogue. Soon after entering the British Museum, it was attributed to the Sienese artist Giovanni Antonio Bazzi, called Sodoma (1477–1549). Popham's tentative attribution to Timoteo Viti (1469/70–1523), made about 1940, was superseded by Pouncey's attribution to Garofalo.

Pouncey remarked that the 'structure of the face corresponds fairly well with Costa's [i.e. Lorenzo Costa (1459/60–1535)] normal type, but the tendency to idealise and, moreover, the handling, point to an artist of the next generation. The most likely author seems to be Garofalo whose early fresco on the ceiling of the Palazzo del Moro contains several heads similar in character.'

42 Attributed to Marcello Fogolino (1483/8–after 1558), *Miracle of St John the Evangelist*

Pen and brown ink; 198 × 293mm

British Museum (1920–4–20–5)

Provenance: Marquis de Lagoy (L 1710); unidentified collector (L 1143); J. C. Robinson (L 1433); C. Fairfax Murray

Literature: Puppi, 1966, p. 63; Bean, 1982, under no. 81

On entering the collection, the drawing was classified as anonymous North-Western Italian, sixteenth century. In March 1950 Pouncey put forward the view that it might be by a follower of Girolamo Romanino (1484/7–after 1559) and soon afterwards tentatively suggested Fogolino in his

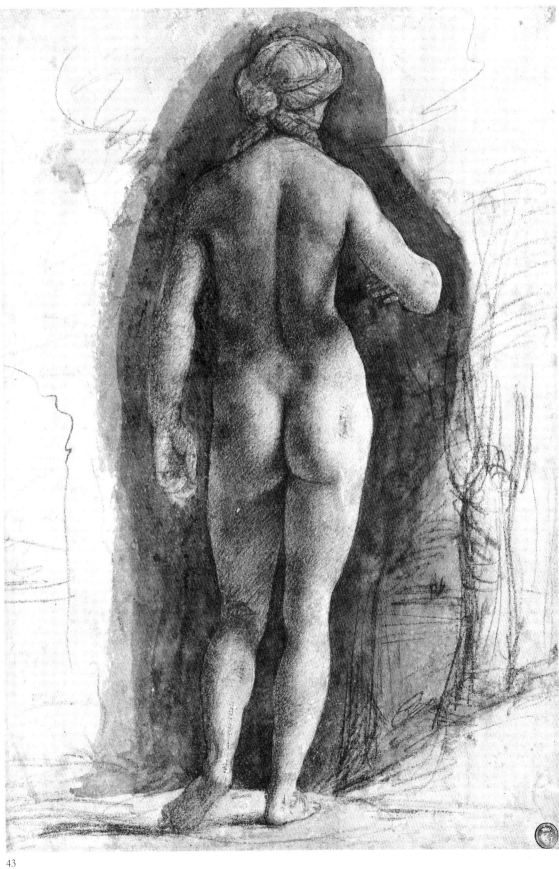

43

later period (these and other pencil attributions are still visible on the old British Museum mount, which would normally have been renewed for exhibition). Pouncey grouped the drawing with four others, in Bayonne, Dijon, the Metropolitan Museum of Art, New York, and the Scholz collection (now in the Pierpont Morgan Library), New York, which he attributed to his 'Pseudo Fogolino'. Although they are clearly by an artist working in the circle of Fogolino, Pouncey was reluctant to make an unqualified attribution to the master himself.

The subject comes from the legendary life of St John and shows the saint about to drink from the poisoned chalice, with two men falling dead at his feet and several figures looking on in astonishment.

43 Attributed to Antonio Allegri, called Correggio (*c*.1494–1534), *Back View of a Standing Nude Woman*

Black chalk and brown wash; 250 × 174mm

British Museum (1895–9–15–490)

Provenance: Commendatore Gelosi (L 545); Revd Dr H. Wellesley; J. Malcolm

Literature: Robinson, 1876, no. 52 (as ascribed to Leonardo da Vinci); Popham, 1967, no. 17* (as attributed to Correggio)

In the Wellesley sale (Sotheby's, 1866) as Leonardo da Vinci, and subsequently catalogued by Robinson as 'ascribed to Leonardo', this beautiful drawing entered the British Museum collection simply as 'anonymous Italian'. Pouncey put forward the attribution to Correggio in 1957, pointing out that it appears to be by the same hand as a drawing of an *Unidentified Mythological(?) Subject*, formerly in his own collection and now in the J. Paul Getty Museum, Malibu (Goldner, 1988, no. 11). In aspects of the handling of the chalk, there is a stylistic connection between the two works.

Popham included the drawing in his catalogue of the Museum's drawings by Parmese artists, but only as 'attributed to Correggio'. He did not discuss its stylistic relationship to the ex-Pouncey Getty drawing, but noted the similarity of the nude to the central figure of the *Three Graces* in one of Correggio's lunettes in the Camera di S. Paolo in Parma. He pointed out that the figure in the drawing must be derived from a work of sculpture, since a drawing of an identical figure, seen from exactly the same viewpoint but standing on a low circular pedestal, is in the Louvre, where it too is attributed to Leonardo.

Correggio was one of the most important painters of the High Renaissance in Northern Italy. Influenced by such artists as Mantegna and Leonardo da Vinci, he quickly developed his own personal style, one of great sophistication and charm.

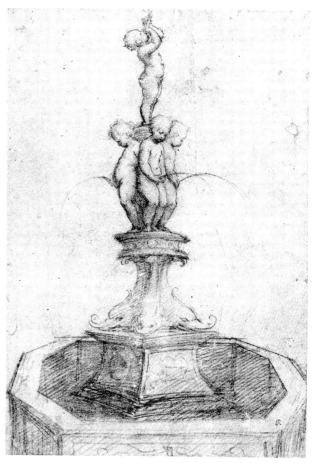

44

45

44 Giovanni Antonio de' Sacchis, called Pordenone (1483/4–1539), *Design for a Fountain with Putti*

Red chalk; 245 × 170mm

British Museum (1953-4-11-112)

Provenance: J. Richardson sen. (L 2184); G. Knapton; S. Higgons

Literature: Popham, 1967, no. 1 (as Correggio); London, 1983–4, no. D42 (as Pordenone)

The attribution to Correggio, suggested by Higgons, was accepted by Popham, who included it in his British Museum Parmese catalogue. Only later did Pouncey come to see the drawing as the work of Pordenone, publishing it for the first time under this attribution on the occasion of the Royal Academy's 1983–4 *Genius of Venice* exhibition. His opinion was probably influenced by the discovery of M. Laskin Jr that a drawing in the Metropolitan Museum of Art, New York, for the decoration of a pilaster, done in the same style and bearing a traditional attribution to Correggio, was a study by Pordenone for the pilaster decorations of the entrance arch of the Pallavicini Chapel in S. Francesco, Cortemaggiore (Laskin, 1967, p. 356; Bean, 1982, no. 193).

The painter came from the small town of Pordenone in the Friuli, hence his name. He was active in much of Central and Northern Italy, where he was one of the leading painters of his generation. Although especially influenced by Venetian painting of the period, he was also aware of other important currents in Italian art of the time.

An amusing story is told by Pouncey's widow, Myril, of their visit to Pordenone in 1984 to see the exhibition of the painter's work held there on the occasion of the fifth centenary of his birth. A local barmaid, a proud inhabitant of the town, was protesting at the fuss, adding a little boastfully that she had never even heard of the artist. To quieten her down, Pouncey replied that where he came from everybody had heard of the painter but nobody of the town.

For another drawing by Pordenone, see cat. no. 62.

45 Innocenzo Francucci, called da Imola (c.1490–c.1545), *The Flagellation*

Pen and brown ink with brown wash, heightened with white; 233 × 192mm

British Museum (1946-7-13-358)

Provenance: S. Woodburn; Phillipps-Fenwick; presented anonymously

Literature: Popham, 1935, p. 58, no. 1 (as Garofalo)

Following the attribution written in pencil on the *verso*, Popham gave this drawing to Garofalo. Pouncey pointed out that 'in style, types and treatment of drapery, this drawing comes very close to Innocenzo'.

The drawing is from the Phillipps-Fenwick collection of Old Master drawings, which was presented to the Museum in 1946, the year after Pouncey joined the Department. Comprising well over 1,000 Italian drawings of all schools, it was the largest single acquisition of such material by the Department in this century. Although the donor wished to remain anonymous, since his death in 1978 his identity has been revealed and his generosity justly acknowledged: the exact circumstances behind Count Antoine Seilern's gift remain unknown, but Popham, who had catalogued the whole collection in 1935, evidently played a key role. Seilern kept for his own collection a few drawings that particularly appealed to him (they are now in the Courtauld Institute Galleries with the rest of his bequest) before presenting the bulk to the British Museum. Popham's catalogue of the Phillipps-Fenwick collection, published in 1935, was only summary, and he was the first to admit that the collection provided rich scope for further study. Other drawings with this provenance reattributed by Pouncey and included in the present catalogue are cat. nos 48, 50–53, 85 and 138.

46 Girolamo Francesco Maria Mazzola, called Parmigianino (1503–40), *Bearded Man Standing in Profile to the Right*

Black chalk and brown wash on brown paper, heightened with white; 273 × 179mm

British Museum (1946-4-13-206)

Provenance: (?)G. M. Mitelli; Resta-Somers (L 2981: *k. 86*); T. Hudson (L 2432); Sir J. Reynolds (L 2364); Miss J. Sharpe; presented by Miss Sharpe's executors

Literature: Popham, 1967, no. 94*; Popham, 1971, no. 197

This is a study, with many differences, for the figure of St Joseph of Arimathaea in Parmigianino's etching of the *Entombment* (Bartsch, 1803–21, xvi, p. 85, no. 5), which probably dates from the painter's Roman period. When acquired, the drawing was thought to be a copy after Parmigianino by the Bolognese painter Giuseppe Maria Mitelli (1634–1718). The attribution to Mitelli, inscribed on the old mount, was based on the partly cut-away inscription on the drawing itself: '. . . *dal Sg Mitelli| . . . ne in Roma 1688. Xbre'*. Once Pouncey argued the case for Parmigianino's authorship, the Resta MS. catalogue was consulted, which stated that the drawing, by Parmigianino, was in fact *presented* to Resta by Mitelli some years earlier in 1682.

Parmigianino was influenced by Correggio and Raphael. He was active mostly in Parma, but visited other centres, including Rome and Bologna. The graceful refinement of his style makes him one of the most important exponents of Mannerism in Northern Italy.

46

F. boullogne. f.

47

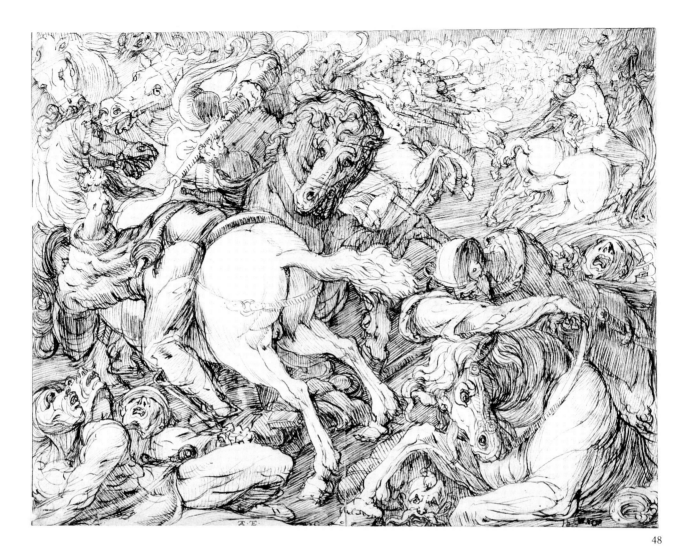

48

47 Niccolò dell'Abbate (1509/12–71), *Ulysses Chiding Thersites*

Pen and brown wash heightened with white on buff paper; 416 × 289mm

British Museum (1860–6–16–81)

Provenance: R. Houlditch (L 2214, followed by *1*); Sir T. Lawrence (L 2445); S. Woodburn

Literature: London, 1951, no. 97; Adelaide and Melbourne, 1980, no. 1.

The drawing is inscribed in an old hand at lower right: *F. Boulloegne F.* (i.e. the French nickname for Primaticcio, who was born in Bologna). On the strength of this traditional attribution, it was placed with those of Primaticcio until Pouncey pointed out (before 1943, see cat. no. 34) that it was by Niccolò dell'Abbate. Carried out during Niccolò's French period (1552–71), the drawing illustrates an incident narrated by Homer in the *Iliad* (Book II, 212ff.). After exhorting the Achaeans to remain loyal to Agamemnon, Ulysses

was interrupted by the seditious speech of Thersites, 'the ugliest man that had come to Troy'. Offended by this action, Ulysses made a public spectacle of Thersites by beating him, first revealing his unsightly nakedness by removing his cloak.

Niccolò dell'Abbate was active in Modena and Bologna during his early career, when he was predominantly influenced by Parmigianino. In 1552 he went to work for the court of Francis I of France at Fontainebleau, one of the most important centres of Mannerist art in Europe.

48 Master of the Egmont Albums (*fl.* (?) second half of sixteenth century), *Battle of Horsemen*

Pen and brown ink over black chalk; 276 × 364mm

British Museum (1946–7–13–92)

Provenance: W. Y. Ottley (L 2663); Sir T. Lawrence (L 2445); S. Woodburn; Phillipps-Fenwick; presented anonymously

Literature: Popham, 1935, p. 166, no. 1 (as Tempesta)

49

In accordance with the monogram *AT. TE.* at the bottom of the sheet, this drawing was given by the early collectors to Antonio Tempesta. It was so catalogued by Popham in 1935, and entered the Museum under that name in 1946.

Pouncey first recognised the existence of an artist whom he named the 'Master of the Egmont Albums' in 1958, when he was studying the collection of drawings at Yale University. There he found four pen drawings by the same distinctive hand, all from albums put together in the early eighteenth century by the first Earl of Egmont. Since this discovery, numerous drawings by the same hand have come to light. Recently an attempt has been made to identify this master with the sixteenth-century Netherlandish artist Dirck Hendricksz. Centen (Dacos, 1990, pp. 49ff.).

49 Agostino Carracci (1557–1602), *Christ and the Samaritan Woman*

Pen and brown ink over traces of black chalk on paper prepared with reddish chalk; 178 × 214mm

British Museum (1858–11–13–340)

Literature: Posner, 1971, ii, p. 33 and fig. 77b (as Ludovico Carracci)

The drawing entered the collection in 1858 with an attribution to Agostino's cousin Ludovico Carracci (1555–1619). The former British Museum mount carried a number of more recent pencil annotations, typical of the dialogue between specialists often found on the mounts of Old Master drawings (for which see also cat. no. 38): 'Possibly early Ag[ostino] (R[udolf] W[ittkower])'; 'Certainly Lodovico (D[onald] P[osner])'; and 'More probably Agostino

(PMRP[ouncey])'. In publishing the drawing as Ludovico, Posner claimed that it had been used by Annibale for the composition of his painting of the subject in the Brera, Milan, datable 1593–4 (Posner, 1971, ii, no. 77). Whether or not this was so seems an open question, but Wittkower and Pouncey were surely correct in believing it to be by Agostino, to whom it was transferred in 1990.

50 Ludovico Cardi, called Cigoli (1559–1613), St Paul

Pen and brown ink and blue wash, squared in red chalk (the squaring numbered in ink); 195 × 131mm

British Museum (1946-7-13-230)

Provenance: W. Y. Ottley; Sir T. Lawrence (L 2445); S. Woodburn; Phillipps-Fenwick, presented anonymously

Literature: Popham, 1935, p. 24, no. 3 (as Cherubino Alberti); Chappell, 1989, p. 207, fig. 16 (as Cigoli)

The old mount carries a traditional attribution to Cherubino Alberti (1553–1615), under whose name the drawing entered

50

the Museum with the Fenwick collection. Pouncey recognised the connection with the figure of St Paul in Cigoli's fresco of the *Immaculate Conception*, painted in 1610–12 in the cupola of the Cappella Paolina in S. Maria Maggiore, Rome. The same figure appears indistinctly on the right in another drawing for the fresco in the Museum (1988-1-30-12).

51 Domenico Cresti, called Passignano (1559–1638), Battle

Pen and brown wash, heightened with white, on blue-grey paper; 553 × 421 mm

British Museum (1946-7-13-596)

Provenance: B. West (L 419); Sir T. Lawrence (L 2445); S. Woodburn; Phillipps-Fenwick; presented anonymously

Literature: Popham, 1935, p. 110, no. 1 (as Vicentino); London, 1986, no. 203 (as Passignano)

When in the Lawrence collection, this drawing was attributed to Jacopo Tintoretto (1518–94). In the Phillipps-Fenwick catalogue Popham gave it to another Venetian, Andrea Michieli, called Vicentino (*c*.1542 – after 1617), who painted battle scenes in the Ducal Palace in Venice. The correct attribution to the Florentine painter Passignano was advanced by Pouncey in 1953. The purpose of the drawing is unknown, but it was probably intended as a *modello*.

Passignano was one of a group of Florentine painters at the turn of the century who practised a proto-Baroque style that was first much dependent on the Venetians and then, after 1600, on the Roman works of Caravaggio and the Carracci.

52 Jacopo Confortini (*fl*.1629–67), The Magdalen

Black chalk; 375 × 270mm

British Museum (1946-7-13-1301)

Provenance: Sir T. Lawrence (L 2445); S. Woodburn; Phillipps-Fenwick; presented anonymously

Literature: Thiem and Thiem, 1964, p. 160, fig. 11

This and cat. no. 53 entered the Museum as anonymous Italian, seventeenth century. Most of the drawings from the Phillipps-Fenwick collection were acquired in 1946, but these two were among a large batch which had been overlooked by Popham in 1935 but which came to light in 1957 among the residue of the collection of manuscripts. Pouncey noticed that a drawing of a *Man in Oriental Costume Holding a Knife*, in the Pierpont Morgan Library, New York (inv. no. 1955.4), inscribed on the *verso*, in pen, *Confortini*, is by the same highly idiosyncratic hand; and that Jacopo Confortini was responsible for other drawings in the Museum's collection which had earlier entered it under a wide variety of names – including even Velásquez.

51

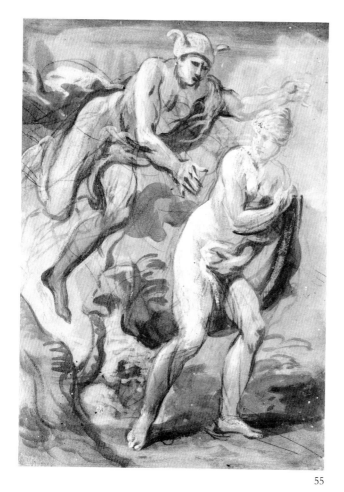

55

55 Benedetto Luti (1666–1724), *Mercury and (?)Herse*

Brush drawing in purplish bodycolour, heightened with white, over red and black chalk, on paper washed light mauve; 287 × 207mm

British Museum (1927-4-11-4)

Provenance: Miss M. H. Williams

Literature: Popham, 1932, p. 154 (as anonymous Italian School)

Purchased as attributed to the Flemish painter Frans Floris (1516–70), the drawing was shortly afterwards transferred by Popham to the Italian School; the attribution to Luti was proposed by Pouncey in July 1941. The drawing remains on the same mount that it was given when first acquired: Floris's name, stamped just below the drawing to the right, has been erased and substituted by a pencil note in Popham's hand: 'BENEDETTO LUTI (Ph. Pouncey)'. The pastel-like appearance – it is in fact a brush drawing in bodycolour – is characteristic of Luti's technique and agrees well with a drawing of the *Mystic Marriage of St Catherine* at Christ Church, Oxford (Byam Shaw, 1976, no. 661), unquestionably by him. Luti, who was a Florentine, established a successful career in Rome.

2(iii) Other writings (cat. nos 56–63)

As many of the drawings in previous sections show, Pouncey's attributions were usually expressed in brief pencil annotations on the mounts of drawings, or in letters to colleagues (for the careful record he kept of all his attributions, see cat. nos 132–8). He was never in any hurry to publish his discoveries: his early attribution of cat. no. 13, for example, was not made known for nearly fifteen years and then only as part of his and Popham's fourteenth- and fifteenth-century catalogue. He believed his time was better spent in making fresh discoveries than in writing up those he had already made.

When he did set pen to paper he wrote with great style and with a notably witty turn of phrase. This section considers some of Pouncey's writings other than the catalogues already reviewed in section II.2.(i). These occasional writings are listed in Gere, 1991, pp. 542–4, and a reprint of them is now being prepared by Mario di Giampaolo. The most important of Pouncey's independent publications is his short essay on the drawings of Lorenzo Lotto, published in 1965 (see cat. no. 56). Several of his articles date from a ten-year period after he joined the British Museum (see under cat. nos 60–62). Among these writings were a few reviews, the most important of which was of the third, Italian, edition of Berenson's *The Drawings of the Florentine Painters* (see cat. no. 63).

56 Philip Pouncey, *Lotto disegnatore*, published with 28 plates by Neri Pozza Editore, Vicenza, 1965

British Museum

A classic study of this great painter's work as a draughtsman, Pouncey's book is full of extraordinary insights into Lotto's humanity and the subtle relationship between his paintings and his drawings (e.g. the passages quoted under cat. nos 58 and 59). Of all Pouncey's writings, this essay most prompts regret that he did not write more.

57 Lorenzo Lotto ((?)1480–1556/7), *Landscape with the Camp of the Assyrians: Design for Intarsia*

Pen and brown wash, heightened with white; 315 × 245mm

Private collection

Literature: Pouncey, 1965, p. 18, pl. 20; Edinburgh, 1969, no. 42; London, 1983–4, no. D21

Inscribed with colour-notes in the artist's hand, e.g. *nocte* (*notte*) in the sky, *biaco* (*bianco*) on the tent to the left of the big tree, *veste de laca* for the dress of Judith's maid.

As Pouncey was the first to recognise, this is a fragment of a study for *Judith and Holofernes*, one of four large intarsia

panels on the rood-screen of S. Maria Maggiore, Bergamo, executed by Gianfrancesco Capodiferro to Lotto's designs. The drawing is on a smaller scale than the intarsia and therefore cannot have formed part of the final cartoon which, according to documentary evidence, was in colour and was executed in 1527–8. The notes suggest that the drawing was made in preparation for the cartoon.

Lorenzo Lotto was trained in Venice, where he was greatly influenced by Giovanni Bellini. In 1509–11 he was briefly in Rome and in 1512 settled in Bergamo, where he stayed until the second half of the 1520s. He was active for the rest of his career in the Veneto, often working in the smaller towns of the district. His popular, realistic style has an archaic quality that often depends on the compositional forms of the Quattrocento.

58 Lorenzo Lotto ((?)1480–1556/7), *The Holy Family in the Temple*

Pen and brown ink with brown wash; 177 × 146mm

British Museum (1895-9-15-684)

Provenance: Mercer; Whitehead; J. Malcolm

Literature: Robinson, 1876, no. 243 (as ascribed to Dosso Dossi); Pallucchini, 1951, p. 196; Pouncey, 1965, p. 16

Ascribed to Dosso Dossi (*c*.1490–1542) when in the Malcolm collection, soon after entering the British Museum the draw-

58

ing was given to Liberale da Verona (*c*.1445–1526/9). In 1951 it was recognised by Pallucchini as the work of Lotto.

Pouncey wrote of this drawing with great sensitivity, pointing to its lyricism:

Against a sober, late-Quattrocentesque architecture, which recalls some severe vision of a Marchigian façade, there moves a crowd, pyramidal in form, disposed as if on a stage. The bodies writhe, the gestures are tremulous, the angels part to make room, ecstatic in their religious anxiety. Something convulsive infuses this composition, culminating in the baby at the apex of the pyramid and appeased only in the architecture of the background. A lingering aura of Gothic mysticism is superimposed over renaissance forms . . .

He then touches on the attribution of 'this extravagant drawing', noting the significance of its former acceptance as the work of Liberale da Verona, one of the most 'Gothic' of Italian fifteenth-century artists.

59 Lorenzo Lotto ((?)1480–1556/7), *An Ecclesiastic in his Study*

Pen and brown wash, heightened with white; 162 × 198mm

British Museum (1951-2-8-34)

Provenance: S. Woodburn; Phillipps-Fenwick; presented anonymously

Literature: Popham, 1935, p. 21, no. 1 (as 'uncertain Italian school, XVIth century'); Popham, 1951, pp. 72f.; Pouncey, 1965, pp. 15f.; London, 1983, no. D23

When Popham published the drawing in 1935, he classified it as uncertain Italian school, sixteenth century, recognising it as by Lotto only when it was presented to the Museum in 1951. For some reason the drawing had become separated from most of the rest of the Fenwick collection and was one of several strays that reached the Department after 1946 (for two others, see cat. nos 52–3). According to J. A. Gere (orally), its arrival occasioned some excitement and quickly generated intense discussion between Popham and Pouncey. After Popham had published the drawing, Pouncey found himself in disagreement over its dating: the period 1510–20 proposed by Popham (and supported by Berenson) was, in Pouncey's opinion, too early, and he suggested around 1530 instead.

In his 1965 book on Lotto (see cat. no. 56) Pouncey calls the drawing a masterpiece in the representation of an interior; in describing the composition he captures the spirit of the scene superbly, seeming almost to identify himself with the sitter:

The young prelate has interrupted his reading for a moment to glance at us and to invite us hither: we are in the presence of a man who is cultivated and well-to-do, who likes books, tasteful furnishing and comfort. From the shadows emerge the more disparate and profane objects: vases, a bust, a bell for calling servants, an open jewel-box; there is also a little dog.

59

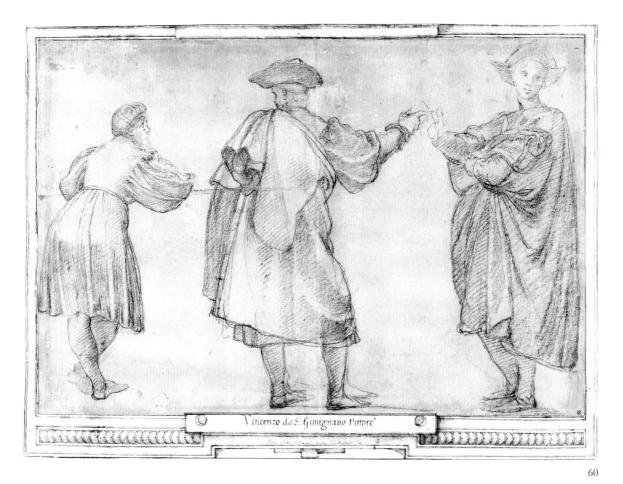

60

60 Vincenzo Tamagni (1492–*c*.1530), *Three Standing Figures*

Black chalk on cream-coloured paper; 270 × 408mm

British Museum (1866–7–14–8)

Provenance: G. Vasari; P.-J. Mariette (L 1852); Paignon-Dijonval; Revd Dr H. Wellesley

Literature: Pouncey, 1946, pp. 3–8 and pl. ia.

This drawing was to prompt one of Pouncey's first articles. Vasari's attribution to Tamagni (to whom he refers as *Vincenzo da S. Gimignano Pittore* on his mount) enabled Pouncey to reattribute the related fresco of *St Catherine Healing Matteo di Cenni* in the Oratory of the Contrada dell'Oca, Siena, to Tamagni. Although Oskar Fischel had previously connected the British Museum drawing with the fresco, he believed the drawing to be by Girolamo del Pacchia (1477–1533), to whom the fresco had been traditionally given, along with others from the same cycle. Pouncey rightly contrasted the 'quaint, countrified manner' of Tamagni's *Healing of Matteo di Cenni* with the more up-to-date rendering of the other frescoes by Pacchia.

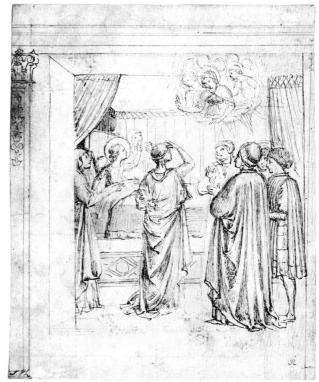

61

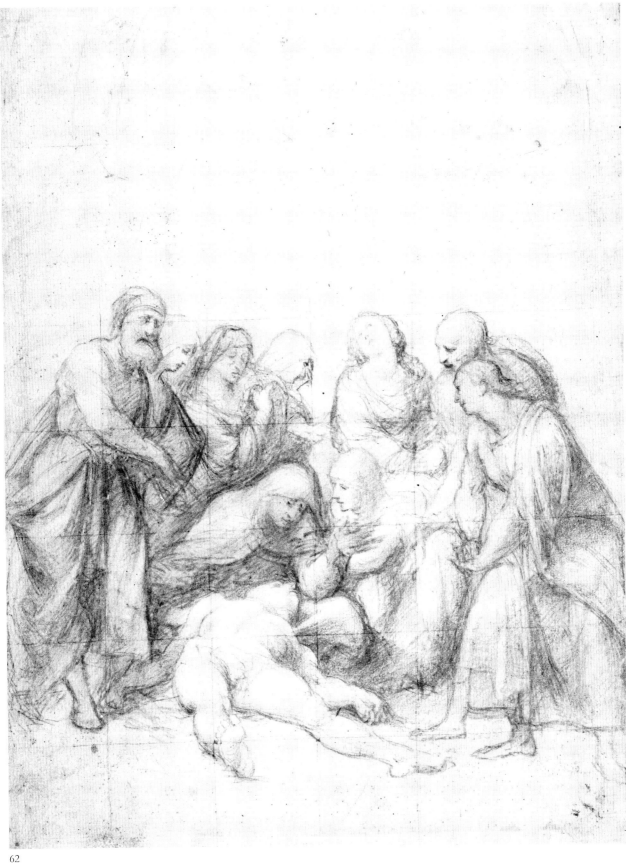

61 Benozzo Gozzoli (1420–97), *The Virgin Appearing to St Rosa of Viterbo*

Pen and brown ink with faint brown wash on paper rubbed with red chalk; 179 × 150mm

British Museum (1885-5-9-38)

Provenance: J. Richardson sen. (L 2184); J. Thane (L 1544); Sir T. Lawrence (L 2445); W. Russell (L 2648)

Literature: Pouncey, 1947, pp. 9ff.; Popham and Pouncey, 1950, no. 86

Like cat. no. 60, this drawing was also the subject of one of Pouncey's early articles. Although it was previously known that the British Museum drawing and a closely related study in Dresden showing the same saint receiving the tonsure were companion pieces by Gozzoli, Pouncey spotted that they had originally formed part of the same sheet. With the composition thus reconstructed, he went on to demonstrate its connection with Gozzoli's destroyed fresco cycle in the church of the convent of S. Rosa at Viterbo, painted in 1453. The frescoes represented scenes from the life of St Rosa, a member of the Third Order of St Francis, who died about 1252, before she was 18. The frescoes were destroyed in 1632, but copies of nine of them were made in that same year by F. Sabatini.

Gozzoli was a Florentine painter of the early Renaissance, whose style owes much to that of his master Fra Angelico (1387–1455).

62 Giovanni Antonio de' Sacchis, called Pordenone (1483/4–1539), *The Lamentation*

Red chalk over stylus underdrawing; 368 × 278mm

British Museum (1958-2-8-1)

Provenance: J. Richardson sen. (L 2184)

Literature: Pouncey, 1961, pp. 27–8; London, 1983–4, no. D37

An attribution to Pordenone is inscribed on the old Richardson mount. This study for the fresco painted in 1522 near the west door of Cremona Cathedral is one of the painter's finest surviving compositional drawings. Writing of it for the *British Museum Quarterly*, Pouncey first commented on the stature of Pordenone himself:

By all accounts he was a formidable personality, and his art too is formidable: in its growth from rustic Quattrocento beginnings to an almost Baroque illusionism that attracted Rubens; in its pioneering fusion of Venetian colour with a Central Italian sense of form acquired by study of Raphael and Michelangelo; [and] in its impact on such varied and prominent artists as Giulio Romano . . . and Parmigianino . . .

He then went on to discuss the differences between drawing and fresco. In the Christ:

Pordenone, following his realistic bent, first visualized Him as though He had been thrown down on the floor by one of the brutal lanzknechts in the near-by *Crucifixion*, but the final version shows Him in a hieratic pose, reverently laid out in an attitude similar to that in which He had died.

For another drawing by Pordenone, see cat. no. 44.

63 Pouncey's review of the 1961 Italian edition of Bernard Berenson's *The Drawings of the Florentine Painters,* in *Master Drawings*, ii, 1964

When the third, Italian, edition of Berenson's classic study appeared, two years after the author's death, the editor of the then newly established American periodical *Master Drawings* turned, not surprisingly, to Pouncey for a review. What he received was not the usual, negative 'hatchet job' so familiar today, but an extraordinarily wide-ranging and detailed supplement to Berenson's own authoritative text, wittily written in a tone of cultivated modesty. Gere (1991, p. 538) rightly refers to the review (listed in the Bibliography of the present catalogue as Pouncey, 1964) as 'masterly' and as 'a *tour de force* that few others could have attempted'; it is in its own way a classic, though still far too little known.

The authority of Pouncey's comments was reinforced by the number of unpublished drawings he was able to add to those listed under each artist by Berenson. Pouncey also used the review to reassert his own strong belief in attributionism, an approach to art history so evidently exemplified by Berenson (much as he might have wished to deny it). Nevertheless, he criticised Berenson for neglecting most of the artists active during and immediately after Michelangelo's lifetime (i.e. Pouncey's beloved Mannerists), observing amusingly that, 'From Berenson's point of view it was a misfortune that Michelangelo lived to be nearly ninety and thus forced him to push out a salient into what must have seemed the no-man's-land of Mannerism'.

2(iv) Acquisitions (cat. nos 64–81)

The drawings in this section are arranged in order of acquisition. For the greater part of the Museum's history, the Italian drawings (like so much else) were acquired by gift or bequest. From the beginning of the present century, however, the Museum has depended increasingly on purchase to expand its collections.

Cat. nos 64 and 76, presented by C. R. Rudolf, a collector whom Pouncey knew and sometimes advised, are examples of the sort of gift made as a result of his encouragement. Cat. no. 65, on the other hand, was purchased. The drawing is of particular interest since it is *en série* with one already in the Museum which had been catalogued two years before. Except for cat. no. 72, a drawing presented to the Museum by the Vasari Society, the other drawings in the section include 'discoveries' bought inexpensively (e.g. cat. nos 66,

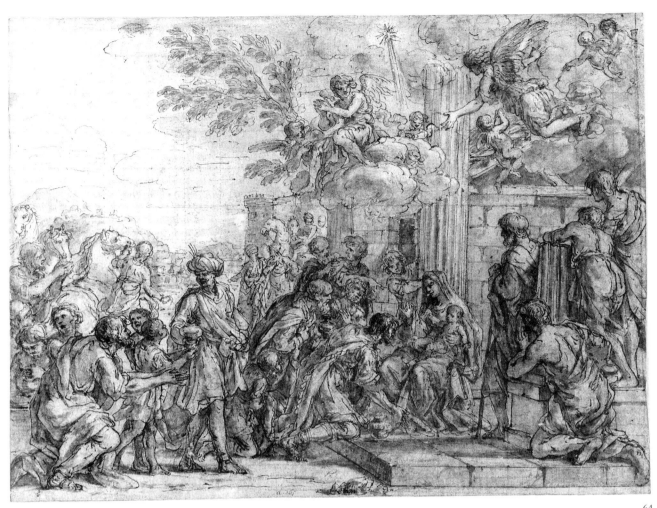

64

74, 79 and 81), as well as drawings purchased at the top of the market, for example two by Raphael (cat. nos 67 and 80). Also included is a drawing by Bruegel found by Pouncey in a miscellaneous parcel at Sotheby's and bought by the Museum for what then seemed a large sum (cat. no. 73).

64 Giacinto Gimignani (1611–81), *The Adoration of the Magi*

Pen and brown ink with light brown wash, heightened with white, over red chalk; squared in black chalk; 251 × 343mm

British Museum (1946-7-5-14)

Provenance: Resta-Somers (L 2981: *d.165*); C. R. Rudolf

Literature: Fischer Pace, 1978, p.348, fig. 10

The drawing was presented to the Museum by the late C. R. Rudolf (d.1975), one of a number of English collectors with whom Pouncey was on friendly terms. It entered the collection with a traditional attribution, going back at least to the period of Padre Resta in the late seventeenth century, to Giacinto's son Ludovico Gimignani (1643–97). At Pouncey's

suggestion, however, it was transferred to Giacinto. Ursula Fischer Pace subsequently pointed out a connection with a painting by Giacinto of the *Adoration of the Magi*, formerly in a private collection in Pistoia and now in the Museo Civico there. The correspondence is by no means exact, and the relationship, such as it is, consists of the repetition of some motifs.

Giacinto was a pupil and follower of Pietro da Cortona (1596–1669), whose style he imitated. His career was spent mostly in Rome.

65 Studio of Francesco Squarcione (1397–1468), *The Arrest of St Christopher*

Pen and brown ink with brown wash on pale brown paper; 133 × 133mm

British Museum (1952-5-10-7)

Provenance: W. H. Schab, New York; H. M. Calmann

Literature: Tietze, 1942, pp. 54ff.; Tietze and Tietze-Conrat, 1944, no. A750; Popham and Pouncey, 1950, under no. 253

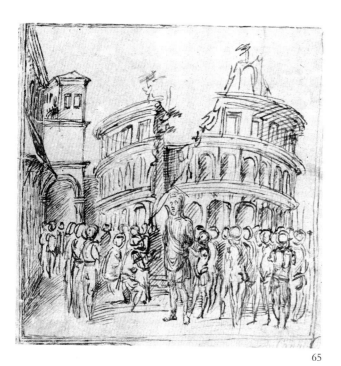

65

St Christopher, who no longer appears in the Roman Catholic Church calendar, was said to have been gigantic in stature and is best known for carrying the infant Christ on his shoulders across a river. According to legend, he ended his life in Lycia, where, after forty archers failed to harm him, he was finally beheaded.

A companion drawing, *St Christopher in Lycia*, was catalogued in Popham and Pouncey, 1950 (no. 253). Tietze (1942) first observed that the two drawings and a sketch attached to a contract of 17 October 1466 in the archives of the de Lazara family at Padua are all by the same hand. Under the terms of this contract, Piero Calzetta undertook to paint a picture based on this sketch in Bernardo de Lazara's chapel in the Santo at Padua. The sketch is stated to be a copy of one by Niccolò Pizzolo in the possession of Francesco Squarcione. Tietze went on to suggest that the St Christopher drawings may perhaps be connected in some way with the fresco cycle by Mantegna and others in the Eremitani Chapel in Padua.

66 Daniele Ricciarelli, called Daniele da Volterra (*c.*1509–66), *Virgin and Child*

Black chalk; 377 × 296mm, with arched top

British Museum (1952–10–11–6)

Provenance: J.-B.-J. Wicar

Literature: Gere and Pouncey, 1983, no. 75; Cambridge, 1985, no. 21

Although traditionally attributed to both Fra Bartolommeo and Daniele da Volterra (according to inscriptions on the former backing), the drawing was offered for sale as 'Florentine School' when it appeared at Christie's, London, in 1952. After its acquisition by the Museum, Pouncey argued for Daniele's authorship, comparing the figures with those in Daniele's painting of the *Virgin and Child with the Infant Baptist* in the Casa Ricciarelli, Volterra (Venturi, 1901–39, ix, no. 6, fig. 150), in which the Virgin similarly holds a scroll. The drawing may be dated about 1545.

After moving to Rome, Daniele was influenced first by Perino del Vaga (1501–47) and then by Michelangelo, whose follower he became. The monumental forms seen in this drawing reflect the sculptor's influence.

67 Raphael (1483–1520), *Study for the 'Phrygian Sibyl'*

Red chalk over preliminary drawing with the stylus; 262 × 167mm

British Museum (1953–10–10–1)

Provenance: J. Richardson sen. (L 2183); Dukes of Rutland; Wildenstein; H. M. Calmann

Literature: Popham, 1954, p. 10; Pouncey and Gere, 1962, no. 36

The drawing passed in about 1906–7 from the 8th Duke of Rutland to the dealers Wildenstein, London, and remained in their possession until its appearance at an exhibition on their premises in 1953. It was bought by H. M. Calmann, then a leading dealer in Old Master drawings in London (for whom see also cat. no. 73), who in turn sold it to the Museum. The acquisition of this study, and also, for example, cat. nos 73, 75, 77 and 80, indicates that the Museum was a successful contender for some of the most important drawings on the market in the 1950s and 1960s. The decision to acquire this one would have been made by the Trustees, acting on a request from Popham supported by Pouncey.

The study closely corresponds with the painted figure of the Sibyl on the right of the arch in the Chigi Chapel in S. Maria della Pace, Rome, decorated by Raphael about 1511–12 for the banker Agostino Chigi. It is an excellent example of the painter's finished studies in red chalk from the beginning of his later Roman period.

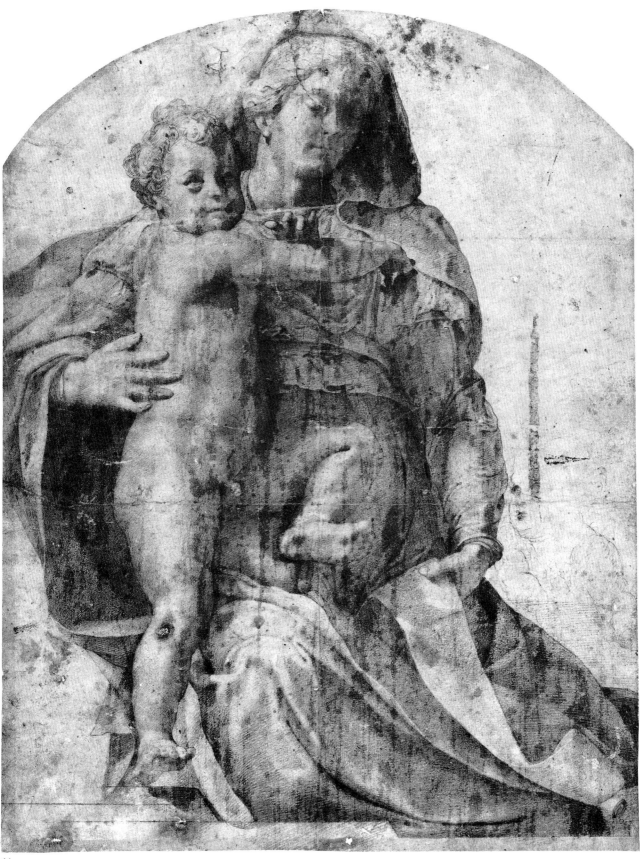

66

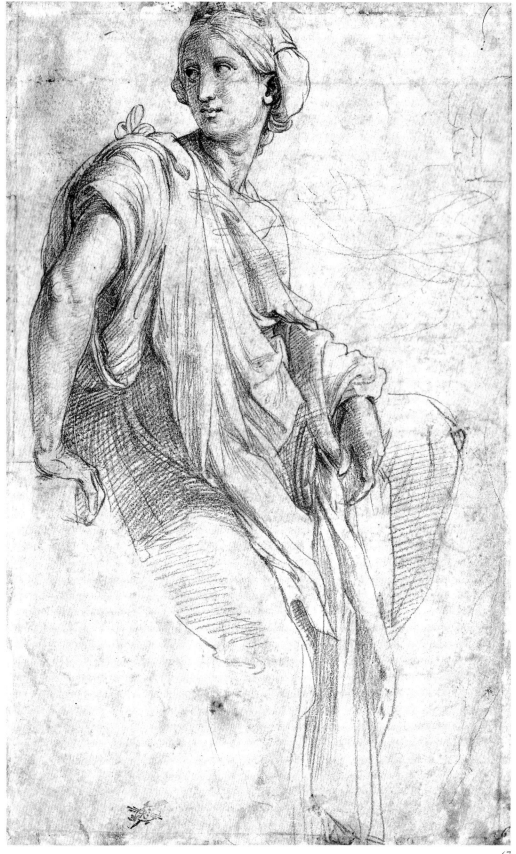

67

68 Domenico Beccafumi (1486–1551), *Head of a Bearded Man*

Brush drawing in tempera, the principal outlines indented; 203 × 146mm

British Museum (1953–12–12–3)

Provenance: H. S. Reitlinger

Literature: Sanminiatelli, 1955, pp. 35 ff.

This and cat. no. 69 belong to a group of nine tempera sketches by Beccafumi formerly in the collection of H. S. (Scipio) Reitlinger; the group is discussed by Sanminiatelli (1955). The head of the bearded man appears to be a study for the soldier on the extreme right in the *Sacrifice of Codrus, King of Athens*, one of the scenes painted on the ceiling of the Sala del Concistoro in the Palazzo Pubblico, Siena, which Beccafumi decorated in 1529–35.

Perhaps more than most areas of collecting covered by the British Museum, Old Master drawings are subject to the vagaries of the market, which, for more than three centuries, has been dominated by auction sales (a trend that seems set to continue, though at a slower rate as supplies dwindle). Such auctions are held intermittently as owners die and as collections are sold off, rather than passing by inheritance to the succeeding generation. When such sales occur, it is the task of a museum curator to decide, given the means at his or her disposal, which lots represent the most desirable additions to the collection.

Among the more important sales of Old Master drawings to take place in London soon after the Second World War was the sale at Sotheby's on 9 December 1953 of the collection formed by H. S. Reitlinger (1882–1950), the author of a short handbook for amateurs on collecting Old Master drawings (1922). A selection of proposed purchases was made jointly by Popham, who was to retire just three months later, and Pouncey and submitted to the Trustees for approval, with the result that nine important sheets were secured by the Museum. Among them were Correggio's *Cupid Bound* (Popham, 1967, no. 6), one of the more distinguished lots in the sale, two tempera sketches on paper by Beccafumi (the present drawing and cat. no. 69) and a sketch by Franco (cat. no. 70).

Only the year before, the Trustees had bought the splendid drawing by Beccafumi of *Damon Pithagorius and Lucius Brutus* (1952–4–5–8a), another study for the decoration of the Sala del Concistoro ceiling. It was purchased with several other drawings from the collection of Richard Gatty of Pepper Arden Hall, Northallerton, which Popham had visited some years previously.

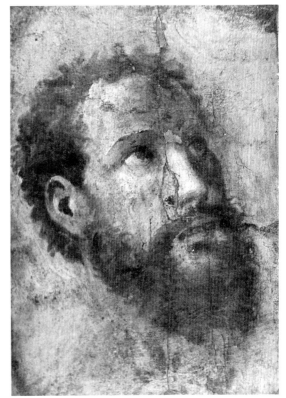

68

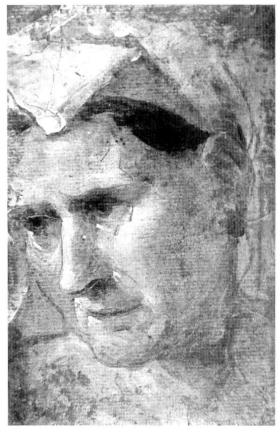

69

69 Domenico Beccafumi (1486–1551), *Head of a Woman*

Brush drawing in tempera, the principal outlines indented; 195 × 131mm

British Museum (1953–12–12–4)

Provenance: H. S. Reitlinger

Literature: Sanminiatelli, 1955, pp. 35ff. and fig. 9

This belongs to the same group of tempera sketches as cat. no. 68 and is also a study for the ceiling of the Sala del Concistoro. The woman's head is that of one of the witnesses, upper right, in the scene of the *Sacrifice of Seleucus, King of Locri*.

70 Battista Franco (1510–61), *The Gods on Olympus*

Pen and brown ink with brown wash, heightened with white, on pinkish-brown tinted paper; 118 × 135mm

British Museum (1953–12–12–6)

Provenance: E. Jabach (L 2122c); H. S. Reitlinger (L 2274a)

Literature: Gere and Pouncey, 1983, no. 147

This drawing was lot 46 in the Reitlinger sale, for which see under cat. no. 68.

A fine example of Franco's finished, compositonal draw-ings in pen and wash, the handling of which seems the more elegant on this smaller than usual scale. Another drawing of the same composition, similarly from Jabach's collection and almost the same size, is in the Louvre.

For another drawing by Franco, see cat. no. 28.

71 Jacopo Zucchi (*c*.1540–*c*.1596), *Aesculapius*

Pen and brown ink with brown wash over black chalk; 336 × 226mm

British Museum (1953–12–12–10)

Provenance: W. Y. Ottley; Sir T. Lawrence (L 2445); Sir J. Knowles; H. M. Calmann

Literature: Pillsbury, 1974, p. 4; London, 1986, no. 151

The attribution to Zucchi goes back at least as far as William Young Ottley (1771–1836), whose old mount is inscribed: *Jacopo del Zucca, Pitt. Fiorentino*. Zucchi's work as a draughts-man is scarce, and this is a particularly good example. Moreover, before its purchase there was only one other drawing in the collection unquestionably by him, and it is very different in character. The subject is an allegory of medicine, showing Aesculapius seated prominently in the foreground holding a staff and surrounded by figures. Pillsbury has suggested that the drawing could be related to a

70

71

72

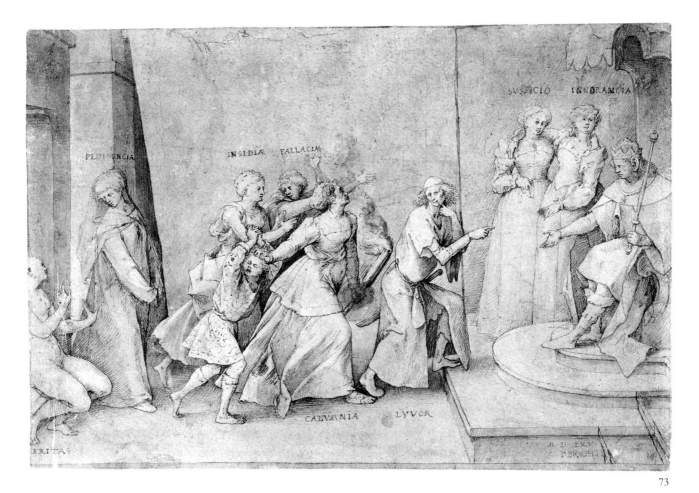

73

commission for some 'signori medici' at Pisa, on which Zucchi's master Giorgio Vasari (1511–74) was engaged shortly after 1560, but its exact purpose remains unknown.

Zucchi worked closely alongside Vasari on several projects, including the decoration of the ceiling of the Salone dei Cinquecento in the Palazzo Vecchio, Florence.

72 Giulio Campi (1502–72), *Arms of Pope Paul III (Farnese) with a Female Personification of the City of Piacenza*

Brush drawing in brown wash, heightened with white; squared in black and red chalk; 315 × 255 mm

British Museum (1954-3-15-1)

Provenance: Presented by the Committee of the Vasari Society

Literature: Bora, 1976, p. 53

The subject of this drawing – a seated woman personifying the city of Piacenza (identified by the shield on which she rests her left arm), beside the coat-of-arms of Paul III – suggests that it may have been a design for a temporary decoration on the occasion of the investiture by the Pope in 1545 of his son Pierluigi Farnese as Duke of Parma and Piacenza.

Bora suggests that the drawing alludes to the meeting in 1543 between Paul III and Emperor Charles V at Busseto, but neither the coat-of-arms of the Emperor nor that of the town of Busseto appears in the drawing.

Giulio Campi, one of a family of painters from Cremona, was first influenced by Romanino (1484/7 – after 1559) and Pordenone and is also said to have worked with Giulio Romano (c.1499–1546) in Mantua in the 1540s. His career was largely spent in Cremona. He was also among Pouncey's favourite artists, and it is not surprising that Pouncey should have picked out this attractive and highly typical example of his work.

73 Pieter Bruegel the Elder (c.1525–69), *The Calumny of Apelles*

Pen and brown ink; 204 × 307 mm

British Museum (1959-2-14-1)

Literature: White, 1959, pp. 336–41; Berlin, 1975, no. 98

Of all Pouncey's discoveries purchased by the Museum, this is among the most important: Bruegel's greatness and the rarity of his drawings were themselves enough to make it

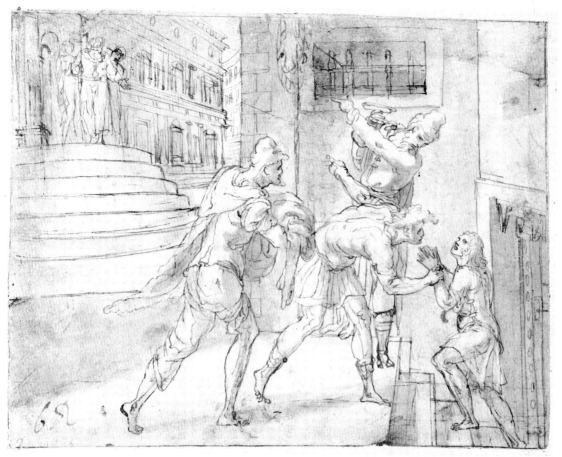

74

noteworthy, but the fact that it had been turned up by a specialist in Italian art gave extra lustre to the find. Pouncey had spotted the sheet at Sotheby's in a miscellaneous parcel of drawings (sale of 21 January 1959, lot 2). The auctioneers had overlooked its importance, in spite of the faint signature in pen in the bottom right corner. Colnaghi's, the Department's 'normal agents', were informed and agreed to secure the lot at the sale. Unfortunately, the drawing had also been recognised by the London dealer Hans Calmann (for whom see also cat. nos 67 and 71), with the result that Colnaghi bought the lot for the then high price of £1,750. The drawing was then immediately sold to the Museum for £1,925, that is the bid price plus 10 per cent (the standard commission).

The subject is based on Lucian and is the only known example of a drawing by Bruegel with a Classical subject. Karel van Mander, in his *Schilderboek* of 1604, mentions a painting of the *Triumph of Truth* which Bruegel had considered his best work, and it is possible that the present study may be connected with this lost composition. The subject was often depicted in Italy but rarely in Northern art, and it is conceivable that Bruegel may have known Girolamo Mocetto's engraving after Mantegna's drawing in the British Museum (Popham and Pouncey, 1950, no. 158).

74 Pellegrino Tibaldi (1527/8–96), *Joseph Released from Prison*

Pen and brown wash over black chalk; 159 × 204mm

British Museum (1954-2-19-8)

Provenance: I. R. Fleming-Williams

Literature: Gere and Pouncey, 1983, no. 273

Pouncey's attribution to Tibaldi, based on comparison with such paintings as the *Visitation* in the Palazzo Ducale, Urbino (Briganti, 1945, fig. 149) and the *Decollation of the Baptist* in the Brera, Milan (Briganti, 1945, fig. 148), was confirmed by David McTavish's observation that this is a preparatory study for one of the ten frescoes in Tibaldi's cycle illustrating the *Story of Joseph*, formerly in the Palazzo Ferretti in Ancona and now detached and in a private collection in Switzerland. Tibaldi's activity in Ancona is documented over the period 1554–61, the approximate date of the two pictures cited by Pouncey in support of his attribution.

For another drawing by Tibaldi, see cat. no. 32.

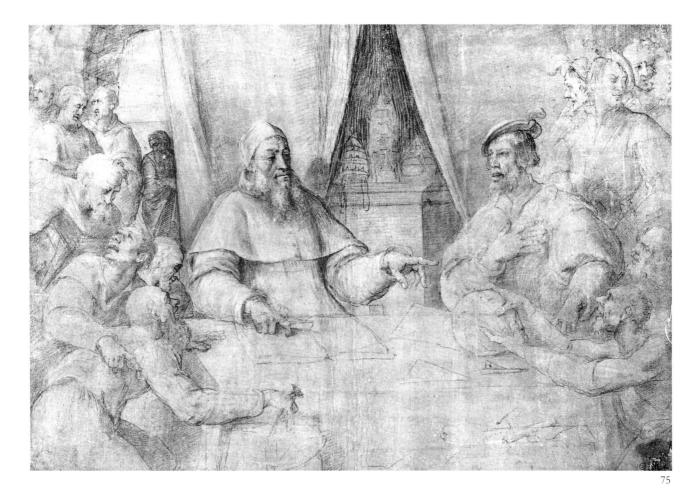

75

75 Sebastiano del Piombo (*c*.1485–1547), *Clement VII in Conference with Charles V*

Black and white chalk on grey-washed paper; 310 × 462mm

British Museum (1955–2–12–1)

Provenance: A. C. Poggi (L 617); Prince N. Esterházy (L 1965: with initials and coronet erased and substituted by *SR* in ink, apparently in an ill-judged attempt to imitate the collector's mark of Sir J. Reynolds (L 2364)). The drawing was probably stolen from the Esterházy collection in 1855 by its then curator, Joseph Altenkopf; L. Goldschmidt; presented by the National Art Collections Fund (Campbell Dodgson Fund)

Literature: Pouncey and Gere, 1962, no. 279; Hirst, 1981, p. 108

The acquisition of this important drawing was a triumph for which Pouncey was wholly responsible (Popham having retired the previous year). It was offered to the Museum in 1955 by the New York dealer Lucien Goldschmidt for what today seems the absurdly low price of $550, or £192. The composition had hitherto been known from a competent (studio?) copy in the Louvre (inv. no. 5062).

Edward Croft-Murray, the new Keeper, submitted the drawing to the Trustees together with a photograph of the Louvre version:

Mr. Pouncey states that several portraits of Clement VII by Sebastiano are known, but no pictures of this subject; nor is there any reference to such a picture in the source books. There is however a fragmentary version in the Louvre. . . . Whenever Mr. Pouncey has seen the Louvre drawing during the last four or five years, he has been disappointed by its quality and doubted whether it could be from the artist's own hand. Even in a small photograph one can detect in it a lack of intelligence as well as a certain hardness and meagreness which contrast unfavourably with the present drawing. It will probably be enough to compare the drawing of the Pope's head in the two versions: not only is the characterisation greatly superior in the present drawing, but the rendering of such features as the mouth and beard, much subtler.

The drawing, which represents Pope Clement VII in conference with the Emperor Charles V, with a number of personages in attendance, some of whom take an animated part in the discussion, is likely to date from soon after their meeting and reconciliation in Bologna in the winter of 1529–30.

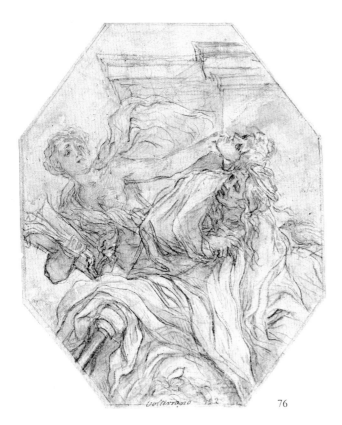

76

76 Baldassare Franceschini, called Volterrano (1611–89), *Truth Unmasking Falsehood*

Black chalk with grey wash, heightened with white (oxidised); 313 × 175 mm (octagonal)

British Museum (1955–5–2–1)

Provenance: C. R. Rudolf, by whom presented

Literature: Turner, 1980, no. 53

Pouncey's interest in the Italian seventeenth century is reflected by the acquisition of this drawing and cat. no. 64, both of which he encouraged C. R. Rudolf to present to the Museum, and of cat. no. 79.

Volterrano was one of the leading painters of the Florentine High Baroque. In the Departmental register the drawing is simply referred to as an 'allegorical subject', which implies that when acquired its purpose was unknown. It is in fact a study for *Truth Unmasking Falsehood*, one of the five scenes glorifying Vittoria della Rovere, wife of Ferdinando II de' Medici, which decorate the ceiling of the Sala delle Allegorie in the Palazzo Pitti, Florence.

Pouncey recognised another drawing by Volterrano, formerly in the collection of Niccolò Gabburri and acquired by the Museum in 1938, as a study for the *Martyrdom of St Lucy* in S. Paolino, Florence (Turner, 1980, no. 54).

77 Lorenzo Lotto ((?)1480–1556/7), *St Mathias*

Black chalk, heightened with white, on blue paper, squared for transfer in black chalk; 407 × 283 mm

British Museum (1958–12–13–2)

Provenance: J. Skippe; his descendants, the Martin family, including Mrs Rayner-Wood (d. 1955); E. Holland-Martin; presented jointly by the National Art Collections Fund and the Holland-Martin family

Literature: Popham, 1938, p. 49; Pouncey, 1965, p. 17, n. 21

The drawing, inscribed across the bottom *[L]orenzo Lot[to] l'opera è in Ancona*, is one of a group of five purchased by the Museum at the sale of the collection formed towards the end of the eighteenth century by the amateur artist John Skippe (Christie's, 20–21 November 1958) – one of the most important sales of Old Master drawings to have taken place in London since the end of the last war. The sale catalogue was compiled by Popham, who knew the collection well and who had retired from the Museum in 1954.

It is not surprising that Pouncey and Gere should have included this magnificent drawing in their choice; it had been first published by Popham (1938) and was by an artist whose work appealed strongly both to him and to Pouncey (see also cat. no. 59). As the inscription indicates, it is a study for the altarpiece of the *Virgin and Child Enthroned with Saints,* probably painted in 1546 and now in the Pinacoteca at Ancona, in which the figure of St Mathias appears, with St Lawrence, in the right foreground. Writing of the drawing in 1965, Pouncey reiterated Popham's observation about the Germanic flavour of the drawing, which invites comparison with the work of such artists as Matthias Grünewald (*c.*1470/80–1528).

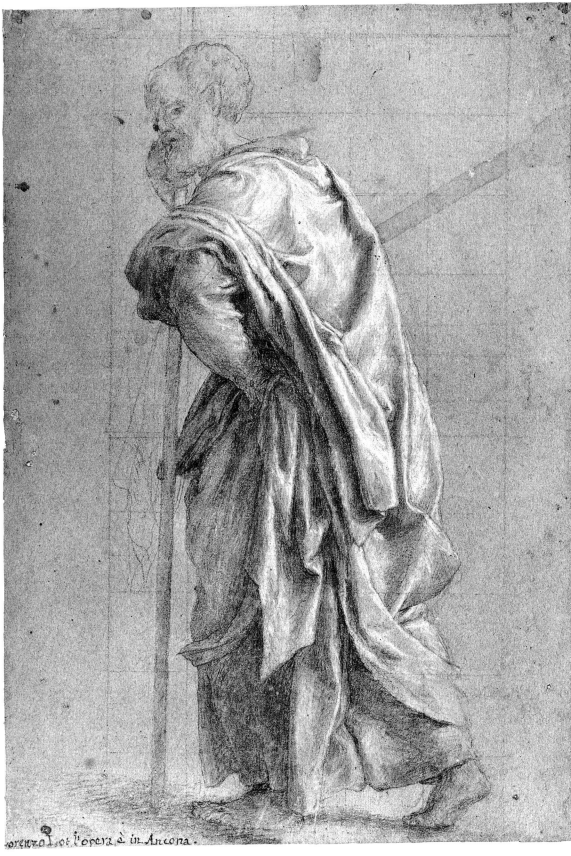

orenzo Lot et l'opera è in Ancona.

77

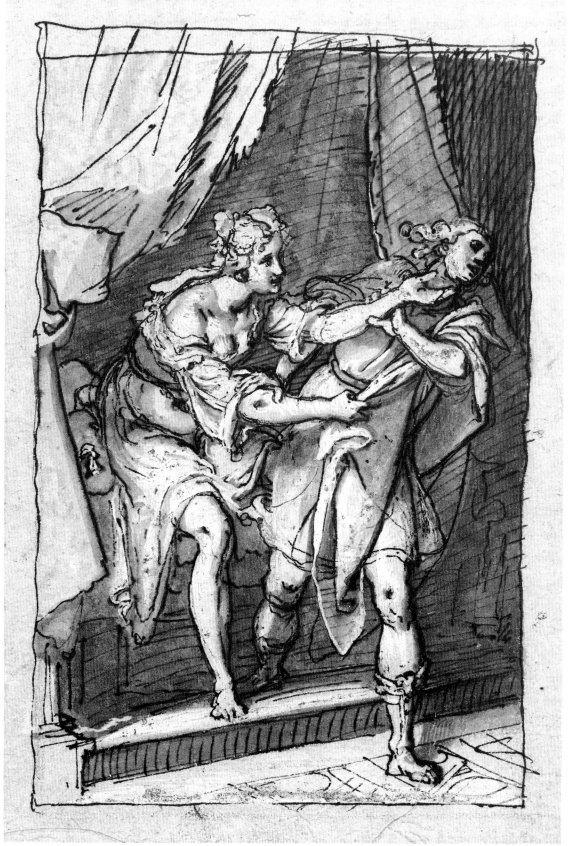

78

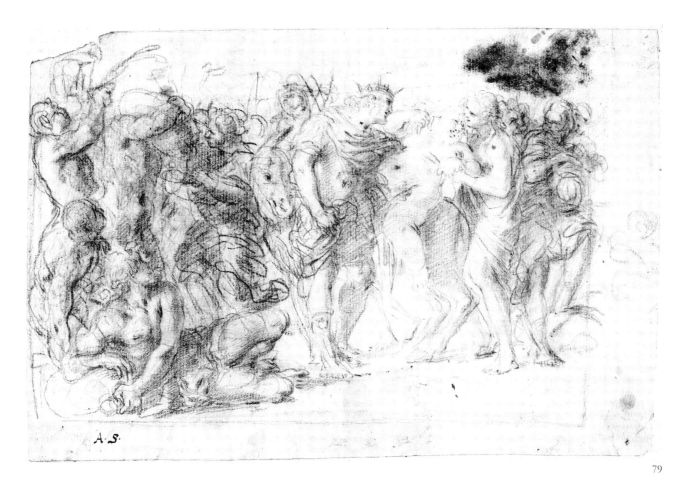

79

78 Ludovico Cardi, called Cigoli (1559–1613), *Joseph and Potiphar's Wife*

Pen and brown ink and blue wash, heightened with white; 272 × 188mm

British Museum (1963–5–18–5)

Provenance: Folio Society, from whom purchased

Literature: London, 1986, no. 201; Florence, 1992, p. 176

Cigoli was the leading painter in Florence at the end of the sixteenth century and one of the city's first exponents of the Early Baroque style. He had not been well represented in the collection, and Pouncey's purchase of this splendid example of his work, in pristine condition, helped to fill the gap. The composition corresponds, in reverse and with many differences, with that of the painting, dated 1610, in the Galleria Borghese, Rome.

For another drawing by Cigoli, see cat. no. 50.

79 Andrea Sacchi ((?)c.1599–1661), *Bacchic Procession, with Midas and Bacchus Supporting Silenus on a Donkey*

Red chalk, with some stumping; 169 × 256mm

British Museum (1963–11–9–26)

Provenance: Broke Hall

Literature: Harris, 1977, pp. 4 and 53

This drawing was included in a collection of seventeenth-century Roman drawings by Sacchi, Pier Francesco Mola (1612–66), Carlo Maratti (1625–1713) and others, contained in an album bought by the Museum at Pouncey's instance at Sotheby's on 10 July 1963 (lot 184). The album, which was described in the catalogue as 'containing seventy-five drawings, mostly copies in red chalk after the Antique, Michelangelo and Raphael ...' and which bears the title *Chalks* on the spine, came, according to an old inscription, from Broke Hall in Suffolk. The four drawings by Sacchi, the two by Mola and the two by Maratti are important additions to the Museum's representation of these artists.

Ann Sutherland Harris was the first to point out that this drawing corresponds with Bellori's description of the rectangular painting above the entrance to the now destroyed

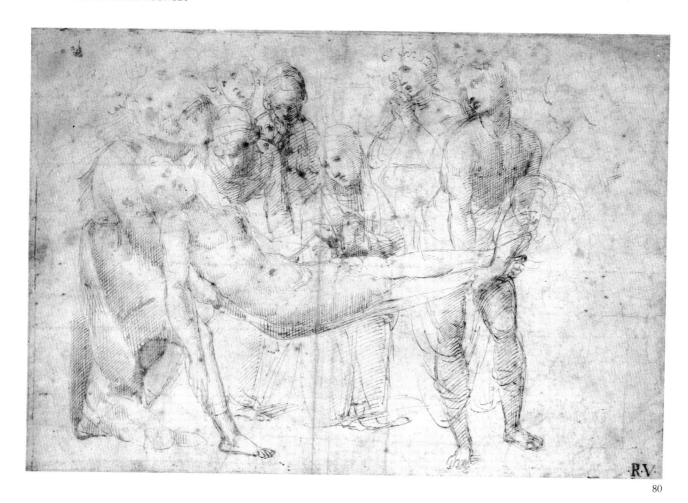

80

summer house of Cardinal del Monte, which stood on the banks of the Tiber, near the Ripetta, in the garden of the Cardinal's villa and was decorated by the young Sacchi about 1622–4 (or possibly earlier, about 1617–19). The composition was clearly inspired by Annibale Carracci's famous fresco *The Triumph of Bacchus*, on the ceiling of the Gallery of the Palazzo Farnese.

In seventeenth-century Rome Sacchi's Baroque Classicism competed with the exuberant High Baroque of his rival Pietro da Cortona (1596–1669).

80 Raphael (1483–1520), *The Entombment*

Pen and brown ink; 213 × 320mm

British Museum (1963-12-16-1)

Provenance: Antaldi (L 2245); P. Crozat; M. Nourri; J. A. Julien de Parme; G. Hibbert; S. Rogers; T. Birchall; R. R. Rothwell; Major F. R. Rothwell

Literature: London, 1983, no. 77; Gere and Pouncey, 1983, no. 361

Though this study by Raphael for his *Entombment of Christ*, dated 1507 (Galleria Borghese, Rome), was well known from

an eighteenth-century facsimile engraving, the drawing itself had been lost for nearly a century when it unexpectedly surfaced in the London saleroom in 1963. Not unnaturally, it aroused much interest; Jacob Bean, recently appointed Curator of the Department of Drawings at the Metropolitan Museum of Art, New York, was most anxious to secure it, and at Sotheby's sale of 21 October 1963 it was knocked down to Messrs Colnaghi, acting for the Metropolitan Museum, for the then huge sum of £27,000. Pouncey, however, felt that it would 'make better sense' for the drawing to be kept in the British Museum, which already owned three studies by Raphael for the same painting. Having persuaded Edward Croft-Murray, the Keeper, to recommend to the Board of Trade that an export licence should not be granted, he argued the case before the Reviewing Committee as the Expert of Works of Art with such eloquence that the objection was upheld.

This result was a great disappointment to Bean. As Pouncey wrote to his friend Keith Andrews, Keeper of the Department of Drawings at the National Gallery of Scotland, 'My name is mud . . . in New York because I stopped the export of the Raphael Entombment drawing: successfully it would seem. Final confirmation of our acquisition of the

drawing has not come through yet, though' (letter of 25 November 1963). That there was indeed some chilliness between Pouncey and Bean is clear from their correspondence at this period (still preserved in the Department), but it soon dissolved and their letters returned to their normal affable style (see cat. no. 111). Since the Chatsworth sales of 1984 and 1987 drawings are stopped from leaving the country on a fairly regular basis. In most cases export licences are eventually granted, because British museums are only rarely able to raise sufficient funds to purchase the drawings.

81 Niccolò Giolfino (*c.*1476–1555), *St Sebastian*

Brush drawing in brown wash and white bodycolour on blue paper, squared in brown ink; 263 × 195mm

British Museum (1965–10–9–4)

Provenance: F. Calzolari; L. Moscardo; L. Grassi; Messrs Faerber & Maison

The drawing bore no attribution when acquired; the Veronese painter Niccolò Giolfino was suggested by Pouncey, and, much to his satisfaction, the attribution was confirmed by the subsequent discovery of a photograph of the drawing as originally mounted on a page from the so-called 'second Moscardo Album' with the old inscription *de m.o nicola d*

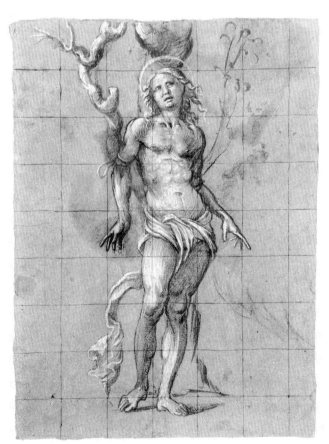

81

julfinj. Old mounts are part of the history of drawings; but in the past restorers, commercial frame-makers and mount-cutters, and even some curators with an austere disapproval of 'prettification', have thought nothing of discarding them.

Niccolò Giolfino is probably the best-known member of a dynasty of Veronese painters, sculptors and engravers, and the only one to devote himself entirely to painting. He was much influenced by his fellow-townsman Liberale da Verona.

2(v) Engraved and photographic reproductions of Italian drawings and the Gernsheim 'Corpus Photographicum' (cat. nos 82–7)

Pouncey made much use of the Department's large collection of reproductions of drawings, both engraved facsimiles and, from about the middle of the nineteenth century, photographs. With their assistance he made many identifications. These reproductions are mostly of three distinct sorts: eighteenth- and early nineteenth-century volumes of engraved facsimiles (cat. nos 82–3); prints and photographs housed loose in solander boxes (cat. nos 84–5); and the photographs in the 'Corpus Photographicum' founded by Dr Walter Gernsheim in 1936, to which the Department has always subscribed (see cat. nos 86–7).

The large collection of photographs in the second category began to be assembled from the mid-nineteenth century for the use of the curatorial staff writing catalogues. The Gernsheim Corpus is a more systematic record of other collections, and is in constant use. It is mounted uniformly and kept separately from the main series of reproductions of drawings.

82 Copy of Charles Rogers, *A Collection of Prints in Imitation of Drawings, to which are annexed lives of their authors with explanatory and critical notes*, 2 vols, 1778, showing a facsimile engraving of a drawing attributed to Correggio

British Museum

As his annotation shows, Pouncey recognised that this drawing, now lost but once in the collection of Rogers himself, who believed it to be by Correggio (for whom see cat. no. 43), is in fact by Correggio's later Baroque follower and fellow Parmesan Giovanni Lanfranco (1582–1647). The attribution was independently confirmed by Erich Schleier's observation that it is a study for a detail of Lanfranco's cupola decoration in S. Andrea della Valle, Rome, painted in 1625–7 (Florence, 1983, pp. 121f.).

82

83 Copy of Conrad-Martin Metz, *Imitations of Drawings in English Collections*, 1798, showing facsimile engravings after two drawings attributed to Giulio Romano

British Museum

The bottom engraving is of a (now lost) drawing of a *Youth Mauled by a Dog and a Bear*, then in the collection of Richard Cosway and believed to be by Giulio Romano. In 1959 Pouncey noted that an original drawing of the same composition by Polidoro da Caravaggio (for whom see cat. no. 25) was in the Louvre (Paris, 1983–4, no. 128). The implication of this observation was twofold: firstly, that the composition was Polidoro's rather than Giulio Romano's, and, secondly, that the ex-Cosway drawing might have been a copy. Another drawing by Polidoro, with studies on the *verso* for the central group in this same composition, is in the British Museum (Pouncey and Gere, 1962, no. 217). The subject is still unidentified; Metz is clearly mistaken in calling it the *Death of Adonis*.

84 Folder of photographs and engravings of drawings by or attributed to Bernardino Barbatelli, called Poccetti (1548–1612)

British Museum

This is one of the folders from the Department's large collection of photographs and facsimile engravings of Old Master drawings. At the top is a late nineteenth-century photograph of a drawing in the Uffizi, inscribed in pen with the name of Daniele da Volterra (for whom see cat. no. 66). The photograph was originally placed under Daniele's name, but Popham, having noted the connection with a drawing by Poccetti then in the Phillipps-Fenwick collection (for which see cat. no. 85), transferred the photograph to the Poccetti wrapper. In another note, Pouncey went on to point out that the Uffizi drawing (and thus, by implication, the other drawing) was a study for Poccetti's *Christ Carrying the Cross* in the Museo Comunale at Arezzo (for which see also cat. no. 85).

Pouncey studied the series of reproductions of Old Master drawings with great thoroughness, and his pencil anno-

tations are frequently to be found. The photographs had been mostly collected in the late nineteenth century to help Departmental staff in cataloguing the collection, while the prints mainly came from eighteenth- and nineteenth-century volumes of reproductions of Old Master drawings such as cat. nos 82–3.

For Poccetti, see cat. no. 85.

85 Bernardino Barbatelli, called Poccetti (1548–1612), *Study for the Drapery of a Reclining Figure*

Black chalk, heightened with white, on paper washed light brown; 355 × 250mm

British Museum (1946-7-13-455)

Provenance: Sir T. Lawrence (L 2445); S. Woodburn; Phillipps-Fenwick; presented anonymously

Literature: Popham, 1935, p. 81 (as Poccetti); London, 1986, no. 188

As Pouncey observed (see cat. no. 84), this and the related drawing in the Uffizi are studies for Poccetti's *Christ Carrying the Cross* in the Museo Comunale at Arezzo, an early work datable about 1584. The technique is reminiscent of that seen

85

in drapery studies by Florentine High Renaissance painters such as Leonardo da Vinci, Fra Bartolommeo and others.

Poccetti was one of a circle of artists in Florence at the end of the sixteenth century whose naturalistic style reflected a reaction against the then prevailing style of Mannerism.

86 Eight mounted Gernsheim photographs of Italian Old Master drawings, including annotations in Pouncey's hand

British Museum

The Gernsheim photographs are kept separately from the series of reproductions of drawings discussed under cat.no.84. As Griffiths and Williams have written (1987, p. 119), 'The "Corpus Photographicum" of drawings was founded by Dr Walter Gernsheim in 1936. The principle was that his photographic team would visit both public and private collections of old master drawings around the world, and distribute the photographs to subscribers. . . . The photographs have all been dry-mounted on to cards, and arranged in boxes alphabetically by artist within schools.'

Gere's diary (see cat. no. 19) reveals that much time was spent sorting and placing the Gernsheim photographs. Because they arrived in batches by collections, rearranging them by artist required the attribution of each drawing to be carefully considered before the photograph was put away, since the reliability of the attributions varied widely from collection to collection. The exercise was invaluable, not only in itself but also because it made it possible to study at leisure and in their entirety collections that had either never been visited, or had been only partly glimpsed. Pouncey made many changes of attribution, especially where photographs came into the collection between 1945 and 1965. Like his annotations to the reproductions, they are another of his hidden contributions to the study of Italian drawings.

The set of Gernsheim photographs in the Department, which is the only complete run in the British Isles, now numbers over 140,000.

87 One of the volumes of the lists of Gernsheim photographs, annotated with new attributions

British Museum

Each batch of Gernsheim photographs is accompanied by a typed sheet giving particulars of the inventory number of each drawing, its dimensions and medium, all of which are transcribed on to the mounts of the photographs. The lists are mounted in volumes and annotated with any new attributions, under which the photographs are placed. This volume shows new attributions written in the hands of both Pouncey and Gere.

3 Sotheby's, 1966–1983

(cat. nos 88–99)

Pouncey's decision to leave the British Museum to pursue a career in commerce occasioned much soul-searching and was perhaps the most momentous one of his life (see cat. no. 88). Popham's disapproval was veiled only thinly (see cat. no. 89), while other reactions were mixed (see cat. nos 90–91). The then chairman of Sotheby's, Peter Wilson (1913–84), and Carmen Gronau, then in charge of the Old Master paintings and drawings, seem to have been behind the decision to invite Pouncey to join the company. It was plain that some-one with so remarkable an 'eye' would be an invaluable asset to any auction-house at a time when issues of authenticity and authorship were becoming increasingly important.

Pouncey's Sotheby's diary for 1975 (see cat. no. 92) shows how his time was spent. During his years there – he resigned his directorship in 1983 but continued to work as a con-sultant until shortly before his death – the flow of attributions continued unabated. Cat. nos 94–7 and 99 are drawings that he successfully identified on the London art market and which were subsequently purchased by the British Museum. Despite his work at Sotheby's, he regularly came into the Museum in order to finish, with Gere, the catalogue of draw-ings by artists active in Rome from *c.*1550 to *c.*1640 (see cat. nos 18 and 28–33); and he was always ready to advise on matters concerning the Italian drawings in the collection.

88 Draft of letter from Pouncey to A. E. Popham explaining his decision to join Sotheby's, written late in 1965

Private collection

The numerous corrections bear witness to Pouncey's diffi-culty in writing the letter.

Dear Hugh [the name by which Popham was known to his friends], I want to let you know before any general announcement is made that I have decided to accept a post [of/as part-time con-sultant at Sotheby's which seems to offer (deleted)] which offers me research facilities so generous that I [really don't feel able to turn it down/cannot ignore (deleted)] feel I am justified in taking the big and in many ways painful step of leaving the Museum. [After examining the question very carefully I find that (deleted)] The new job is at Sotheby's who want me to act as a part-time adviser and are prepared to do all sorts of things with the matter of travel, photographs, etc., to help me with my private work [research (deleted)].

I know you are extremely sceptical about my own writing anything, but the fact remains that I am planning, egged on by Myril and others, [to produce (deleted)] a [sort of (deleted)] book of samples of drawings by lesser known Italians working between 1500 and about 1600 with brief [short (deleted)] bio-graphies and even briefer bibliographies. ... By taking the

Sotheby's job I believe I should stand a much better chance of getting on with this. ...

Obviously I should not be cutting [myself (deleted)] adrift from the Museum completely. I cannot imagine that any week would pass without the need for visiting the Department & equally obviously I should always be available if needed by Gere.

I hope that on reflection you will see the advantages of what I am proposing to do. At least the promotion prospect of those working with me will be brightened! I don't want to make this long letter any longer but I do want to thank you, dear Hugh, for all the kindness & help you have lavished on me during and *before* my time at the Museum.

With affectionate ... wishes for Xmas & 1966 to you both.
PS I should have to leave on 31 March.

Pouncey's decision to leave the Museum and join Sotheby's has been admirably analysed by Gere (1991, p. 540). It was not motivated primarily by financial considerations, though they were a factor, but rather by a desire to 'get back to pictures'. He was also to some extent influenced by the consideration that his closeness in age to Popham's suc-cessor, Edward Croft-Murray, meant that he was unlikely ever to be head of his Department.

89 Letter to Pouncey from A. E. Popham

Private collection

Popham's letter of 22 December 1965 in reply to Pouncey's announcement of his decision to leave the Museum (drafted in cat. no. 88) was short and to the point, and did not conceal his disappointment: 'All I can say is I am sorry you have decided to do so and that your great abilities will no longer be devoted to putting the Italian drawings in the Print Room in order and cataloguing them, which you are so eminently qualified to do.' He went on to wish him well in his new post: 'I hope this job at Sotheby's will come up to your expectations and that you will succeed in producing the book of which you speak.'

90 Letter to Pouncey from Professor T. S. R. Boase (1898–1974)

Private collection

In this letter of 3 January 1966, Professor T. S. R. Boase, then a Trustee, and Chairman of the Departmental Sub-Committee, expresses the regret of the Trustees at Pouncey's decision to leave the Museum: 'This is of course a great blow to the Museum, for whose reputation in the world of learning you have done so much. ... I am always arguing on the Board that the Museum does not provide sufficient time and facilities for the researches of its staff.'

91 Letter to Pouncey from Professor Sydney J. Freedberg

Private collection

Pouncey received many letters once news of his imminent departure from the Museum had become generally known. This one, dated 4 January 1966, from Sydney Freedberg, then Professor of Fine Arts at Harvard University, expresses some of the mixed feelings caused by his decision: 'I do not know whether to be wholly pleased or a little sad that you have chosen to join Sotheby's. My only reservation is because this defeats the hope I did have that you might come to the United States, even if it would have been to the rival institution in New York [i.e. to the Institute of Fine Arts at New York University, where Pouncey once gave a course in the study of Italian drawings].'

92 Sotheby's diary for 1975, showing the page for 1 August

Private collection

Pouncey's principal engagement for the day was a visit to the art dealer David Carritt (1927–82) at his premises at 15 Duke Street, St James's, to inspect a drawing of *Judith and Holofernes* by Rosso Fiorentino (1494–1540) which was eventually bought by the Los Angeles County Museum (inv. no. M.77.13). (A note on the same page to Stanley Clark about the British Academy was probably informing Sotheby's press office about Pouncey's recent appointment as Fellow of the British Academy.)

Not surprisingly, Carritt took advantage of Pouncey's visit to show him a number of Italian pictures and drawings then in stock, including a Corrado Giaquinto; a predella ascribed to Lorenzo di Niccolò but, in Pouncey's view, perhaps from the studio of Niccolò di P[ietro] G[erini]; a predella by Giovanni di Paolo; a *Self-Portrait* by Bernini and other items.

Normally there were a number of such engagements in the day. The large appointment diaries (as opposed to the pocket diaries, for which see cat. no. 1) give a good picture of the work on which Pouncey was engaged while at Sotheby's, as well as the great number of his acquaintances.

93 One of Pouncey's letter books, kept while he was at Sotheby's, showing the pages for June 1980

Private collection

Pouncey methodically logged his extensive correspondence. Each letter was given a number, which was written in the left margin of the page, with the date in the narrow column immediately to the right. The name of the correspondent, in capital letters, was followed by a summary of the con-

tents of the letter and (always in red biro) of Pouncey's reply.

Entry no. 5710 consists mostly of a typewritten text about the importance of the *Burlington Magazine* that Pouncey had sent to Peregrine Pollen, then Deputy Chairman of Sotheby's, in connection with a fund-raising venture being undertaken by the magazine. For many years Pouncey had been a member of the magazine's Consultative Committee.

The letter received at no. 5711 concerned a picture, signed E. S. Hooper and apparently representing an East Anglian landscape, which belonged to the 'charlady' of Lady Laura Easthaugh (daughter of the 3rd Earl of Selborne) and which needed restoration. Pouncey wrote back to say that he had been 'unable to find any inf[ormation] in even [the] best dictionaries'. Eventually the picture was successfully cleaned.

94 Aurelio Lomi (1556–1662), *Studies of a Seated Figure*

Black chalk; 331 × 233mm

British Museum (1966-3-3-1)

Provenance: Presented by P. Pouncey

Literature: Ciardi, Galassi and Carofano, 1989, pp. 239–40, nos 55A and B; Turčić and Newcome, 1991, p. 41

Inscribed by the artist in black chalk with notes indicating minor changes in the pose of the figure.

Soon after his resignation from the Museum, Pouncey presented this drawing to the Department in commemoration of his twenty years of service. The drawing is one of a group of similar studies, all evidently by the same hand, which appeared on the London art market under the name of the Florentine painter Agostino Ciampelli. Pouncey's observation that one of the group is a study for a figure in Lomi's *Rest on the Flight into Egypt* in S. Francesco, Pistoia (Turčić and Newcome, 1991, p. 42, no. 19), enabled the artist to be properly understood as a draughtsman for the first time. The connection of the present drawing with Lomi's *Feast of King Ahasuerus*, formerly in the Baptistery of Pisa Cathedral and now in the Museo dell'Opera del Duomo, painted in 1617–18, was made by Carofano. The *recto* study is for the figure of the king seated on the right in the painting, while the studies of a youth with a vase on the *verso* are for one of the servants in the left foreground.

Lomi, who was the half-brother of Orazio Gentileschi, was active in, among other centres, Rome, Florence, Lucca and Genoa.

94

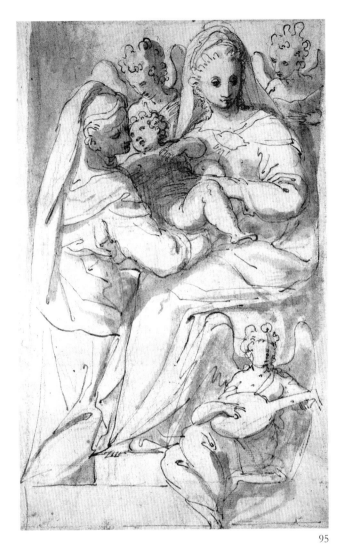

95

95 Bernardino India (1528–c.1590), *Madonna and Child with St Anne*

Pen and brown ink with light brown wash over black chalk; 239 × 147mm

British Museum (1972-5-13-1)

Literature: Verona, 1974, p. 82, no. 51

When this drawing turned up in a sale at Christie's, London, in 1971 (23 November, lot 39, as Samacchini), Pouncey recognised its relationship with the picture in the Cappella Pellegrini in S. Bernardino, Verona, painted in 1579 by the little-known Veronese artist Bernardino India. This typical Pouncey 'find' is another example of a minor artist being resuscitated as a draughtsman.

The drawing reveals a highly personal graphic style, a combination of elements derived from Veronese and Schiavone mingled with influences from such Central Italian Mannerists as Taddeo Zuccaro, who was working in Verona in 1552/3. Indeed, Pouncey's attribution to the young Zuccaro of a drawing of the *Virgin and Child* at Christ Church, Oxford, was accepted by Gere, who included it in his book on Zuccaro's drawings (Gere, 1969, pp. 184f., no. 161); but as India's artistic personality became better defined, it was clear that the drawing was in fact by him (Byam Shaw, 1976, no. 807).

Particularly characteristic of India's drawing style are the kitten-like faces of some of the figures and the affected curls of hair suggested by loops of the pen (see especially the angel at the top right). This distinctive style enabled many more drawings by this interesting figure to be identified.

India spent much of his career as a painter of fresco decorations, following the style of artists such as Giulio Romano and Parmigianino, in the palaces and villas built by local architects such as Sanmicheli and Palladio. At the end of his life, India was a successful painter of altarpieces in the new Counter-Reformation manner.

96 Giovanni Paolo Lomazzo (1538–1600), *Madonna and Child with Sts Peter, Paul and Augustine*

Black chalk on grey-green paper; 276 × 193mm

British Museum (1972-7-22-7)

Provenance: (?) Mrs I. Scharf

Literature: Bora, 1980, no. 22; Cambridge, 1985, no. 30

When this drawing was brought to Sotheby's for sale in 1972, Pouncey, by yet another extraordinary feat of memory, pointed out its connection with the altarpiece painted in 1571 by the Milanese artist Giovanni Paolo Lomazzo for the Cappella Foppa in S. Marco, Milan. The drawing was sold under this name on 8 June 1972, lot 242, and was bought by Miss Yvonne Tan Bunzl on behalf of the British Museum for £110.

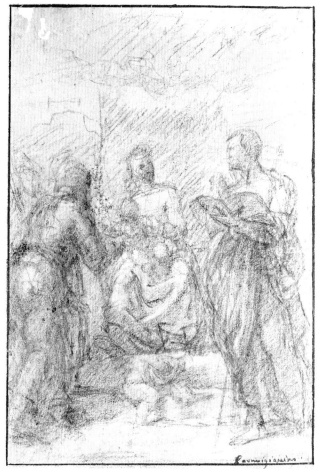

96

As a painter, Lomazzo was influenced both by the work of such local Milanese artists as Bramantino and Gaudenzio de' Ferrari and by the more up-to-date style of Pellegrino Tibaldi, who had arrived in the city in 1561. He went blind in his early thirties (soon after the S. Marco commission) and thereafter devoted himself to the study of art theory, publishing his *Trattato della pittura* in 1584. Because of the brevity of his career as a painter, drawings by him are rare.

97 Sebastiano del Piombo (*c*.1475–1547), *Virgin and Child*

Black chalk, heightened with white, on blue-grey paper (faded); 254 × 188mm

British Museum (1974–9–14–1)

Provenance: Mr Pryde; A. Delon; Y. Tan Bunzl

Literature: Gere, 1975, pp. 270–73; Hirst, 1981, p. 139; Gere and Pouncey, 1983, no. 379

This drawing was attributed to Sebastiano by Pouncey, who found it in an album of miscellaneous drawings sent for sale to Sotheby's, London, in 1974. The style suggests a dating

after about 1530, in the period of the artist's full maturity. The drawing is evidently a study for a complete composition in which the Virgin was to have been seen half-length behind a ledge, down on to which the Child is stepping.

For another drawing by Sebastiano, see cat. no. 75.

98 Francesco Mosca ((?) active at the end of the sixteenth century), *Christ Falling under the Cross*

Watercolour and bodycolour over black chalk with some pen and brown ink; 745 × 535mm

British Museum (1980–6–28–35)

Provenance: Mrs Arnott

Inscribed below in brown ink: *HIC IACET EXCEL-LENS OPUS AC OPERANTIS IMAGO IN QUA, SI VELLIS SCINDERE, NOMEN HABES*. According to this couplet, the composition includes a self-portrait of the artist, with a concealed reference to his name. The portrait is clearly the bearded half-length figure in the lower right corner, on whose right wrist a fly (*mosca*) is indicated. Mosca, who was from Lendinara, was active in Mantua. Details of his career remain confused, with many authorities stating that he lived at the end of the seventeenth century.

The drawing appeared in a sale of watercolours at Phillips, London, in May 1980, as 'Italian School', and was bought for the very modest price of £144.95. Soon afterwards it was shown to Pouncey, who immediately recalled having seen it some twenty years earlier (about 1960) at Mrs Arnott's, a dealer in Kensington. He had already identified it at that time as a reduced-size replica of an altarpiece painted by Mosca for the church of S. Bartolomeo in Rovigo and now in the Ducal Palace at Mantua. The elaborate nature of the conceit and the intelligence and quality of the drawing itself suggest that it is an autograph replica.

99 Giuseppe Caletti (*c*.1600–*c*.1660), '*Siamo set[t]e*' (*We are seven*)

Pen and brown ink with brown wash, over red chalk; 187 × 143mm

British Museum (1980–10–11–5)

Provenance: B. Charbonnier; Sir A. Alison

Literature: Turner, 1984, pp. 681ff.

The title is inscribed by the artist in ink on the banner. When the drawing was submitted for sale at Sotheby's in 1980 Pouncey recognised it as a finished study, in reverse and with some differences, for Caletti's popular etching entitled *Noi siamo sette*. Two impressions of the etching are placed under the artist's name at the British Museum. The print had not been reproduced anywhere in the literature, and to make the identification Pouncey relied on his memory of the Museum's

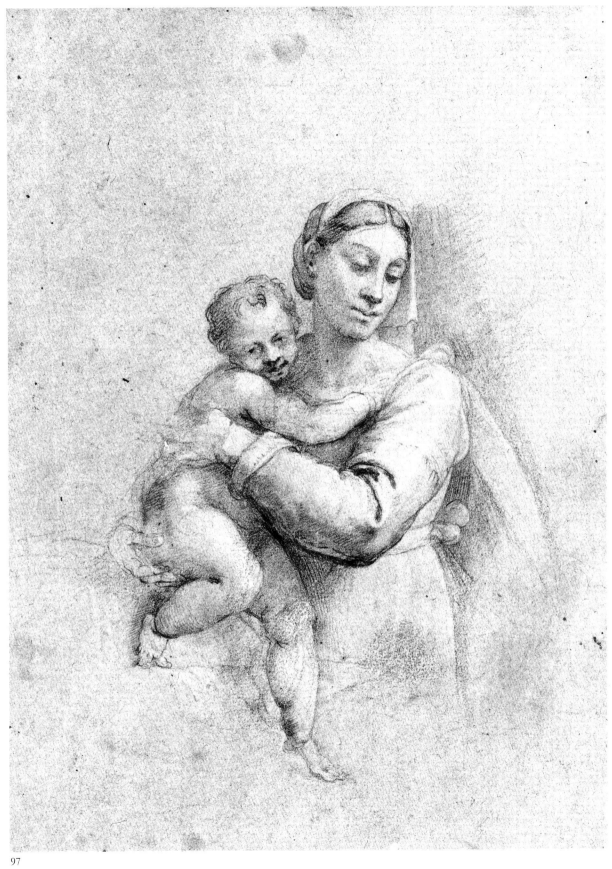

97

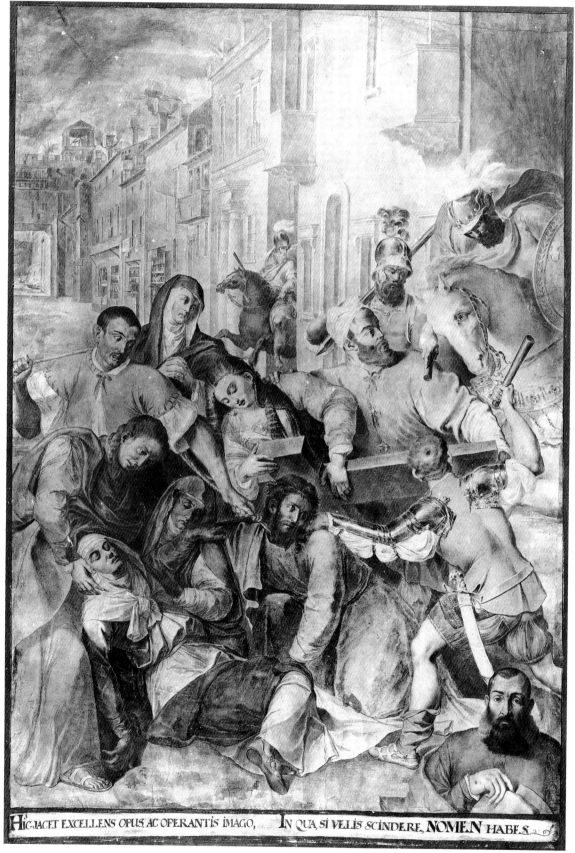

HIC JACET EXCELLENS OPUS AC OPERANTIS IMAGO, IN QUA, SI VELIS SCINDERE, NOMEN HABES.

98

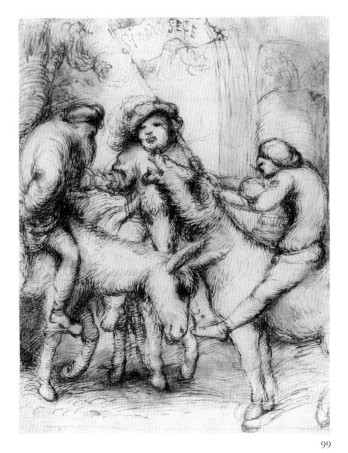

99

examples. The subject is a riddle: three peasants are mounted on three asses. The seventh (ass) is the spectator, who is exhorted in an inscription on the print to '*contate bene*' (count well).

Caletti was born in Ferrara. His early work reflects the Ferrarese tradition as exemplified by such painters as Dosso Dossi and Scarsellino, but his style later changed under the influence of the Bolognese painter Guercino. A mere handful of his drawings have survived, and only three studies for prints are known. This was the first drawing by Caletti to enter the collection.

4 The Fitzwilliam Museum, Cambridge, 1973–1990

(cat. nos 100–103)

Pouncey's association with the Fitzwilliam went back as far as 1931–3, when he worked there as a voluntary attaché (see cat. nos 8–9). In 1973 Professor Michael Jaffé, the then Director, offered him the position of Honorary Keeper of Italian Drawings, which he held until his death. In this capacity he advised first Duncan Robinson and then David Scrase on matters concerning the catalogue of the Italian drawings, now near completion under Scrase's charge. Journeys to and from the Pounceys' country cottage at Wenhaston in Suffolk were broken at Cambridge to allow further inspection of the collection or the examination of some new acquisition. The first exhibition held in Pouncey's honour took place at the Fitzwilliam (see cat. no. 100). The three drawings included in this section illustrate aspects of his work on the drawings there and his ties with the collection.

100 *The Achievement of a Connoisseur, Philip Pouncey*, catalogue to an exhibition of Italian Old Master drawings held at the Fitzwilliam Museum, Cambridge, in 1985, under the sponsorship of Sotheby's

British Museum

The exhibition *The Achievement of a Connoisseur*, held in Pouncey's honour in 1985, included sixty-two drawings by fifty-six artists from European collections, many of them British, which Pouncey had identified over the previous fifty years. Among these was a drawing by Leonardo da Vinci of a *Woman Washing a Child's Feet* from the Escola de Belas Artes, Oporto. Formerly placed as by Raffaellino da Reggio, it was attributed to Leonardo by Pouncey in 1965 from a photograph. (The drawing is no. 28 in the Fitzwilliam catalogue.)

The exhibition was organised by Julien Stock, then Head of the Department of Old Master drawings at Sotheby's, and David Scrase, Keeper of Pictures, Drawings and Prints at the Fitzwilliam, who jointly compiled the accompanying catalogue. It is an indication of the range of Pouncey's work that only eight drawings in the present exhibition were also included in the Cambridge exhibition (cat. nos 23, 25, 66, 96, 101, 122–3 and 137).

101 Bernardino Campi (1522–91), *The Raising of the Son of the Widow of Nain*

Pen and brown ink with brown wash, heightened with white, over black chalk on blue paper (faded); squared in black chalk; 247 × 167mm

Fitzwilliam Museum, Cambridge (PD. 2903)

Provenance: Earl of Aylesford (L 58); G. T. Clough

Literature: Cambridge, 1985, no. 9

Before Pouncey's correct attribution of this sheet in 1947, various suggestions as to its authorship had been made. Berenson gave it to the School of Titian; Ellis Waterhouse to a sixteenth-century Brescian painter active in Rome, Girolamo Muziano; and Otto Benesch to a North Italian hand, close to Lambert Sustris (a sixteenth-century Netherlandish painter active in Venice). The matter was settled by Pouncey's observation that this is a preparatory study for the fresco by Bernardino Campi, signed and dated 1589, on the wall of the presbytery of the church of S. Prospero, Reggio Emilia (Pirondini, 1982, p. 157, repr.), one of a pair of frescoes that were among the artist's last commissions.

Bernardino Campi, who was trained by Giulio Campi (though he was apparently not a relation), was one of the most prolific painters of the sixteenth-century Cremonese School. His style was strongly influenced by the Mannerist painters of Emilia, especially Parmigianino.

102

102 Giovanni Baglione (1571–1644), *An Episcopal Saint Appearing to a Roman Warrior during a Siege*

Pen and brown ink with brown wash over red chalk; 267 × 206mm

Fitzwilliam Museum, Cambridge (PD.263–1985)

Provenance: P. Pouncey, by whom presented

When offered for sale at Christie's in 1977 (6 July, lot 51), described as 'Roman School, 17th Century', Pouncey recognised the hand of the seventeenth-century Roman painter Giovanni Baglione, and bought the drawing for his own collection. He later presented it to the Fitzwilliam in commemoration of the exhibition held there in his honour in 1985 (see cat. no. 100). Two studies for the same composition are on another sheet recently on the London art market (sale, Christie's, 20 April 1993, lot 29). The Fitzwilliam drawing seems to have been executed later, since it includes elements from both alternative designs and is more carefully finished.

Baglione, who like Vasari was a biographer as well as a painter, is best known for his *Vite de' pittori, scultori et architetti . . . dal . . . 1572 infino . . . al 1642* and for his quarrel with Caravaggio, who claimed that he had imitated his style of painting. This resulted in a lawsuit between the two artists, in which Baglione accused Caravaggio of slander.

101

103 Francesco Menzocchi (1502–74), *The Holy Family with St John the Baptist and Putti*

Point of brush in brown wash, heightened with white, with some touches in pen and brown ink; 267 × 233mm

Fitzwilliam Museum, Cambridge (PD.39–1991)

Provenance: (?) Z. Sagredo; De Boissieu; P. Scarpa; presented by the Friends of the Fitzwilliam Museum

Literature: Scrase, 1991, pp. 773–6; Venice, 1992, no. 18

An old attribution to Parmigianino is inscribed in brown ink in the lower right. The correct authorship was first recognised by Stephen Pepper when the drawing appeared at Sotheby's (1 July 1991, lot 18), catalogued as 'Emilian School'. Pepper pointed out its correspondence with a painting by Menzocchi in the Bob Jones University Museum in Greenville, South Carolina (Pepper, 1984, p. 76, no. 76.1), which Pouncey had attributed to the artist many years earlier and which Pepper had recently catalogued, along with the rest of the Italian pictures in the museum. The drawing, which had been bought by Kate Ganz, was given to the Fitzwilliam by the Friends in memory of Philip Pouncey, with a special contribution from Miss Ganz.

Menzocchi, who was a pupil of Genga, was active in Forlì. Although he is said to have been prolific as a painter (Pepper), his drawings are scarce. They include two examples in the British Museum, both attributed to the artist by Pouncey on stylistic grounds, the *Coronation of the Virgin with Saints* (1946–7–13–352), transferred to Menzocchi in 1948, and *God the Father with Putti*, transferred in 1974. In the draft entry on the former drawing for the sixteenth-century catalogue, Pouncey wrote: 'Comparison with pictures by Francesco Menzocchi . . . leaves no doubt . . . that it is by the same hand, so similar are the compositions, the attitudes and placing of the figures and the facial types.'

5 Travel, Teaching and Visits to Other British Collections
(cat. nos 104–27)

5(i) Travels, teaching and correspondence (cat. nos 104–15)

Each summer for more than forty years the Pounceys set off abroad to study Italian pictures and drawings in museums, galleries and exhibitions. These journeys took them not only to Italy but to other countries in Europe and also to North America. They were an essential part of Pouncey's work, since they provided new information for his files. Cat. nos 104–5 and 106–7 illustrate such visits and show the sort of material that was collected.

Pouncey's enthusiasm for his subject made him a natural teacher. By listening to his reactions to a drawing, not only were his colleagues often given the answers they sought but they also learnt something of his approach. He also gave a number of lectures in which he touched on his ideas on the connoisseurship of Italian drawings (see cat. nos 108–9).

His extensive travels and his international reputation gave him a wide circle of friends and colleagues with whom he was constantly exchanging information. Reading through his diaries, which cover most of his life from his early twenties until a year or two before his death, one is struck by the great number of his acquaintances. To illustrate this aspect of his career, some of the many hundreds of letters he wrote while working at the Museum are included in this section (see cat. nos 111 and 114).

104 Pouncey's diary for 1948

Private collection

The entries for 3–6 September record visits to churches and museums in Rome, and meetings with eminent Italian colleagues. On 3 September Pouncey saw D.ssa Paola della Pergola, Director of the Borghese Gallery, and afterwards went 'To [Palazzo] Barberini, [the] Quirinal, S. Maria in Via Lata (includ. crypt), S. Marcello in [*sic*] Corso, SS. Apostoli'. On 4 September he met Federico Zeri at D.ssa della Pergola's, and on the following morning he had another rendezvous with him, to visit 'S. Giovanni Decollato, S. Maria della Consolazione, S. Niccolò in Carcere & Palazzo dei Conservatori'. On 6 September he noted the publication of Pietro Toesca's article on Francesco Marmitta (*L'Arte*, xvii, 1948, pp. 33ff.), a subject of special interest to him because of his discovery of some drawings by the artist (see cat. nos 23–4). The rest of the day consisted of more visits

to Roman churches, interrupted by a visit to the *carabinieri* to obtain a *permesso di soggiorno*: 'To S. Silvestro in Capite. 10. Questura to get *carta di soggiorno*. To S. M. Maggiore where I look specially at Passignano.'

105 One of Pouncey's duplicate books

Private collection

When travelling, Pouncey noted in duplicate books particulars of drawings and paintings in collections he visited. The carbon copies were left in the duplicate book as a record of the collection visited, and the top copies distributed among the appropriate artists' files, according to the authorship of the drawings listed on the page, the particulars of any discoveries having been first noted on the *fiches* in the Attributions Cabinet (cat. nos 132–3).

The book shown here records the drawings seen in the Szepmuveszeti Muzeum (Museum of Fine Arts), Budapest, in 1964.

106 Photograph of Philip and Myril Pouncey in a gondola in Venice

Private collection

On Pouncey's foreign trips his wife Myril was constantly at his side. They visited Venice on a number of occasions in the 1950s and 1960s; this photograph was taken in 1953.

107 Photograph of Philip and Myril Pouncey in the Cathedral in Parma in 1989

Private collection

This photograph was taken on the last of Pouncey's innumerable visits to Italy, when he was already suffering from the illness that was to cause his death in the following year.

108 List of topics covered in a series of talks given to students at Columbia University, New York, in 1958

Private collection

In his memoir of Pouncey, J. A. Gere remarked on his style of public speaking: 'He did not read from a prepared text nor even commit one to memory, but extemporised his talk round a carefully chosen sequence of slides – a method disastrous if resorted to out of laziness, but supremely successful when the lecturer can think on his feet and possesses what was described as "Philip's infinite capacity for instant verbalisation"' (Gere, 1991, pp. 539–40).

In 1958 Pouncey was Visiting Professor at Columbia, where he gave a series of seminars on Italian art. The titles

106

were left deliberately vague so that a written text would not have to be prepared, a solution much admired by the then Head of the Department of Art History and Archaeology, Professor Rudolf Wittkower (1901–71). Pouncey's approach is especially evident in the last of the three headings on this list: 'XVIth Century Italian drawings. Visits to Museums & Collections will be combined with detailed study of specific problems'. These talks, in which 'he publicly put fully to use his power of lucid and fluent exposition', were outstandingly successful and 'are still remembered by his students'.

109 Text of a speech given by Pouncey at the Royal West of England Academy, Bristol, 25 October 1968

Private collection

In one of his few public talks for which a written text does exist, Pouncey, after paying his compliments to Lord Methuen (1886–1974), President of the Academy, began by explaining that he himself had given up 'the unequal struggle' to be an artist in his early twenties. He then went on briefly to describe the skills required of the art historian, in the process revealing his own insight into artistic creation:

I would include among these the capacity to recognize in a picture or drawing the fibre of a particular artist's mind, his 'will to form' as it has been called. . . . I have found that a preparatory drawing for a painting (and occasionally for a piece of sculpture) nearly always has an exciting quality which, except in the case of the very best artists' work, begins to evaporate in the end product. . . . Surely the excitement experienced by the spectator must reflect an even more intense excitement going on in the artist's mind, as he sets down his original idea and then, more often than not, alters it, in his efforts to arrive at the solution which will satisfy him.

110 Photograph of Jacob Bean (1923–92), Curator of Drawings at the Metropolitan Museum of Art, New York

Private collection

Bean is shown looking at drawings among the stacks at the Metropolitan Museum. Until 1960, when a separate department was created, the drawings had been kept with the paintings. Pouncey was one of those consulted about the choice of a curator for the new department, and enthusiastically recommended Bean, whom he had known in Paris when Bean was working in the Cabinet des Dessins of the Louvre. The new curator quickly set about expanding the collection (see under cat. no. 80), and in the thirty years of his tenure doubled it in size, with more than 1,000 drawings acquired by purchase and nearly 800 by gift or bequest. Much of the extensive correspondence between Pouncey and Bean for the period 1960–65 (preserved in the British Museum) is concerned with these acquisitions and makes fascinating reading (see cat. no. 111).

111 Letters between Pouncey and Jacob Bean

British Museum

The first letter, dated 7 June 1957, was written by Bean when he was *chargé de mission* (i.e. working as a volunteer) in the Cabinet des Dessins of the Louvre (see cat. no. 110). He reports discoveries by Roseline Bacou and Walter Vitzthum, respectively of a study by the sixteenth-century Sienese painter Domenico Beccafumi among the Stefano della Bella drawings, and a drawing by the sixteenth-century Florentine Mannerist painter Giovanni Battista Naldini among the anonymous. He asks for particulars of a related drawing by Beccafumi which Pouncey had discovered at Lille.

In his reply of 13 June, Pouncey gives the reference to the drawing at Lille and asks for a photograph of the new Beccafumi; he goes on to give a somewhat sceptical report on a lecture given by Popham at the Warburg about 'coincidence' as a factor in art history.

The next exchange of letters was written shortly after Bean had joined the Metropolitan Museum. Writing on 17 March

1963, Bean asks for an offprint of Pouncey's article on drawings by the Florentine Mannerist painter Girolamo Macchietti (Pouncey, 1962). He then goes on to comment on some of the drawings in Sotheby's sale of 12 March 1963. He had bought for the Metropolitan a beautiful Perino del Vaga (Bean, 1982, no. 166), but was alarmed at its cost (£800).

Pouncey replied that the British Museum had failed to buy the Polidoro and Taddeo Zuccaro drawings it was after, and in the third paragraph gives some details of his planned visit to Italy that summer.

The last letter, dated 3 February 1967, is from Bean and wryly congratulates Pouncey on the purchase of Raphael's *Entombment* (cat. no. 80): '. . . I daresay that you can imagine how sorry we are to have lost this drawing, which would have been a capital addition to our small collection and how particularly sorry we are that official machinery was used against us. . . . Now, in the light of the precedent established, I wonder what chance we have of purchasing any major drawing in England.'

112 Photograph of Walter Vitzthum (1928–71)

British Museum

The portrait is the frontispiece to *Ricordi su Walter Vitzthum*, by Giuliano Briganti and Detlef Heikamp, published in 1971. Vitzthum was one of the most brilliant of the younger generation of Italian drawings specialists of the immediate post-war period. His particular field was the Italian seventeenth century, especially in Rome and Naples. Assistant Professor, and shortly before his death Professor, of Art History at Toronto University, he travelled widely and was a frequent visitor to the print rooms of Europe and North America. Pouncey's diary for 1953 (cat. no. 113) records their first meeting on one of Vitzthum's early visits to the Print Room at the British Museum. Shortly thereafter the two men came to be on friendly terms, and an often amusing correspondence between them, dating until shortly before Vitzthum's premature death, survives in the Department (see cat. no. 114).

Vitzthum's approach to art history was in much the same mould as Pouncey's, and centred on the precise definition of individual artistic personalities. The history of art, he once wrote, is the history of artists, not of 'abstraction, *Geist*, and principles'. Like Pouncey, he was wont to inscribe new attributions in pencil on mounts of drawings, though only rarely did he sign them. As Gere has pointed out, these annotations may be identified by the fact that they are usually in slightly backwards-sloping capital letters and are invariably correct: 'A correct attribution is like the tip of an iceberg – the visible culmination of a complex intuitive and intellectual process' (Gere, 1972, p. 722).

Vitzthum realised a project for the publication of selected

Old Master drawings on rather the same lines as that outlined by Pouncey in his letter to Popham (see cat. no. 88). The Fratelli Fabbri series *I disegni dei maestri*, edited by Vitzthum and consisting of sixteen volumes, each written by a specialist in a different area of the subject, admirably covered the history of European drawing from the Renaissance and has not been superseded.

113 Pouncey's diary for 1953

Private collection

Pouncey came to know Walter Vitzthum in 1953. On 12 January he records: 'Vitzthum, a young student from Munich & Florence in, studying Poccetti. . . .' On 31 January, the last day of Vitzthum's short visit, Pouncey noted Vitzthum's discovery among the Museum's drawings of a 'study by Poccetti for [the] Badia a Ripoli fresco of *Marriage of Cana* (1604)'. The drawing (1946-7-13-321; London, 1986, no. 189) had been catalogued by Popham as by Francesco Vanni (1563-1609) when in the Phillipps-Fenwick collection, but was placed as Cigoli on entering the Museum in 1946.

When Vitzthum visited the Print Room in September of the following year, he and Pouncey discussed the drawings of Pietro da Cortona, another subject in which Vitzthum was particularly interested. He visited the Pounceys' house more than once, and a firm friendship soon developed. Five years later, on 19 September 1959, there is a note of what must have been an enjoyable dinner party: 'Vitzthum and Aimée at dinner: soufflé, boeuf mode with rice, stewed peaches . . . Pontet Canet/1949. Look at Cortona Photos.' This description is typical of the innumerable evenings when the Pounceys entertained colleagues, both British and foreign. Myril's delicious cooking and fine wines from Pouncey's cellar (see cat. no. 149) were as often as not followed, as on this occasion, by discussion of some aspect of Italian drawings, illustrated by photographs from the extensive Pouncey *Fototeca* (see cat. nos 139-40).

114 Letters between Pouncey and Walter Vitzthum

British Museum

In a letter of 15 July 1954 Vitzthum comments on two drawings which Pouncey thought might be by Poccetti, one of them in the Louvre (inv. no. 4537, now attributed to Balducci; Viatte, 1988, no. 43). He then offers to send photographs of the drawings by Cigoli at Munich, if these were not already in the Pouncey *Fototeca*. (Vitzthum was a competent photographer and whenever possible took his own photographs of drawings.) Finally, he asks if Pouncey would read a draft of a letter he was planning to send to the *Burlington Magazine* and comment on its grammar and spelling. (The

letter was published soon afterwards ('Zuccari's "Paradise" for the Doges' Palace', xcvi, 1954, p. 291).)

In his reply (dated 21 July), Pouncey repeats his uncertainty about the attribution of the Louvre drawing, but continues:

You have certainly whetted my appetite in dangling in front of me the Munich Cigolis, none of which are represented as yet in my fototeca; and I should dearly like them to be there in force! He is a fascinating artist and I have found a good many in my time. Do you ever come across any Giovanni de' Vecchi drawings? I am mad about him. Other artists I am particularly keen to get examples of are Paris Nogari, Antonio Viviani, Alessandro Vitali, G. B. Ricci of Novara, Baldassare Croce, any of the Pomarancio blighters, G. B. Pozzo, Vespasiano Strada. . . . But I could go on almost endlessly and don't want to bore you. . . . The really precious thing, as you realise quite as well as I do, is the drawing which can be connected with a painting.

He then tells Vitzthum that he has passed his letter on to the *Burlington* and that 'it stood in no need of doctoring'.

The next letter from Vitzthum to Pouncey is dated 9 November 1960. Written after Vitzthum's return to Toronto from New York, it is dense with references to Italian drawings in Edinburgh, Paris, Leningrad and Munich. Vitzthum also asks for particulars of a drawing by Pietro da Cortona in the British Museum which he had found under Lanfranco and which he has now identified as a study for the ceiling of the gallery of the Palazzo Pamphilj in Rome (5212-45). Finally, he asks Pouncey if he has seen the drawings at Norfolk (Virginia) and at Bowdoin College (Brunswick, Maine).

In Pouncey's reply of 12 November he admits that he has been neither to Norfolk nor to Bowdoin College, and adds, 'I should be most grateful for any photos you feel inclined to send along. Photos of pictures are also most welcome at all times.'

The third letter from Vitzthum, dated 7 February 1961, asks urgently for particulars of a group of drawings in the Museum by Girolamo da Carpi which are part of a dismembered sketchbook. The last paragraph contains an amusing comment on Pouncey's recent discovery of a Ciro Ferri and his pursuit of a *bozzetto* by Cecco Bravo for his own collection: 'As the saying goes: the road to Cecco Bravo is paved with Ciro Ferris.'

Pouncey's reply of 13 February is apologetic: 'I am terribly sorry to be late in answering your SOS. My foolish family persuaded me to take some leave and this of course is the result.' Only four drawings from the Girolamo da Carpi sketchbook proved to be in the collection and Pouncey duly provided their inventory numbers and measurements. (During leave he had visited the Courtauld Institute Galleries, where he found a 'cache' of Italian drawings among the Spanish.) At the end Pouncey turned to the subject of the Cecco Bravo *bozzetto*:

We for our part look forward to showing our Bravo to one who appreciates such things. We only bought it to please our friends with decadent tastes, and I was busy explaining this to one of them whom I had always supposed to be the most decadent of all. When he got into the room and found himself opposite the thing itself he exclaimed: 'why, this is the picture we had on approval a few weeks ago and sent back because we found it too trivial'. So we felt very small and took to drink for the rest of the evening.

The Pounceys eventually sold the picture. Its present whereabouts are unknown.

115 Letter to Pouncey from Professor Frank Dowley of the University of Chicago

British Museum

The letter is dated 25 November 1955, and was written partly in response to some photographs of drawings from the newly acquired Cavendish Album which Pouncey had sent him. Dowley's opinion had been particularly sought on the drawings traditionally attributed to Carlo Maratti (1625–1713), an artist in whom he took a particular interest. In his view the *St Matthew* (1952–1–21–31) can be connected with the series of painted *Apostles* commissioned by Cardinal Antonio Barberini from Andrea Sacchi and completed by Maratti after

Sacchi's death in 1661 (cf. cat. no. 79). Dowley's opinion was noted by Pouncey on the album page beneath the drawing. Such letters between colleagues are typical of the many hundreds in the Pouncey correspondence in the British Museum.

Dowley's view of the authorship and purpose of the drawing has not been supported by more recent research. The figure corresponds more closely with the marble statue in the nave of S. Giovanni in Laterano, designed by Maratti not long before his death in 1713 and executed by Camillo Rusconi (1658–1728), while the style of the drawing itself suggests, rather, the hand of some member of Maratti's large and flourishing studio, perhaps Andrea Procaccini (1671–1734).

5(ii) Attributions of drawings in other British collections (cat. nos 116–27)

Pouncey had a good knowledge of the public and private collections of Italian drawings in this country, and the following section includes examples of the 'discoveries' he made in them. When Keith Andrews (1920–89) was preparing the catalogue of Italian drawings in the National Gallery of Scotland, Edinburgh, he frequently called on Pouncey for advice

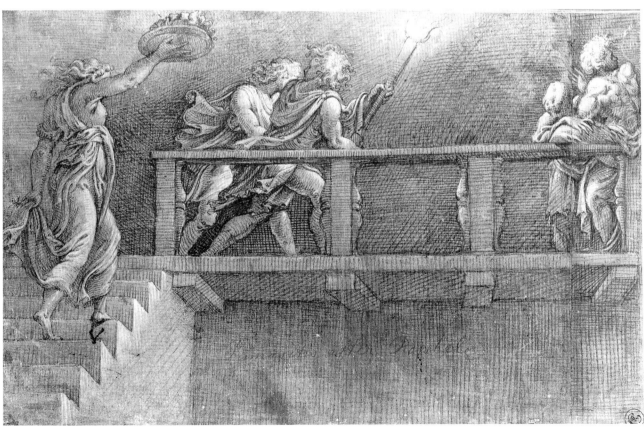

116

(see cat. nos 125–6). The extensive correspondence between the two men on various problems posed by the Edinburgh drawings is still preserved in the Department and makes fascinating reading. Similarly, when Pouncey's old friend Peter Ward-Jackson was working some ten years later on the fine, and still relatively little-known, group of Italian drawings at the Victoria and Albert Museum, Pouncey was again forthcoming with help (see cat. nos 117, 123 and 127). (For Pouncey's research into the Italian drawings at the Fitzwilliam Museum, Cambridge, where he was Honorary Keeper of Drawings, see section II.4.)

No attempt has been made here to cover Pouncey's study of foreign collections, since this has been dealt with in the 1985 Fitzwilliam Museum exhibition, *The Achievement of a Connoisseur, Philip Pouncey* (see cat. no. 100), while his work at the Louvre has already been the subject of two exhibitions (Paris, 1978 and 1992); that at the Uffizi will be shown in a forthcoming exhibition.

The drawings from British collections shown in this section are ordered by artists' date of birth.

116 Giulio Campi (1502–72), *Salome Carrying the Head of the Baptist*

Black chalk, heightened with white, on light brown-washed paper; 256 × 409mm

Ashmolean Museum, Oxford (KTP 252)

Provenance: R. Cosway (L 628); F. Douce

Literature: Parker, 1956, no. 252 (as Giulio Romano); Macandrew, 1980, p. 263 (as Giulio Campi)

Parker classified this drawing among copies after Giulio Romano, to whom it was already attributed when in Cosway's collection, though he recorded Pouncey's 'rather convincing suggestion that [the drawing] shows characteristics of the hand of Giulio Campi'. In April 1975 Pouncey's view was supported by A. Ballarin (note in the interleaved copy of Parker's catalogue in the Ashmolean Museum) and in 1980 Macandrew transferred the drawing to Giulio Campi.

The subject is represented dramatically: Salome is seen from behind, mounting a flight of steps with the Baptist's head held aloft in her right hand; two men, one holding a torch, walk ahead of her along a gallery. The purpose of the drawing is unknown.

For another drawing by Campi, see cat. no. 72.

117 Francesco Salviati (1510–63), *Charity, Fortitude, Hope and Faith*

Pen and brown ink with brown wash, heightened with white; 117 × 142mm

Victoria and Albert Museum, London (D.2222–1885)

Literature: Ward-Jackson, 1979, no. 279; Mortari, 1992, no. 334

Pouncey connected this and cat. no. 118 (a fragment trimmed off the top of the same sheet), to the *soprapporta* on the south wall of the Sala dell'Udienza of the Palazzo Vecchio, Florence (Mortari, 1992, pp. 29 and 111, repr.). Salviati's well-known fresco decoration of this room was carried out about 1544. Pouncey also pointed out that the appearance of the original sheet before it was cut into two is recorded in a drawing in the Held Collection, New York (Mortari, 1992, no. 401), the status of which is uncertain, though it has been given to Salviati himself. The two fragments are here shown together for the first time since their division. In the drawing the lower part of the *soprapporta* is close to the final painting (though there the superscription appears in the blank central roundel). However, the upper section with *Abraham's Sacrifice* differs substantially; the poses of the figures have been changed, and panels of grotesque ornament substituted for the background drapery.

Alessandro Cecchi was the first to point out that a drawing in the Louvre (inv. no. 2204; Monbeig-Goguel, 1972, no. 80 repr., as Poppi; Mortari, 1992, no. 482) is by Salviati and is another study for *Abraham's Sacrifice*.

Salviati, a pupil of Andrea del Sarto, was one of the great geniuses of High Mannerism in Florence.

118 Francesco Salviati (1510–63), *Abraham's Sacrifice*

Pen and brown ink with brown wash, heightened with white; 102 × 141mm

Private collection

Literature: Mortari, 1992, pp. 32 and 224, no. 314

See cat. no. 117.

119 Andrea Meldolla, called Schiavone (1522–63), *Angel Appearing to St Roch*

Brush and brown-grey wash, heightened with white; 140 × 107mm

Private collection

Provenance: P.-J. Mariette (L 1852)

Literature: Edinburgh, 1969, no. 78; Richardson, 1980, pp. 114f., no. 138

This drawing is still on the characteristic grey-blue mount of the eighteenth-century French connoisseur and collector Pierre-Jean Mariette, inscribed in the cartouche with the name of Parmigianino. But although Parmigianinesque in style, its difference in handling means it cannot be by Parmigianino himself; and Pouncey's attribution to Schiavone was confirmed by the fact that the composition is repeated, in the reverse direction, in an etching by him datable *c*.1538–40 (Bartsch, 1803–21, xvi, p. 40, no. 1; Richardson, 1980, p. 79,

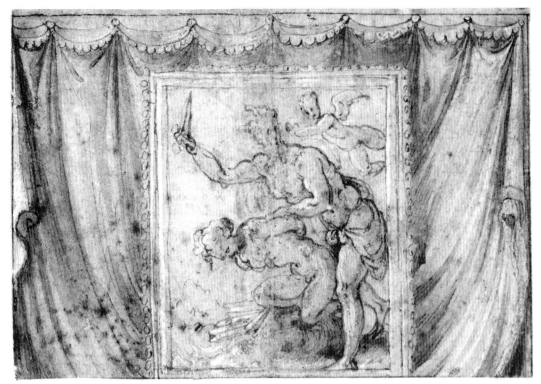

118

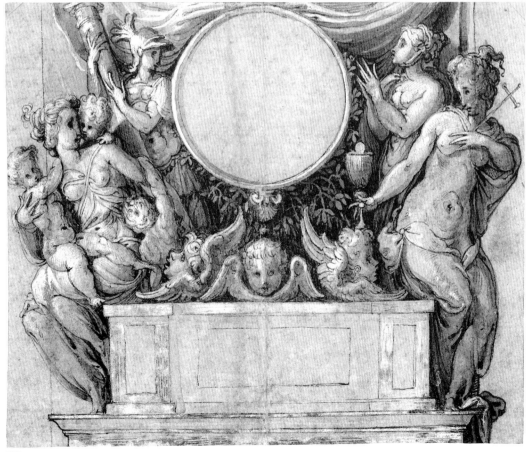

117

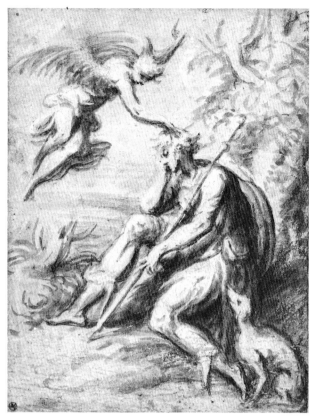

119

name of Gambara at the suggestion of Pouncey, who had pointed out its resemblance in style to a *Massacre of the Innocents* (then in the Janos Scholz collection and now in the Pierpont Morgan Library, New York) which Popham had recognised as a study for a fresco by the artist in the nave of the Duomo at Parma (Washington and New York, 1973–4, no. 80). In July 1963 Pouncey confirmed the authorship of the Ashmolean drawing by his observation that the figure appears 'high up next to a window in Parma Cathedral' (i.e. to the right of the window above Gambara's fresco of *St Peter Walking on the Water*, the penultimate fresco on the right-hand side). The connection is duly recorded by Macandrew.

Gambara, who was born in Brescia, settled at an early age in Cremona, where he was greatly influenced by the work of the Campi, especially Antonio; he later returned to Brescia, where he was Romanino's pupil (and later his son-in-law). The influences of the Campi and of Romanino, combined with that of Pordenone, determined his development as an artist.

121 Carlo Urbino (*fl.*1553–85), *Birth of a Saint (St John the Baptist(?))*

Pen and brown ink; 177 × 131mm

Private collection

Literature: Edinburgh, 1969, no. 85

First published in 1969 with Pouncey's attribution to Carlo Urbino. Very little was then known of the artist, and the Edinburgh catalogue confined itself to saying: 'A few drawings with contemporary inscriptions giving the name of this obscure artist, a pupil of Bernardino Campi, are known, and it seems that the present drawing belongs to this group.' Since then, many more drawings by the same hand have come to light and been studied (e.g. in the catalogues of the exhibitions of Lombard drawings at the Accademia, Venice, in 1982 and of the Campi in Cremona in 1985), but Pouncey was the first to identify Urbino as a distinct personality.

Urbino settled in Milan, where he worked as a painter of frescoes, and it was here that his collaboration with Bernardino Campi began. By the end of his career he seems to have specialised as a draughtsman rather than a painter.

no. 1). Bartsch identified the subject as *Jacob's Dream*, but the angel is not on a ladder and the presence of the pilgrim's staff and the dog establishes that the principal figure is St Roch. According to the legend, the saint, suffering from plague and banished from the city of Piacenza for fear of infection, was succoured by his dog, who brought him a loaf of bread every day, and by an angel.

Schiavone was born in Zara, Dalmatia, which was then under Venetian jurisdiction, and seems to have arrived in Venice by the late 1530s or 1540s. His work combines the influence of contemporary Venetian painters, especially Titian, with the exaggerated style of Parmigianino and other Central Italian artists of the period.

120 Lattanzio Gambara (*c.*1530–74), *Seated Female Figure*

Black and white chalk on bluish-grey paper; squared for transfer in black chalk; 280 × 207mm

Ashmolean Museum, Oxford (KTP 240)

Provenance: Sir J. Reynolds (L 2364)

Literature: Parker, 1956, no. 240; Macandrew, 1980, p. 262

Parker catalogued this drawing, which had previously been attributed to Pordenone and to Giulio Campi, under the

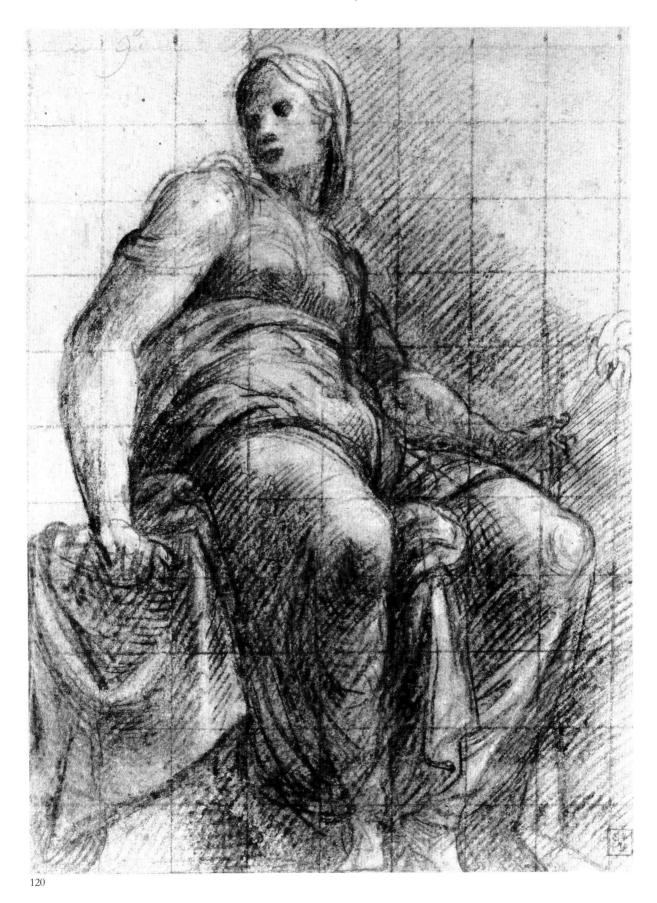

120

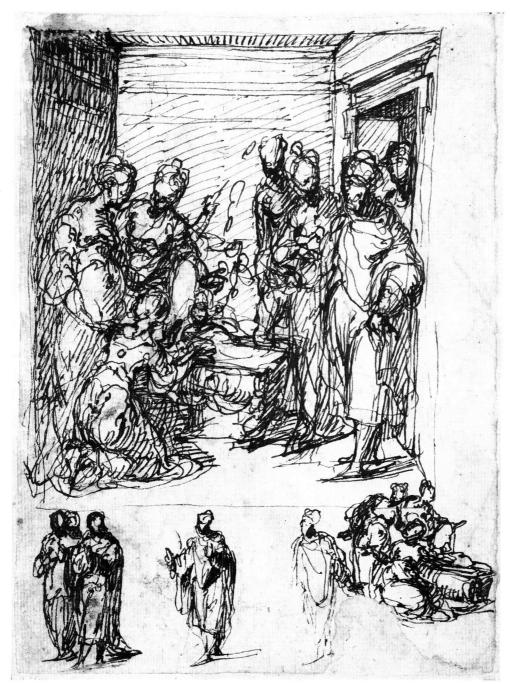

121

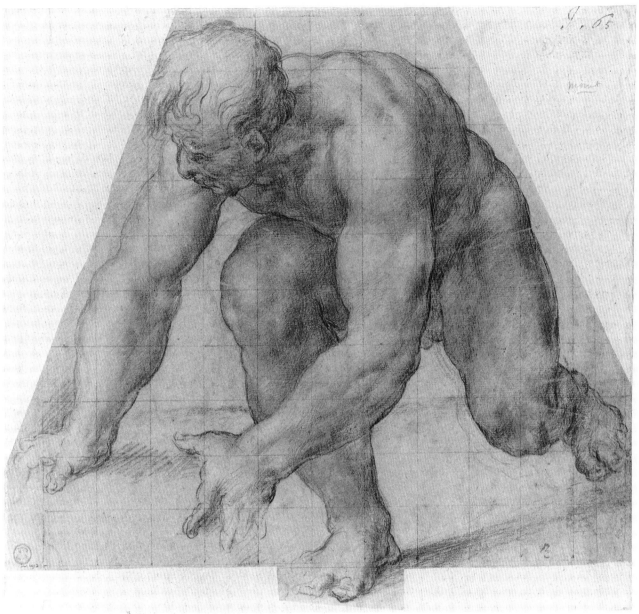

122

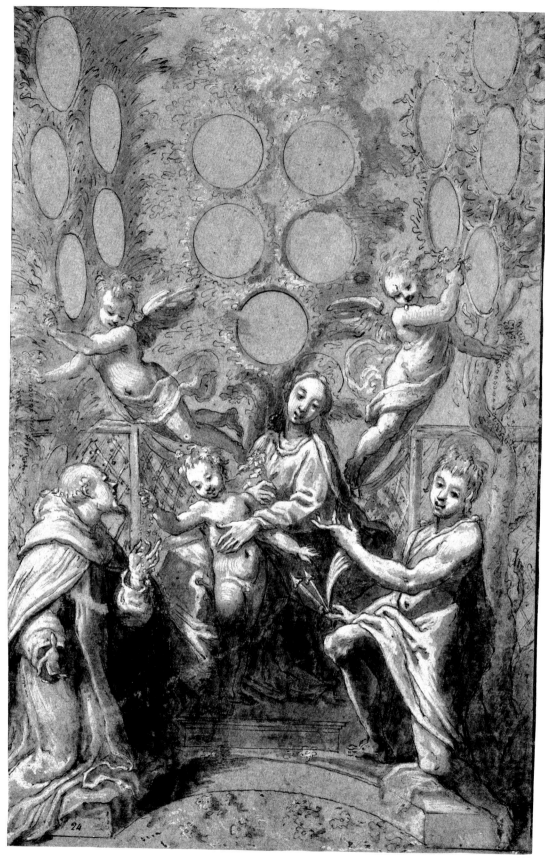

123

122 Sebastiano Filippi, called Bastianino (1532/4–1602), *A Crouching Nude Man*

Black chalk with some white chalk on blue paper; squared in black chalk; irregularly cut, maximum measurements 292 × 320mm

Christ Church, Oxford (JBS 908)

Provenance: C. Ridolfi; General Guise

Literature: Pouncey, 1972, p. 126; Byam Shaw, 1976, no. 908; Byam Shaw, 1985, p. 761; Cambridge, 1985, no. 7

The drawing was where it had always been, among the anonymous, when Pouncey wrote on the mount: 'Cf Sebastiano Filippi (*Bastianino*) PMRP (1971)'. This attribution is something of a legend among specialists in Italian drawings. As a draughtsman, Bastianino was an entirely unknown quantity when Pouncey remarked that 'if Bastianino had made drawings, this is exactly the sort of drawing one would have expected from him'. The observation was triumphantly confirmed by his discovery of the figure – a devil about to seize his victim – in Bastianino's altarpiece of the *Last Judgement*, now in the Arcipretale at Rovello Porro. As J. A. Gere has commented: 'Such feats of divination seem miraculous, but they are achieved only by prolonged and single-minded absorption in the subject' (1991, p. 537).

Bastianino was an obscure Ferrarese imitator of Michelangelo; his best-known work, another *Last Judgement* (1578–80), is a fresco in the apse of Ferrara Cathedral.

123 Gregorio Pagani (1558–1605), *Virgin and Child with Saints*

Pen and brown ink with brown wash, heightened with white, on blue paper; 387 × 254mm

Victoria and Albert Museum, London (8942)

Literature: Thiem, 1970, pp. 30 and 78f., no. z.23; Ward-Jackson, 1979, no. 214; Cambridge, 1985, no. 38

The drawing was formerly given to Giovanni da San Giovanni (1592–1636), but Pouncey recognised it as the work of Gregorio Pagani, another, somewhat earlier, Florentine. According to Thiem (p. 30), it may be a study for 'a picture of the *Rosary*' painted in about 1595 for Giovansimone Tornabuoni, who asked Pagani to represent the Virgin '. . . in a rose garden, with three trees; on the first, a palm, with the Joyful Mysteries; on the second, a thorn, with the Sorrowful Mysteries; and on the third, a rose, . . . with the Glorious Mysteries . . .'.

Pagani was a pupil of Santi di Tito. Like Cigoli and Passignano, he was an exponent of the new, naturalistic trend in late sixteenth-century Florentine painting associated with the Counter-Reformation.

124

124 Belisario Corenzio (*c.*1588 – after 1646), *The Deposition*

Brush drawing in brown wash, heightened with white, on grey paper; 202 × 163mm

Private collection

Literature: Edinburgh, 1972, no. 38

Inscribed in black chalk in the lower left: *Belisario*. When this drawing was exhibited at Edinburgh in 1972, the work of Corenzio was known only to a few specialists in the Neapolitan Seicento. Vitzthum, for example, had already identified a number of drawings by him. Corenzio was a Greek (one source says that he was from the province of Achaia) and is said to have trained in Venice under Tintoretto, afterwards moving to Naples. His drawings, of which this is a typical example, are sometimes confused with those of other painters, for example those of the Florentine Giovanni Balducci (1560 – after 1631), who was also active in Naples.

The drawing appears to be a study, in reverse and with variations, for one of the scenes in Corenzio's cycle of frescoes of the *Life of Christ* on the ceiling of the Cappella del Monte Pietà, Naples (Pasculli Ferrara, 1986, p. 229, fig. 85).

125

125 Francesco Allegrini (*fl.*1624–63), *St Sebastian Converting the Prefect Cromatio and his Son*

Pen and brown ink with brown wash; 242 × 259mm

National Gallery of Scotland, Edinburgh (D 915)

Provenance: D. Laing; Royal Scottish Academy

Literature: Andrews, 1971, p. 3; Rodinò, 1990, p. 231

The inscriptions in pen, presumably in the artist's hand, identify the subject of this drawing, which was given to the Cavaliere d'Arpino until Pouncey's attribution to the artist's follower Francesco Allegrini. Pouncey also attributed to Allegrini a group of some sixty drawings also in the National Gallery of Scotland (Cambridge, 1985, no. 1). Pouncey's

work on the Italian drawings at Edinburgh dates mostly from the early 1960s, when the late Keith Andrews, then Keeper of Prints and Drawings, was preparing his catalogue of this material. An extensive correspondence between them survives in the Department of Prints and Drawings of the British Museum, much of it dealing with problems of attribution posed by the Edinburgh drawings.

What is known of the work of Francesco Allegrini and his father Flaminio – often confused in the past – has been admirably summarised by Gere and Pouncey (1983, pp. 26–7), while a further attempt to distinguish their hands has been made by Rodinò (1990, pp. 229–44).

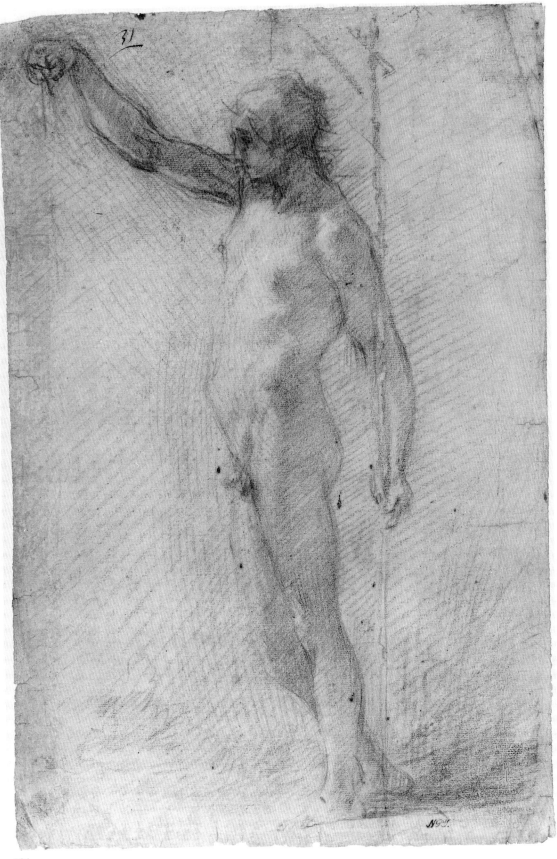

126

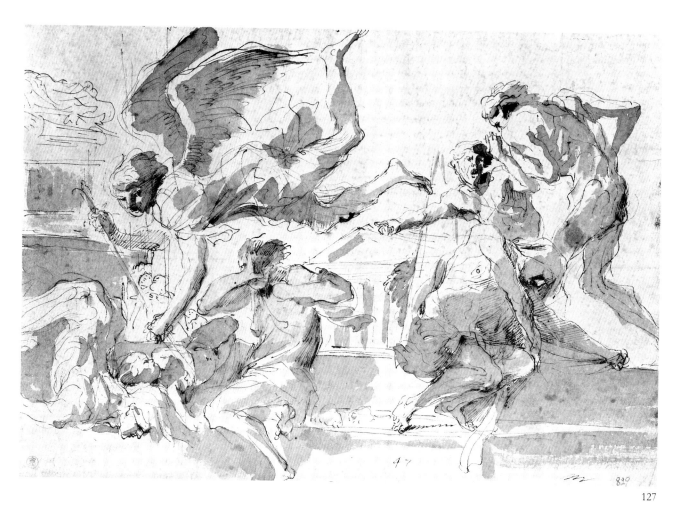

127

126 Francesco Montelatici, called Cecco Bravo (1607–61), *Standing Male Nude Holding a Cross*

Red chalk; 397 × 253mm

National Gallery of Scotland, Edinburgh (D 1957)

Provenance: (?) Allan Ramsay; Lady Murray

Literature: Andrews, 1971, p. 76

The figure is clearly St John the Baptist. The drawing is one of a group of seventeen in the National Gallery of Scotland, all previously given to Giovanni da San Giovanni and re-attributed by Pouncey to Cecco Bravo. One of the leading painters of the Florentine Baroque, Cecco Bravo is best known for his eccentric, slightly over-dramatic easel pictures, though he was also an attractive draughtsman, with a preference for working in red chalk; the present study is a good example of his work in the medium.

The Pounceys once owned an oil sketch by the artist, which they later sold. This is referred to by Pouncey in his correspondence with Vitzthum (see cat. no. 114).

127 Giovanni Benedetto Castiglione (1609–64), *Angel Sheathing his Sword over the Plague-Stricken*

Pen and brown ink with brown wash; 254 × 374mm

Victoria and Albert Museum, London (CAI.829)

Provenance: R. Cole; C. A. Ionides

Literature: Ward-Jackson, 1980, no. 666

Formerly placed as anonymous Italian, eighteenth century. Pouncey recognised Castiglione's distinctive hand in this fine example of his work. The drawing has been dated *c.*1640–45.

Castiglione was a leading painter of the Genoese Baroque and is best known for his landscapes and pictures of mythological subjects. He was greatly influenced by the Flemish painters Rubens and Van Dyck, both of whom had worked in Genoa.

III Philip Pouncey's Way of Working

Pouncey's profound knowledge of Italian art was the result not only of an extraordinary eye and an exceptional visual memory but also of a highly disciplined working method. This section attempts to describe how he set about his work. Much was done at home in the evenings and at weekends, when photographs would be filed, indexes compiled and other data assembled. His house was a repository for his notes and papers, including the 'Attributions Cabinet', a record of the hundreds of attributions he had made of drawings and pictures in different collections (see cat. nos 132–8), his '*Fototeca*' (see cat. nos 139–40) and a substantial library (see cat. nos 144–5). This section will include miscellaneous examples from this apparatus to show how meticulously he set about his work.

1 Favourites

(cat. nos 128–31)

Pouncey had a particular interest in lesser-known Italian masters. He would gradually collect photographs of their work until he could formulate a reliable idea of their *oeuvre* and their artistic personalities. And in the process he often developed a special affection for them. One such artist whom he rescued from oblivion in this way, and whom he grew especially to like, was Giovanni de' Vecchi. In a letter to Walter Vitzthum of 21 July 1954 he wrote: 'Do you ever come across any Giovanni de' Vecchi? I am mad about him' (see cat. no. 114).

Other lesser artists he did not admire so much (though this did not prevent him from continuing to study their work). He jokingly referred to Niccolò and Antonio Circignani as 'the Pomarancio blighters' (see cat. no. 114), while Avanzino Nucci, whom he rediscovered as a draughtsman (see cat. nos 139–43), he always regarded as 'dim'.

128 Giovanni de' Vecchi (*c.*1537–1615), *Religion Distributing the Girdles of St Francis to the Penitents*

Pen and black ink and grey-brown wash; squared for transfer in black chalk; 337 × 197mm

National Gallery of Scotland, Edinburgh (D 632)

Provenance: Sir P. Lely; D. Laing; Royal Scottish Academy

Literature: Andrews, 1971, p. 127; Macandrew, 1980, p. 256

The subject commemorates the inauguration on 19 November 1585 of the Confraternity of the Girdles of St Francis by Pope Sixtus V (the figure kneeling in front of the pedestal to the right). Religion, enthroned in the centre, receives with her raised right hand the girdles given her by St Francis, who kneels on clouds above her; she holds in her left hand a sceptre crowned by the badge of the Order (two arms crossed).

The drawing was formerly attributed to Agostino Carracci, probably because of its connection with his signed engraving of the composition, dated 1586, which shows only slight differences in detail (Bartsch, 1803–21, xviii, p. 98, no. 109; Washington, 1979, no. 141). In spite of the connection with the engraving, Pouncey rightly doubted the attribution of the Edinburgh drawing, noticing that the overall handling was typical of de' Vecchi's style. His observation called into question the assumption that Carracci was responsible for the design of the engraving, which is sometimes thought to be his (see Washington, 1979, no. 141).

129 Giovanni de' Vecchi (*c.*1537–1615), *The Visitation*

Pen and brown ink over black chalk, with pale brown, grey, pale purple, greenish-brown and rose-red wash; 295 × 188mm

British Museum (1965–10–9–3)

Provenance: R. Cosway (L 628); A. E. Wrangham

Literature: Gere and Pouncey, 1983, no. 283

An old pencil attribution to Paolo Veronese appears near the lower right edge. When the drawing appeared at auction at Sotheby's on 22 July 1965 (lot 151), described as 'North-Italian school, 16th century', Pouncey recognised de' Vecchi's authorship and pressed for its acquisition by the British Museum. It was bought for £40 through Colnaghi's. Writing of the drawing in their 1983 catalogue, Gere and Pouncey remark, 'It would be difficult to find a more typical example of Giovanni de' Vecchi's draughtsmanship. The characteristic watercolour technique is paralleled in several of the group of drawings traditionally attributed to him in the Uffizi.'

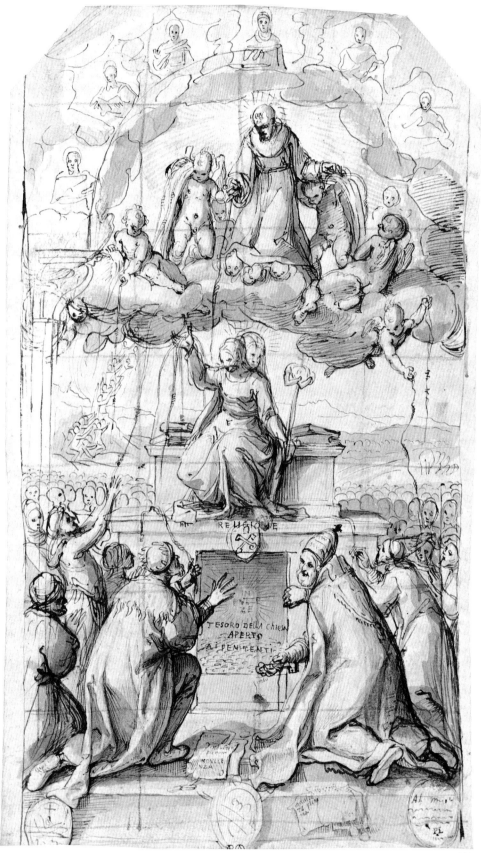

128

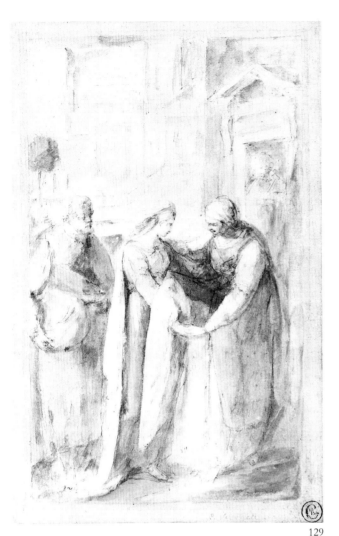

129

130 Giovanni de' Vecchi (*c*.1537–1615),
The Deposition

Pen and brown ink with purple wash; squared in black chalk;
195 × 145 mm
Private collection
Provenance: King Philip V of Spain
Literature: Edinburgh, 1969, no. 90

Pouncey was the first to point out that this is a study for
the altarpiece painted for the second chapel on the right (the
Cappella Tani, built in 1595) in S. Prassede in Rome, and
now in the sacristy of the church. Other drawings for it are
in the Biblioteca Nacional, Madrid (7639) and in the Escola
Superior de Belas-Artes, Oporto (6).

131 Miscellaneous notes and papers on Giovanni
de' Vecchi, compiled by Pouncey

Private collection

At one stage Pouncey planned an article on the drawings
of de' Vecchi, but, like his projected essay on those of
Avanzino Nucci (see cat. nos 139–43), the idea came to
nothing. His intention explains the many notes on the subject
among his papers. These include the typescript draft of the
article, index cards for many of the drawings, one or two
sketches after drawings, notes taken from the principal
sources, and a photocopy of an article on de' Vecchi by
Renato Roli (Roli, 1965), Pouncey's reaction to which seems
to have been one of the reasons for taking up his pen.

Pouncey's draft article began with a lament for history's
unjustified neglect of the artist: 'Giovanni de' Vecchi da
Borgo S. Sepolcro is one of those brilliantly gifted but unfor-
tunate artists who have suffered much through the passing
of time and the hand of man.' After considering an impress-
ive list of the painter's works provided by Baglione (for
whom see cat. nos 102 and 150), he observed how many have
since been lost, among them his decoration of the cupola
of the Gesù in Rome, destroyed in 1671 and replaced by
Gaulli's. Of those works that have survived, some have been
heavily repainted (e.g. the frescoes of the *Life of St Catherine
of Siena* in the Cappella del Sacramento in S. Maria sopra
Minerva, Rome), while others, such as his frescoes at the
Villa Farnese at Caprarola, have been denied him 'by some
art-historians who, nevertheless, profess a great admiration
for him'.

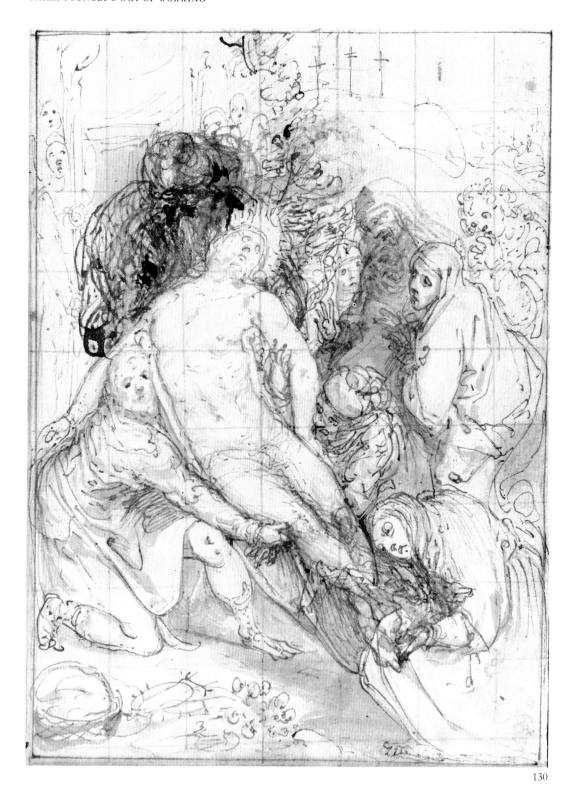

130

2 The Attributions Cabinet
(cat. nos 132–8)

For Pouncey the whole basis of the history of art was connoisseurship, and the excitement of the subject lay in making attributions. As he often said: 'An attribution a day keeps depression at bay'. On 4 March 1954 he must have been especially happy to be able to record in his diary: 'Attribute 6 drawings to Peruzzi'. Since Baldassare Peruzzi was an artist in whom he was particularly interested, and on whom he was working until the very end of his life, it seems appropriate to examine the nature of his 'Attributions Cabinet' (the record he kept of the hundreds of attributions of paintings and drawings that he made over the years) through his notes on this artist.

As discoveries sustained Pouncey's enthusiasm, so their unacknowledged adoption by other art historians was a recurring grievance throughout his life. Pouncey complained of one such instance in a letter to the owner of a drawing by Polidoro da Caravaggio which he had correctly attributed not long previously and which he was subsequently shocked to see published by somebody else under this same identification, without proper credit being given to him:

I am only sorry to note that there is no reference whatsoever to the fact that I was responsible for this information. . . . I am sure you will agree that as a matter of principle the originator of an idea should receive the appropriate credit, at any rate when the information is first published.

In another letter written to the owner some days later Pouncey commented further:

He is a nice fellow and I admire his assiduity. But he has practically told me in so many words that he has little faith in attributions made on the evidence of style. Certainly he never attempts to make one himself – and I think he is wise. But this type of mentality, that, in short, of the archivist rather than of the connoisseur, makes it difficult for him to realise that some of us have a paternal affection for our attributions. This affection, amounting in some cases to pride, seems to me a perfectly legitimate emotion and certainly a perfectly natural one.

132 One of the three boxes that make up Pouncey's Attributions Cabinet

Private collection

Each box contains two blocks of small *fiches*, placed on end, on which Pouncey recorded attributions, mostly his own. Between 950 and 1,000 Italian artists are represented.

See also cat. no. 133.

133 *Fiches* on Baldassare Peruzzi (1481–1536) from the Attributions Cabinet

Private collection

The Attributions Cabinet was the nerve-centre of Pouncey's study of Italian Old Master drawings. In it he kept a careful record of the drawings and paintings that he had attributed over the years, closely written in his small handwriting on both sides of the paper, on hundreds of small *fiches* contained in the three small purpose-built boxes which constitute the Cabinet (see cat. no. 132). The information is now being entered on a computer. Technical information is not always provided, but this was available elsewhere (e.g. in the duplicate books, for which see cat. no. 105); in the *fiches* he simply gives the name of the artist, the collection, the title or subject of the work, an inventory number whenever possible, and a brief but often highly informative comment. The idea of the Attributions Cabinet owes something to Berenson's 'Lists' (see cat. no. 145).

The twelve *fiches* dedicated to Peruzzi – an artist in whose work Pouncey did so much to revive interest – record some 110 works that had been given to the artist, mostly drawings but also a few paintings and engraved compositions. When an attribution was changed, the relevant entry was crossed out and the name of the artist to whom the work had been reattributed was noted in the margin. Unpublished discoveries still appear from time to time, for example Pouncey's attribution to Peruzzi of some of Cassiano dal Pozzo's drawings after the Antique in the Department of Greek and Roman Antiquities. For comments from the *fiches* on specific drawings, see cat. nos 136–8.

134 Letter to Pouncey from A. E. Popham

Private collection

This letter, dated 26 August 1944, is one of many written to Pouncey and his wife, Myril, during the Second World War, mostly between October 1941 and June 1945 when Popham was still at Aberystwyth and Pouncey at Bletchley. Popham ends the letter by modestly casting doubt on many of his own attributions and saluting Pouncey's more methodical approach:

Yes, I find a great many of my attributions need revising. Some of them were very wild shots. I worked from a different angle to yours. The look of the sheet or some little twiddle of the pen would give me an idea, which often was quite misleading. Your attributions were anyhow in the right direction as a rule.

Naturally enough for a correspondence conducted during the war years, the topics of discussion varied widely and focused as much on the inconveniences of wartime living (regarded with amused detachment, not with complaint) as on problems of attribution.

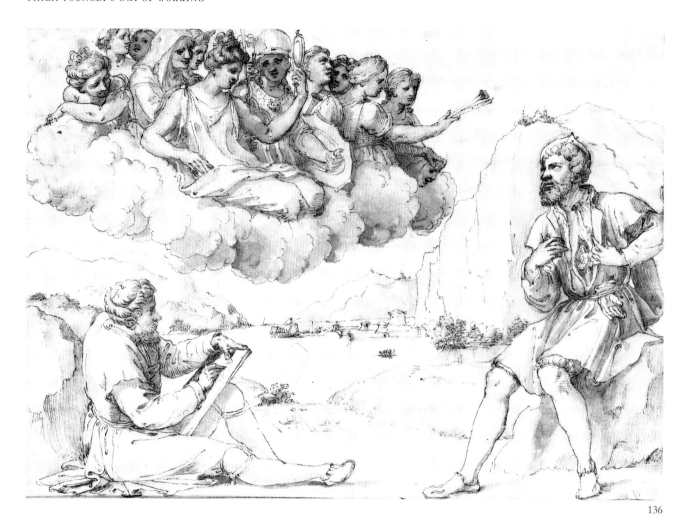

136

135 Photographs of three drawings by Baldassare Peruzzi

British Museum

In November 1989, shortly before his death, Pouncey endorsed the attribution to Peruzzi of a drawing of *Nymphs Bathing* then on the art market. The drawing fitted well in style with two others by the artist, both of the *Holy Family*, which had been on the market in New York not long before: one at Sotheby's (sale, 18 January 1984, lot 212); the other at Christie's (sale, 14 January 1986, lot 93).

136 Baldassare Peruzzi (1481–1536), *An Artist in a Landscape Drawing a Gentleman who Opens his Doublet and Shirt to Reveal an Image of a Female Figure*

Pen and brown ink with brown wash over red chalk; 185 × 255mm

Private collection

Provenance: J. P. Zoomer (L 1511); Marquis de Lagoy (L 1710); Lord David Cecil

Literature: Frommel, 1967–8, p. 161, no. 132; Edinburgh, 1969, no. 63

This drawing was sold at Sotheby's on 25 March 1965, lot 146, as 'Italian School, last quarter of the sixteenth century'. Pouncey, then in the United States, had been sent a photograph by Julien Stock of Sotheby's. In the *fiches* he records how the drawing was 'attr. by me to B[aldassare]. P[eruzzi]. on train from New York to Boston, 18/3/65'.

The subject is still not satisfactorily explained, but it is presumably some sort of allegory of love. The drawing has been dated *c.*1532–5, towards the end of the artist's life.

137

138

137 Baldassare Peruzzi (1481–1536), *Arms of Leo X and Cardinals Orsini and Sauli*

Pen and brown ink and wash; 358 × 238mm

British Museum (1946-4-13-211)

Provenance: Sir J. Pope-Hennessy; A. Scharf; presented by Anthony Blunt

Literature: Pouncey and Gere, 1962, no. 242; Frommel, 1967–68, p. 76, no. 34; Cambridge, 1985, no. 42

The attribution was made by Pouncey in 1946 and was confirmed by the subsequent uncovering of an inscription in a sixteenth-century hand on the *verso*: *mano di [Baldas]sare de Siena*. The *fiche* in the Attributions Cabinet reads: 'Bt by BM from Scharf (recd. Jan. 1946) arms of Leo X with those of Cardinals Sauli & Orsini below. Sauli died 1518, Orsini created 1517. Quite possibly this dwg is the sketch for the coat of arms of Leo X in Banchi "con tre fanciulli a fresco, che di tenerissima carne e vivi parevano" described by Vasari IV, 596' (cat. no. 133, fol. 2r.).

In this design for a tabernacle-like decoration on a palace façade (the curved lines on either side about half-way up the columns could indicate arched windows), the smaller shields are those of Cardinal Franciotto Orsini (on the left) and Cardinal Bandinello de' Sauli (on the right). Originally both contained Sauli's arms: Orsini's were drawn, by Peruzzi himself, on another piece of paper carefully stuck over the left-hand shield. Sauli was implicated in the Petrucci conspiracy against the life of Leo and was arrested on 19 May 1517. He was soon released and lived on in retirement until March 1518, but it seems unlikely that he would have commissioned such a decoration after his disgrace. The design can therefore be dated between 1513, when Leo was elected Pope, and 1517. It was later adapted for the use of Orsini, who was created cardinal in June 1517 and who died in 1533 or 1534. The fact that Leo's name is painted out in the tablet below while the papal arms are unaltered suggests that this adaptation was made during the pontificate of Leo's nephew Clement VII (1523–34).

138 Baldassare Peruzzi (1481–1536), *The Tiber*

Pen and brown ink with brown wash, heightened with white, on paper tinted brown; 234 × 348mm

British Museum (1946-7-13-15)

Provenance: S. Woodburn; Phillipps-Fenwick; presented anonymously

Literature: Popham, 1935, p. 61, no. 11 (as Giulio Romano); Pouncey and Gere, 1962, no. 244 (as Peruzzi); Frommel, 1967–8, p. 136, no. 99

Popham's attribution to Giulio Romano was abandoned when the drawing entered the collection in favour of Niccolò dell'Abbate. Pouncey's attribution to Peruzzi is recorded in the Attributions Cabinet: 'BM 1946-7-13-15 River God (Tiber) hitherto called N. dell'Abbate. (June 7 1948).'

The drawing represents the antique statue now in the Louvre which was unearthed in January 1512 in the neighbourhood of S. Maria sopra Minerva and S. Stefano del Cacco, Rome. Pouncey and Gere noted that 'due gran fiumi' (two great rivers) are said to have been part of Peruzzi's decoration of the façade of a nearby house.

3 The *Fototeca*
(cat. nos 139–43)

The photograph has revolutionised the study of the history of art. The earliest photographic publication was Thurston Thompson's of the Raphael drawings at Windsor (1857), and much use of photographs was made in the great Windsor Raphael collection (Ruland, 1876). While there is no substitute for direct study of the original, much may be learnt from a good photograph. Berenson (for whom see cat. no. 11) was one of the first connoisseurs to realise the great potential of photographs and he made an extensive photographic collection as part of his work. Pouncey's own archive of such material was similarly a logical outcome of his interests.

Pouncey's 'Fototeca' documented the work of between 2,800 and 3,000 Italian artists. Besides photographs of paintings and drawings, it included illustrations 'gutted' from sale catalogues, art-historical journals, and so forth. As some of his records show, Pouncey bought many hundreds of photographs each year, especially after he had joined Sotheby's. Indeed, one of the attractions of joining the company in 1966 had been the prospect of 'limitless' photographs (see cat. no. 88). The laborious task of placing the photographs and cuttings in the appropriate files was undertaken in evenings and at weekends, a task in which he was assisted by his wife Myril and, later, by his assistant at Sotheby's, Julien Stock.

Pouncey's work on the minor Roman painter Avanzino Nucci (1551–1629) has been chosen to illustrate the sort of material contained in the *Fototeca*.

139 Folder of photographs of paintings and drawings by Avanzino Nucci (1551–1629) from Pouncey's *Fototeca*

Private collection

Pouncey's *Fototeca* or photograph archive contains photographs and reproductions cut from sale catalogues, etc., of the work of approximately 2,800–3,000 Italian artists. The material, mostly reproducing drawings, is arranged in alphabetical order by artist. Because of their great number, the photographs and reproductions of the work of the more important, or more productive, artists were kept in separate folders, while minor figures, sometimes represented by only one or two photographs, were grouped together within the main sequence, also in strict alphabetical order.

140 Two photographs from the Avanzino Nucci folder in Pouncey's *Fototeca*

Private collection

One of these photographs is of a drawing of a kneeling figure in Berlin (Berlin-Dahlem, 15505, as Domenichino), corresponding with the kneeling Emperor in Avanzino Nucci's documented altarpiece *The Baptism of Constantine* in S. Silvestro al Quirinale, Rome; the other is of the painting itself. The connection provided the evidence that enabled Pouncey, on 24 January 1967, to identify Avanzino Nucci as a draughtsman. He had already grouped about fifty drawings by this hand under the name 'pseudo-Bernardo Castello', because of affinities in style with drawings by this Genoese painter. J. A. Gere still remembers how Pouncey excitedly put his head round the door of his office one morning and announced: 'The pseudo-Bernardo Castello is identified! He is Avanzino Nucci!'

Pouncey went on to find further evidence for Nucci's authorship of the group, including a drawing in the Walker Art Gallery, Liverpool (5083), which he was able to connect with the altarpiece of the *Virgin and Child with Saints* (signed and dated 1620) in S. Francesco at Serrasanquirico, near Ancona; and a drawing in the Albertina, Vienna (Wickhoff, 1892, SC. R. 700), with an old inscription *Avanzino del Borgo* (i.e. Borgo San Sepolcro).

Nucci may have been born at Gualdo Tadino, a small town some thirty miles from Città di Castello (Gere and Pouncey, 1983, pp. 138–9). On a fragment of a painting, dated 1620, now in the Pinacoteca at Gualdo Tadino, he describes himself as *Gualdensis*, and a drawing in the Uffizi (96801NA) is inscribed *Avanzino Nucci da Gualdo*.

For further information on Nucci, see cat. nos 141–3.

141 Pouncey's *fiches* on Avanzino Nucci from the Attributions Cabinet

Private collection

For an explanation of the *fiches*, see cat. no. 133. Some four previous attempts to identify the artist, all four crossed out, may be seen at the top of the first *fiche*: 'CASTELLO, pseudo-Bernardo', 'CIRCIGNANI, pseudo-Antonio', 'near to/possibly C. Roncalli??' and, again, 'CASTELLO, pseudo-Bernardo' yield to the final heading, 'NUCCI, Avanzino, Avanzino dal Borgo'. Most of the entries on the rest of the page refer to the group in the Louvre.

On fol. 3*v*. the Berlin drawing referred to under cat. no. 140 is noted as follows: '. . . "Domenichino" . . . Kneeling Saint 1/2 naked, hands crossed on breast = unusually large scale ps[uedo]. B[ernardo]. C[astello]. 24/5/62.', to which Pouncey has added in the margin 'Constantine, for altar in S. Silvestro in Quirinale 24/1/67'.

On fol. 4*r*. there is a note to the effect that the Albertina drawing, similarly referred to under cat. no. 140, was attributed to pseudo-Bernardo Castello on 8 October 1964, in spite of the old inscription on the drawing which Pouncey transcribed as '*m. Avantno dal Borgo*'.

The fullest account in the *fiches* of Pouncey's discovery appears on fol. 5*v*., in connection with the Liverpool drawing (see cat. no. 140), which Pouncey had evidently attributed to his pseudo-Bernardo Castello on the day before his great discovery:

Liverpool, Walker Art Gallery: dwg 5083 'Avanzino Nucci' (said to be traditionally so att[ribute]d) V[irgin] & Ch[ild] SS Francesco da Paola & Anthony of Padua. Black and red chalk 26.6 × 18.6. Said to be for altar in S. Francesco, Serra San Quirico (but description of altar in Ancona Inv[entory]. doesn't tally at all closely) = ps[eudo]. B[ernardo]. C[astello]. 23/1/67. . . . On 24/1/67 I noticed that the ps[eudo].-B[ernardo]. C[astello]. group fits perfectly with Baglione-sponsored altarpiece of Baptism of Constantine in S. Silvestro al Quirinale by Avanzino *Nucci*.

The note is triumphantly headed: 'Found ps[eudo]-B[ernardo] C[astello] = A[vanzino] N[ucci] on 24/1/67.'

142 Miscellaneous pages of notes on Avanzino Nucci

Private collection

Besides lists of works by Nucci taken from Baglione's *Le vite de' pittori, scultori et architetti* (1642), Pouncey's notes include the beginning of the draft of an article on Nucci's drawings, the first paragraph of which is worth quoting in full, so admirably does it explain his reasons for studying the work of lesser artists:

The reconstruction of a minor figure in the field of Roman Mannerism may seem hardly worth the effort even to those who do not take the view that this is a chapter in the history of art which can be safely skipped. Judged by his artistic value, Avanzino Nucci (1551–1629) perhaps hardly deserves the shortest of shorter notices. But in art history, as in life, nuisance value is a factor to be reckoned with and it must be admitted that an artist like Avanzino who is not only prolific but is found competing or collaborating with more important painters is liable to prove a stumbling block to those who are not aware of his existence. It seems, in short, desirable that enough of his work should be published to enable the student of the period to isolate him from his Mannerist colleagues.

143 Avanzino Nucci (1551–1629), *Decorative Panel Containing the Arms of Paul V (Borghese)*

Pen and brown ink with wash, heightened with white, on blue paper; 378 × 163mm

British Museum (1955–5–14–1)

Literature: Gere and Pouncey, 1983, no. 229

Gere and Pouncey write of this drawing as follows: 'An entirely characteristic example of Nucci's draughtsmanship, both in style and medium. It is tempting to connect it with the now vanished painting "sotto il Portico de' SS. Apostoli ... le due Virtù intorno all'arme del Pontefice Paolo V" which Baglione (p. 301) lists among Nucci's works.'

143

4 The Library

(cat. nos 144–9)

Pouncey had a very complete working library, which, in addition to the standard histories of Italian art and monographs on Italian artists, contained most of the early source books, such as Vasari, Baldinucci and others, early and modern guide books, and a number of periodicals. Cat. no. 145 is an example from his library (another is cat. no. 3). The section is supplemented by volumes from the library of the Department of Prints and Drawings, which he used extensively, many of which contain his annotations (see cat. no. 146).

144 Photograph of Pouncey at home in his study

British Museum

This picture was taken in the mid-1960s, just before Pouncey's move to Sotheby's.

145 Pouncey's copy of Bernard Berenson's *Italian Pictures of the Renaissance. A List of the Principal Artists and their Works with an Index of Places*, Oxford, 1932

Private collection

According to a note on the fly-leaf, Pouncey acquired this book in Florence in January 1932, during his first visit to Italy. As his former colleague J. A. Gere recalls, he always kept the volume on his desk at the British Museum.

The pages are extensively annotated in Pouncey's hand with abbreviated bibliographical references to reproductions of the works listed, and a key to most of these abbreviations appears on the inside of the front cover. When they came to his attention, he also noted any changes in ownership of the pictures.

144

146 Two volumes of Adolfo Venturi's *Storia dell'arte italiana*, Milan, 1901–39

British Museum

This classic work in eleven volumes (from vol. vi onwards subdivided into parts) covers the history of Italian art from the beginning of the Christian era to the end of the sixteenth century. It was especially valuable for its account of the different regional schools of painting in the sixteenth century, the volumes in question (ix (1–7)) each containing hundreds of illustrations of pictures often by minor artists, many of which had not been previously reproduced and have only recently been illustrated elsewhere. Unfortunately, the text is sometimes unreliable and is now out of date. Pouncey seems to have memorised every illustration in the volumes on sixteenth-century painting, which further enabled him to identify the compositions of many drawings that he came across in his studies. His pencil notes reveal the connections he could make as a result of this familiarity.

Two of the illustrations in the chapter on the sixteenth-century Bolognese painter Orazio Samacchini (vol. ix (6), pp. 696–7, figs 419–20) carry such annotations in the margin. The first, reproducing the fresco of the *Virgin in Glory*, in the Archiginnasio, Bologna, elicited the comment 'Looks suspiciously like Gatti, P[hilip] P[ouncey], but listed as S[amacchini] by Bodmer in Th[ieme]-B[ecker].' The second, of a fresco of the *Last Supper*, in S. Girolamo, Bologna, also believed by Venturi to be by Samacchini, has another pencil note, 'dwg for this, Louvre 9008 with Vasari label calling it Sabbatini. Zucchini *Guida di Bologna* calls it [i.e. the fresco] *attr.* to Sammacchini. Bodmer in Th.-B. implies that Lamo gives it to Samacchini.'

A note to an illustration in another volume (ix (7), p. 59, fig. 30) once more corrects an error: one of the paintings in the Sala del Maggior Consiglio in the Palazzo Ducale in Venice, which Venturi had given to the Veronese artist Giulio del Moro, is attributed by Pouncey to 'Girolamo Gambarato helped by Palma Giov[ane]' on the authority of the seventeenth-century artists' biographer Carlo Ridolfi.

147 Typescript index to Venturi, *Storia dell'arte italiana*

British Museum

Since it was never completed, Venturi's *Storia dell'arte italiana* (for which see cat. no. 146) is not accompanied by a complete index, though each volume has its own list of contents. The need for so essential an apparatus was quickly perceived, and at some point between the two wars one was produced in typescript. This copy was lodged with the Print Room, where it has remained an invaluable aid to those wishing to consult Venturi.

The volume is opened near the beginning of the letter G. Some of the names will be familiar to students of Italian painting, but many will not. It is towards the work of these lesser-known artists that Pouncey tended to direct his research.

148 Volume of the *Burlington Magazine* for 1963, showing two illustrations with Pouncey's pencil ticks

British Museum

The illustrations shown (figs 31–2 on pp. 410–11) reproduce drawings by the Florentine sculptor Baccio Bandinelli (1493–1560). During the early 1960s Pouncey marked with an unobtrusive pencil tick the reproductions in certain periodicals received by the Department to show that he had noted the painting, drawing or print reproduced and made a record of it.

149 Pouncey's cellar-book

Private collection

In his memoir Gere mentions Pouncey's 'carefully chosen and lovingly cherished cellar of claret, which was indexed as scrupulously as his collection of photographs' (1991, p. 541). Pouncey recorded the information as follows: first column, the number of bottles in each purchase; second, whether or not the wine had been château bottled ('CB'); third, the château; fourth, the year of the vintage; fifth, the date of purchase; sixth, the name of the wine-merchant; seventh, the average cost per bottle. The '0' symbol in the last column apparently signified that the lot had been drunk.

IV Epilogue

Pouncey's long association with the British Museum and other museums in this country continues to bring benefits. Half the purchase price of cat. no. 150 was donated by Mr Julien Stock of Sotheby's in Pouncey's memory, while a further contribution towards its purchase was given by the National Art Collections Fund. Moreover, according to the terms of Pouncey's will, the Lotto shown here as cat. no. 57 will be transferred to the British Museum after the closure of the present exhibition.

150 Giovanni Baglione (1571–1644), *Leo Emperor of the Armenians Killed in the Presence of his Mother*

Oil on paper (grisaille); 272 × 293mm

British Museum (1993-4-3-8)

Provenance: J. Stock; acquired with contributions from Mr Stock given in memory of Philip Pouncey, and the National Art Collections Fund.

This is a preparatory study, with significant differences, for a fresco on the ceiling of the Cappella Paolina in S. Maria Maggiore, Rome, one of the most lavishly decorated chapels erected in the city in the first quarter of the seventeenth century. It contains the tombs of Paul V (Borghese), who commissioned the chapel, and Clement VIII (Aldobrandini), by whom he had been created Cardinal. The frescoes, by various artists, celebrate the virtues of the Virgin, illustrate the devotion to holy images reaffirmed by the Counter-Reformation theologians, and commemorate opponents of heresy. This particular fresco, by Baglione, illustrates God's vengeance on iconoclasts. The gruesome death of the Emperor Leo, which was foretold to his mother by the Virgin in a dream, was a punishment for his persecution of worshippers of holy images.

Julien Stock, who contributed half the price of the drawing in memory of Pouncey, had purchased it some years earlier as the work of the seventeenth-century Bolognese painter Giacomo Cavedone (1577–1660), but suspecting that it was by Baglione, he established its authorship by finding a photograph of the corresponding fresco in Pouncey's *Fototeca* before showing the drawing to Pouncey himself.

Drawings for the same composition are in the University Art Museum, Princeton (48–620), and in the collection of Joseph F. McCrindle, as Stock has pointed out.

150

Bibliography

ADELAIDE AND MELBOURNE, 1980
Leonardo, Michelangelo and the Century of Genius. Master Drawings from the British Museum, exh. cat. by Nicholas Turner and Martin Royalton-Kisch, Art Gallery of South Australia, Adelaide, and National Gallery of Victoria, Melbourne.

ANDREWS, 1971
Keith Andrews, *National Gallery of Scotland. Catalogue of Italian Drawings*, 2 vols, Cambridge.

BAGLIONE, 1642
Giovanni Baglione, *Le vite de' pittori, scultori et architetti: dal Pontificato di Gregorio XIII del 1572. In fino a' tempi di Papa Urbano Ottavo nel 1642*, Rome (facsimile reprint of copy in the library of the Accademia dei Lincei, Rome, with annotations by G. P. Bellori and others, ed. V. Mariani, Rome, R. Istituto d'Archeologia e Storia dell'Arte, 1935).

BARTSCH, 1803–21
Adam Bartsch, *Le Peintre-graveur*, 21 vols, Vienna.

BEAN, 1982
Jacob Bean, with the assistance of Lawrence Turčić, *Fifteenth-and Sixteenth-Century Italian Drawings in the Metropolitan Museum of Art*, New York.

BERENSON, 1895
Bernard Berenson, *Lorenzo Lotto. An Essay in Constructive Art Criticism*, New York.

BERENSON, 1903
Bernard Berenson, *The Drawings of the Florentine Painters*, 2 vols, London.

BERENSON, 1932
Bernard Berenson, *Italian Pictures of the Renaissance. A List of the Principal Artists and their Works, with an Index of Places*, Oxford.

BERENSON, 1938
Bernard Berenson, *The Drawings of the Florentine Painters*, 3 vols, Chicago (amplified edition of Berenson, 1903).

BERENSON, 1956
Bernard Berenson, *Lorenzo Lotto*, London.

BERENSON, 1961
Bernard Berenson, *I disegni dei pittori fiorentini*, 3 vols, Milan (Italian edition of Berenson, 1938, with further amplifications).

BERLIN, 1975
Pieter Bruegel d. Ä. als Zeichner, exh. cat. edited by M. Winner, Kupferstichkabinett, Berlin.

BORA, 1976
Giulio Bora, 'Note cremonesi, II – L'eredità di Camillo e i Campi', *Paragone*, 311, pp. 49–74.

BORA, 1980
Giulio Bora, *I disegni lombardi e genovesi del cinquecento*, Treviso.

BRIGANTI, 1945
Giuliano Briganti, *Il Manierismo e Pellegrino Tibaldi*, Rome.

BRIGANTI AND HEIKAMP, 1971
Giuliano Briganti and Detlef Heikamp, *Ricordi su Walter Vitzthum*, Florence.

BYAM SHAW, 1976
James Byam Shaw, *Drawings by Old Masters at Christ Church, Oxford*, 2 vols, Oxford.

BYAM SHAW, 1985
James Byam Shaw, 'Philip Pouncey – a celebration', *Burlington Magazine*, cxxvii, p. 761.

CAMBRIDGE, 1985
The Achievement of a Connoisseur. Philip Pouncey, exh. cat. by Julien Stock and David Scrase, Fitzwilliam Museum, Cambridge.

CHAPPELL, 1989
Miles Chappell, 'On some drawings by Cigoli', *Master Drawings*, xxvii, pp. 195–214.

CIARDI, GALASSI AND CAROFANO, 1989
Roberto Paolo Ciardi, Maria Clelia Galassi and Pierluigi Carofano, *Aurelio Lomi, maniera e innovazione*, Pisa.

CREMONA, 1985
I Campi e la cultura artistica cremonese del Cinquecento, exh. cat. edited by Mina Gregori, Comune di Cremona.

CROWE AND CAVALCASELLE, 1871
J. A. Crowe and G. B. Cavalcaselle, *A History of Painting in North Italy*, 2 vols, London.

CUST, 1906
R. H. Cust, *Giovanni Antonio Bazzi*, London.

DACOS, 1990
Nicole Dacos, 'Le Maître des albums Egmont: Dirck Hendricksz. Centen', *Oud Holland*, 104, pp. 49–68.

EDINBURGH, 1969
Italian Sixteenth-Century Drawings from British Private Collections, exh. cat. by Yvonne Tan Bunzl, Edinburgh Festival Society and Scottish Arts Council, Merchants' Hall, Edinburgh.

EDINBURGH, 1972
Italian Seventeenth-Century Drawings from British Private Collections, exh. cat. by Yvonne Tan Bunzl, Edinburgh Festival Society and Scottish Arts Council, Merchants' Hall, Edinburgh.

FISCHER PACE, 1978
Ursula Fischer Pace, 'Les oeuvres de Giacinto Gimignani dans les collections publiques françaises', *Revue du Louvre et des Musées de France*, 5–6, pp. 343–58.

FLORENCE, 1983
Disegni di Giovanni Lanfranco (1582–1647), exh. cat. by Erich Schleier, Gabinetto Disegni e Stampe, Uffizi, Florence.

FLORENCE, 1992
Disegni di Lodovico Cigoli (1559–1613), exh. cat. by Miles L. Chappell, Gabinetto Disegni e Stampe, Uffizi, Florence.

FREEDBERG, 1963
S. J. Freedberg, '"Drawings *for* Sebastiano" or "Drawings by Sebastiano": the problem reconsidered', *Art Bulletin*, xlv, pp. 253–8.

FROMMEL, 1967–8
Cristoph Luitpold Frommel, *Baldassare Peruzzi als Maler und Zeichner*, Beiheft zum *Römischen Jahrbuch für Kunstgeschichte*, ii, Vienna and Munich.

GERE, 1962–3
J. A. Gere, 'Some drawings by Pellegrino Tibaldi', *British Museum Quarterly*, xxvi, pp. 40–43.

GERE, 1969
J. A. Gere, *Taddeo Zuccaro. His Development Studied in his Drawings*, London.

GERE, 1971
J. A. Gere, 'Some early drawings by Pirro Ligorio', *Master Drawings*, ix, pp. 239–50.

GERE, 1972
J. A. Gere, 'Walter Vitzthum' (obituary), *Burlington Magazine*, cxiv, pp. 721–2.

GERE, 1975
J. A. Gere, 'Drawings by Sebastiano del Piombo and Agnolo Bronzino', *British Museum Yearbook, 1. The Classical Tradition*, London, pp. 270–75.

GERE, 1991
J. A. Gere, 'Philip Pouncey, 1910–1990', *1990 Lectures and Memoirs: Proceedings of the British Academy*, 76, pp. 529–44.

GERE AND POUNCEY, 1983
J. A. Gere and Philip Pouncey, with the assistance of Rosalind Wood, *Italian Drawings in the Department of Prints and Drawings in the British Museum. Artists working in Rome c.1550 to c.1640*, 2 vols, London.

GOLDNER, 1988
George R. Goldner, with the assistance of Lee Hendrix and Gloria Williams, *European Drawings, 1. Catalogue of the Collections* (J. Paul Getty Museum), Malibu.

GRIFFITHS AND WILLIAMS, 1987
Antony Griffiths and Reginald Williams, *The Department of Prints and Drawings in the British Museum. User's Guide*, London.

HARRIS, 1977
Ann Sutherland Harris, *Andrea Sacchi*, Oxford.

HIRST, 1981
Michael Hirst, *Sebastiano del Piombo*, Oxford.

HUNTER, 1988
John Hunter, 'The drawings and draughtsmanship of Girolamo Siciolante da Sermoneta', *Master Drawings*, xxvi, pp. 3–40.

L
Frits Lugt, *Les Marques de collections de dessins et d'estampes*, Amsterdam, 1921.

LASKIN, 1967
Myron Laskin Jr, 'A note on Correggio and Pordenone', *Burlington Magazine*, cix, pp. 355–6.

LONDON, 1951
Emilian Drawings of the XVI Century, exh. cat. by A. E. Popham, Department of Prints and Drawings, British Museum, London.

LONDON, 1974
Portrait Drawings, XV–XX Centuries, exh. cat. by J. A. Gere, Department of Prints and Drawings, British Museum, London.

LONDON, 1981–2
Splendours of the Gonzaga, exh. cat. by David Chambers and Jane Martineau, Victoria and Albert Museum, London.

LONDON, 1983
Drawings by Raphael, exh. cat. by J. A. Gere and Nicholas Turner, Department of Prints and Drawings, British Museum, London.

LONDON, 1983–4
The Genius of Venice, 1500–1600, exh. cat., with entries on drawings by David Scrase, under the direction of Philip Pouncey, Royal Academy of Arts, London.

LONDON, 1986
Florentine Drawings of the Sixteenth Century, exh. cat. by Nicholas Turner, Department of Prints and Drawings, British Museum, London.

MACANDREW, 1980
Hugh Macandrew, *Ashmolean Museum Oxford: Catalogue of the Collection of Drawings, III. Italian Schools, Supplement*, Oxford.

MONBEIG-GOGUEL, 1972
Catherine Monbeig-Goguel, *Musée du Louvre, Cabinet des Dessins. Inventaire général des dessins italiens. Maîtres toscans nés après 1500, morts avant 1600. Vasari et son temps*, Paris.

MORTARI, 1992
Luisa Mortari, *Francesco Salviati*, Rome.

NEW YORK, 1979
Drawings by Michelangelo from the British Museum, exh. cat. by J. A. Gere and Nicholas Turner, Pierpont Morgan Library, New York.

OFFNER, 1931–79
Richard Offner, *Critical and Historical Corpus of Florentine Painting*, New York.

PALLUCCHINI, 1951
Rodolfo Pallucchini, 'Cataloghi', *Arte Veneta*, v, pp. 194–7.

PARIS, 1978
Nouvelles Attributions, exh. cat. by Roseline Bacou, Musée du Louvre, Paris.

PARIS, 1983–4
Autour de Raphael, exh. cat. by Roseline Bacou, Musée du Louvre, Paris.

PARIS, 1992
L'Oeil du Connaisseur. Hommage à Philip Pouncey, exh. cat. by Lizzie Boubli, Dominique Cordellier, *et al.*, Musée du Louvre, Paris.

PARKER, 1956
K. T. Parker, *Catalogue of the Collection of Drawings in the Ashmolean Museum, II. Italian Schools*, Oxford (reprinted with corrections, 1972).

PARTHEY, 1853
Gustav Parthey, *Wenceslaus Hollar. Beschreibendes Verzeichniss seiner Kupferstiche*, Berlin.

PASCULLI FERRARA, 1986
Mimma Pasculli Ferrara, 'Aggiunte a Fabrizio Santafede e Belisario Corenzio', *Ricerche sul '600 napoletano, dedicato a Ulisse Prota-Giurleo nel centinario della nascita*, Milan, pp. 201–35.

PEPPER, 1984
D. Stephen Pepper, *Bob Jones University Collection of Religious Art. Italian Paintings*, Greenville, South Carolina.

PILLSBURY, 1974
Edmund Pillsbury, 'Drawings by Jacopo Zucchi', *Master Drawings*, xii, pp. 3–33.

PIRONDINI, 1982
Massimo Pirondini, *Reggio Emilia, guida storico-artistica*, Reggio Emilia.

POPHAM, 1932
A. E. Popham, *Catalogue of Drawings by Dutch and Flemish Artists Preserved in the Department of Prints and Drawings in the British Museum, V. Dutch and Flemish Drawings of the XV and XVI Centuries*, London.

POPHAM, 1935
A. E. Popham, *Catalogue of Drawings in the Collection formed by Sir Thomas Phillipps, Bart., F.R.S., now in the possession of his grandson, T. Fitzroy Phillipps Fenwick of Thirlestaine House, Cheltenham*, 2 vols, privately printed.

POPHAM, 1936–7
A. E. Popham, 'Sebastiano Resta and his collections', *Old Master Drawings*, xi, no. 44, pp. 1–19.

POPHAM, 1937–8
A. E. Popham, 'Lorenzo Lotto (1480 – after Sept. 1st 1556) – Study of drapery – Collection of Mrs. Rayner-Wood, Old Colwall', *Old Master Drawings*, xii, no. 48, p. 49.

POPHAM, 1951
A. E. Popham, 'A drawing attributed to Lorenzo Lotto', *British Museum Quarterly*, xvi, pp. 72ff.

POPHAM, 1954
A. E. Popham, 'A sheet of drawings by Raphael', *British Museum Quarterly*, xix, p. 10.

POPHAM, 1967
A. E. Popham, *Italian Drawings in the Department of Prints and Drawings in the British Museum. Artists working in Parma in the Sixteenth Century*, 2 vols, London.

POPHAM, 1971
A. E. Popham, *Catalogue of the Drawings of Parmigianino*, 3 vols, New Haven and London.

POPHAM AND POUNCEY, 1950
A. E. Popham and Philip Pouncey, *Italian Drawings in the Department of Prints and Drawings of the British Museum. The Fourteenth and Fifteenth Centuries*, 2 vols, London.

POSNER, 1971
Donald Posner, *Annibale Carracci. A Study in the Reform of Italian Painting around 1590*, 2 vols, London.

POUNCEY, 1946
Philip Pouncey, 'Vincenzo Tamagni at Siena', *Burlington Magazine*, lxxxviii, pp. 3–8.

POUNCEY, 1947
Philip Pouncey, 'A drawing by Benozzo Gozzoli for his fresco-cycle at Viterbo', *Burlington Magazine*, lxxxix, pp. 9–13.

POUNCEY, 1951
Philip Pouncey, 'A drawing by Francesco Bonsignori', *British Museum Quarterly*, xvi, pp. 99–101.

POUNCEY, 1955
Philip Pouncey, 'Drawings by Garofalo', *Burlington Magazine*, xcvii, pp. 196–200.

POUNCEY, 1961
Philip Pouncey, 'A drawing by Pordenone', *British Museum Quarterly*, xxiv, pp. 27–8.

POUNCEY, 1962
Philip Pouncey, 'Contributo a Girolamo Macchietti', *Bollettino d'Arte*, xlvii, pp. 237–8.

POUNCEY, 1964
Philip Pouncey, Review of Bernard Berenson, *I disegni dei pittori fiorentini* (Milan, 1961), *Master Drawings*, ii, pp. 278–93.

POUNCEY, 1965
Philip Pouncey, *Lotto disegnatore*, Vicenza.

POUNCEY, 1972
Philip Pouncey, 'Drawings by Bastianino', *Arte Illustrata*, v, p. 126.

POUNCEY AND GERE, 1962
Philip Pouncey and J. A. Gere, *Italian Drawings in the Department of Prints and Drawings of the British Museum. Raphael and his Circle*, 2 vols, London.

PUPPI, 1961
Lionello Puppi, 'Nota sui disegni del Fogolino', *Arte Veneta*, xv, pp. 223–7.

PUPPI, 1966
Lionello Puppi, *Marcello Fogolino pittore e incisore*, Trent.

RAGGHIANTI, 1954
Carlo Ragghianti, 'Biblioteca' (review of A. E. Popham and Johannes Wilde, *The Italian Drawings of the XV and XVI Centuries in the Collection of His Majesty the King at Windsor Castle* and A. E. Popham and Philip Pouncey, *Italian Drawings in the British Museum*), *Critica d'Arte*, vi, pp. 594–600.

RAVELLI, 1978
Lanfranco Ravelli, *Polidoro Caldara da Caravaggio*, Bergamo.

REITLINGER, 1922
Henry Scipio Reitlinger, *Old Master Drawings. A Handbook for Amateurs and Collectors*, London.

RESTA MS.
Manuscript transcript, apparently by Jonathan Richardson senior, of notes made by Padre Sebastiano Resta in the albums of drawings formed by him and acquired about 1710 by Lord Somers. British Library, Department of Manuscripts, Lansdowne 802 and 803.

RICHARDSON, 1980
Francis L. Richardson, *Andrea Schiavone*, Oxford.

ROBERTSON, 1981
Giles Robertson, *Giovanni Bellini*, New York (reissue of 1968 edition).

ROBINSON, 1876
Sir J. C. Robinson, *Descriptive Catalogue of Drawings by the Old Masters, forming the Collection of John Malcolm of Poltalloch, Esq.*, London.

RODINÒ, 1990
Simonetta Prosperi Valenti Rodinò, 'Allegrini: Francesco o Flaminio?', *Nuove ricerche in margine alla mostra: Da Leonardo a Rembrandt. Atti del Convegno Internazionale di Studi*, ed. Gianni Carlo Sciolla, Turin, pp. 229–44.

ROGERS, 1778
Charles Rogers, *A Collection of Prints in Imitation of Drawings, to which are annexed Lives of their Authors with explanatory and critical Notes*, 2 vols, London.

ROLI, 1965
Renato Roli, 'Giovanni de' Vecchi', *Arte Antica e Moderna*, 29, part I, pp. 45–56, and part II, 324–34.

ROLI, 1977
Renato Roli, *Pittura bolognese, 1650–1800*, Bologna.

RULAND, 1876
C. Ruland, *The Works of Raphael Santi da Urbino as represented in The Raphael Collection in the Royal Library at Windsor Castle, formed by H.R.H. The Prince Consort, 1853–1861, and completed by Her Majesty Queen Victoria*, privately printed.

SANMINIATELLI, 1955
Donato Sanminiatelli, 'The sketches of Domenico Beccafumi', *Burlington Magazine*, xcvii, pp. 35–40.

SCHARF, 1952
A. Scharf, 'Italian drawings in the Print Room' (review of Popham and Pouncey, 1950), *Burlington Magazine*, xciv, pp. 209–10.

SCRASE, 1991
David Scrase, 'A drawing by Francesco Menzocchi acquired by the Fitzwilliam Museum', *Burlington Magazine*, cxxxiii, pp. 773–6.

THIEM, 1970
Christel Thiem, *Gregorio Pagani*, Stuttgart.

THIEM AND THIEM, 1964
Christel and Gunther Thiem, 'Der Zeichner Jacopo Confortini', *Mitteilungen des Kunsthistorischen Institutes in Florenz*, xi, pp. 153–65.

TIETZE, 1942
Hans Tietze, 'Mantegna and his companions in Squarcione's shop', *Art in America*, xxx, pp. 54–60.

TIETZE AND TIETZE-CONRAT, 1944
Hans Tietze and E. Tietze-Conrat, *The Drawings of the Venetian Painters in the Fifteenth and Sixteenth Centuries*, New York.

TOESCA, 1948
Pietro Toesca, 'Di un miniatore e pittore emiliano Francesco Marmitta', *L'Arte*, xvii, pp. 33–9.

DE TOLNAY, 1975
Charles de Tolnay, *Corpus dei disegni di Michelangelo*, ii, Novara.

TURČIĆ AND NEWCOME, 1991
Lawrence Turčić and Mary Newcome, 'Drawings by Aurelio Lomi', *Paragone*, xlii, no. 29 (499), pp. 33–46.

TURNER, 1980
Nicholas Turner, *Italian Baroque Drawings*, London.

TURNER, 1984
Nicholas Turner, 'Some drawings by Giuseppe Caletti, called il Cremonese', *Scritti in Onore di Federico Zeri*, ii, Turin, pp. 681–8.

VENICE, 1982
Disegni lombardi, exh. cat. by Ugo Ruggeri, Galleria dell'Accademia, Venice.

VENICE, 1992
Da Pisanello a Tiepolo. Disegni veneti dal Fitzwilliam Museum di Cambridge, exh. cat. by David Scrase, Fondazione Giorgio Cini, Venice.

VENTURI, 1901–39
Adolfo Venturi, *Storia dell'arte italiana*, 11 vols (from vol. vi onwards subdivided into parts), Milan.

VENTURI, 1927
Adolfo Venturi, *Studi dal vero attraverso le raccolte artistiche d'Europa*, Milan.

VERONA, 1974
Cinquant'anni di pittura veronese, 1580–1630, exh. cat. by Licisco Magagnato *et al.*, Palazzo della Gran Guardia, Verona.

VIATTE, 1988
Françoise Viatte, *Musée du Louvre, Cabinet des Dessins. Inventaire général des dessins italiens. Dessins toscans XVIe–XVIIIe siècles, I. 1560–1640*, Paris.

VITZTHUM, 1954
Walter Vitzthum, 'Zuccari's "Paradise" for the Doges' Palace' (letter), *Burlington Magazine*, xcvi, p. 291.

VITZTHUM, 1970–71
Walter Vitzthum (ed.), *I disegni dei maestri*, 16 vols, Milan.

WARD-JACKSON, 1979
Peter Ward-Jackson, *Victoria and Albert Museum Catalogue. Italian Drawings, I. 14th–16th Century*, London.

WARD-JACKSON, 1980
Peter Ward-Jackson, *Victoria and Albert Museum Catalogue. Italian Drawings, II. 17th–18th Century*, London.

WASHINGTON, 1979
Prints and Related Drawings by the Carracci Family, exh. cat. by Diane DeGrazia Bohlin, National Gallery of Art, Washington, DC.

WASHINGTON AND NEW YORK, 1973–4
Sixteenth-Century Italian Drawings from the Collection of Janos Scholz, exh. cat. by Konrad Oberhuber and Dean Walker, National Gallery of Art, Washington, DC, and Pierpont Morgan Library, New York.

WHITE, 1959
Christopher White, 'Pieter Bruegel the Elder: two new drawings', *Burlington Magazine*, ci, pp. 336–41.

WICKHOFF, 1892
F. Wickhoff, 'Die italienischen Handzeichnungen der Albertina, römische Schule', *Wiener Jahrbuch*, xiii, pp. clxxv–cclxxxiii.

WILDE, 1953
Johannes Wilde, *Italian Drawings in the Department of Prints and Drawings in the British Museum. Michelangelo and his Studio*, London.

Lenders to the Exhibition

British Museum
4, 6, 9, 13, 15–16, 18–56, 58–62, 64–87, 94–100, 111-12, 114–15,
129, 135, 137–8, 143–4, 146–8, 150

Private Collections
1–3, 5, 10, 12, 14, 57, 88–93, 104–10, 113, 118–19, 121, 124,
130–34, 136, 139, 141–2, 145, 149

Fitzwilliam Museum, Cambridge
8, 101–3

National Gallery of Scotland, Edinburgh
125–6, 128

Victoria and Albert Museum, London
117, 123, 127

Ashmolean Museum, Oxford
116, 120

Christ Church, Oxford
122

Concordances

Reg. no.	Cat. no.	Reg. no.	Cat. no.	Reg. no.	Cat. no.
British Museum		1946–7–13–1301	52	Fitzwilliam Museum, Cambridge	
5210–75	30	1946–7–13–1303	53	PD.2903	101
5211–76	24	1946–12–21–1	31	PD.263–1985	102
Pp.2–123	28	1950–5–26–1	29	PD.39–1991	103
Pp.2–127	33	1951–2–8–34	59		
1857–6–13–360	54	1952–5–10–7	65	National Gallery of Scotland, Edinburgh	
1858–11–13–34	49	1952–10–11–6	66	D 632	128
1860–6–16–68	23	1953–4–11–112	44	D 915	125
1860–6–16–69	23	1953–10–10–1	67	D 1957	126
1860–6–16–70	23	1953–12–12–3	68		
1860–6–16–81	47	1953–12–12–4	69	Victoria and Albert Museum, London	
1866–7–14–8	60	1953–12–12–6	70	D.2222–1885	117
1885–5–9–38	61	1953–12–12–10	71	8942	123
1895–9–15–490	43	1954–2–19–8	74	CAI.829	127
1895–9–15–541	39	1954–3–15–1	72		
1895–9–15–591	22	1955–2–12–1	75	Ashmolean Museum, Oxford	
1895–9–15–684	58	1955–5–2–1	76	KTP 240	120
1895–9–15–770	41	1955–5–14–1	143	KTP 252	116
1895–9–15–790	40	1958–2–8–1	62		
1895–9–15–813	26	1958–12–13–2	77	Christ Church, Oxford	
1897–4–10–2	27	1958–12–13–5	25	JBS 908	122
1900–7–17–31	21	1959–2–14–1	73		
1902–8–22–5	13	1962–7–14–3	32		
1920–4–20–5	42	1963–5–18–5	78		
1927–4–11–4	55	1963–11–9–26	79		
1946–4–13–206	46	1963–12–16–1	80		
1946–4–13–211	137	1965–10–9–3	129		
1946–7–5–14	64	1965–10–9–4	81		
1946–7–13–15	138	1966–3–3–1	94		
1946–7–13–92	48	1972–5–13–1	95		
1946–7–13–230	50	1972–7–22–7	96		
1946–7–13–358	45	1974–9–14–1	97		
1946–7–13–455	85	1980–6–28–35	98		
1946–7–13–596	51	1980–10–11–5	99		

Index of Artists